THE DRAWING BOOK

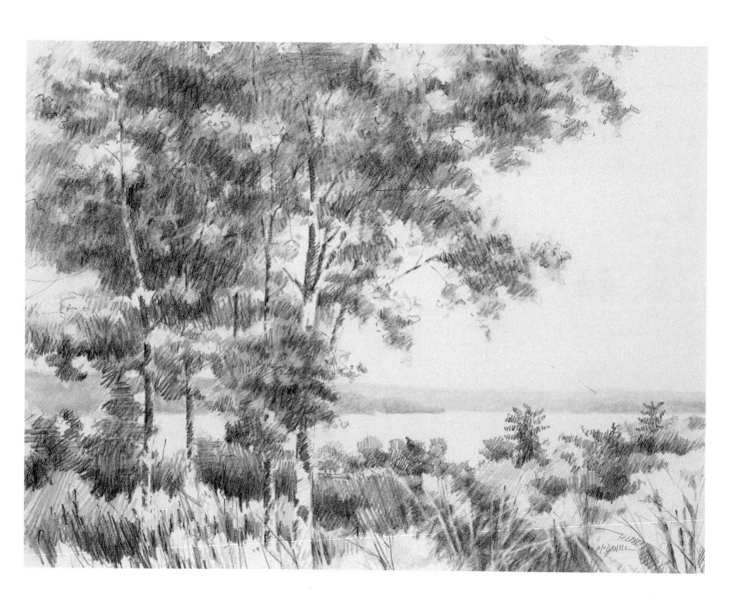

THE DRAWING BOOK

Materials and Techniques for Today's Artist

RICHARD McDANIEL

WATSON-GUPTILL PUBLICATIONS/NEW YORK

Art on page 1:
WEST PARK SERENADE
Pencil on museum board, 8 × 10" (20 × 25 cm).
From *Hudson River Drawings* by Richard McDaniel (1994).
Collection of Mr. and Mrs. Robert Gravinese.

Art on page 5:
RIPARIAN WINTER
Colored pencil on Lana Royal Classic paper, 6 × 15" (15 × 38 cm).

Images as noted on pages 1, 8, 64, 75, 78, 84, 87, 88, 91, 155, and 176 were first published in *Hudson River Drawings* (1994) or *Catskill Mountain Drawings* (1990), both Phantom Press Editions published by Purple Mountain Press, Woodstock, New York.

Copyright © 1995 by Richard Webb McDaniel

First published in 1995 by Watson-Guptill Publications,
a division of BPI Communications, Inc.,
1515 Broadway, New York, N.Y. 10036

Library of Congress Cataloging-in-Publication Data

McDaniel, Richard, 1948–
 The drawing book: materials and techniques for today's artist /
Richard McDaniel.
 p. cm.
 Includes index.
 ISBN 0-8230-1392-8
 1. Drawing materials. 2. Drawing—Technique. I. Title.
NC845.M34 1995
741.2—dc20 95-22250
 CIP

Manufactured in Singapore

First printing, 1995

1 2 3 4 5 6 7 8 9 / 03 02 01 00 99 98 97 96 95

It is a pleasure to offer a word of praise to those who helped make this book possible.

At Watson-Guptill, I applaud Candace Raney, who asked me to write the book in the first place, then made it easier with her enthusiasm and gentle humor; Areta Buk, for her design ideas and skillful application thereof; Ellen Greene, for her experienced eye and persistent attention to detail; and Joy Aquilino, whose love of the language, patience, and smiling cooperation proved indispensable.

There are several I wish to thank for their professional expertise and technical information, including Kent Barnes, Chuck Bennett, John Brandewie, Ed Brickler, Karen Marton, Peter Ouyang, Allen Shefts, Steve Steinberg, Wendell Upchurch, and the helpful staff at Daniel Smith Inc., with special thanks to Pierre Guidetti, Richard Frumess, and David Piña.

I am grateful to those collectors of my work who allowed it to be reproduced herein; to Phantom Press and Purple Mountain Press for the same; and for the ongoing support of the James Cox Gallery and the Paradox Gallery in Woodstock, New York, and the John Pence Gallery in San Francisco.

Also, I owe a hearty handshake to my colleagues and fellow instructigators at the Woodstock School of Art; and all partners, opponents, spectators, and dogs at Wednesday Night Ping Pong.

Thanks to my students, who taught me so much; to the following painters, with whom I've discussed the merits of drawing: Bob, Bruce, Deane, Eva, Jack, Tom, and Will; also to Linda, Louise, Nadja, Philip, Simon, and the Reiter family; and very special thanks to Elizabeth, for her radiance, friendship, and those wonderful green boxes.

And finally, words alone cannot express my appreciation for my mother and father, who shared their wisdom, humor, and love from far away, yet were always very near.

Do not mourn the loss of lead from a pencil;
Rather, rejoice in the mark it has made.

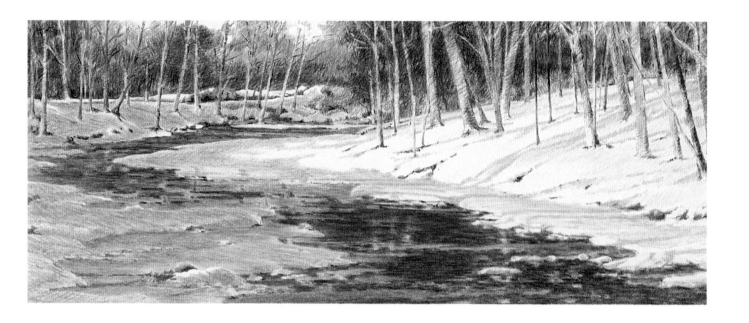

CONTENTS

Introduction 8

MATERIALS AND TOOLS 10

Pencils 12
 Graphite Pencils 12
 Soft-Lead Pencils 14
 Woodless Pencils 14
 Watersoluble Pencils 15
 Carbon Pencils 15
 Mechanical Pencils and
 Lead Holders 16
 Lead Fillers 16
Graphite Products 17
 Graphite Sticks 17
 Graphite Crayons 17
 Powdered Graphite 17
Charcoal 18
 Stick Charcoal 18
 Compressed Charcoal 18
 Charcoal Pencils 18
 Powdered Charcoal 18
Chalk 19
 White Chalk 19
 White Pastel Pencils 19
 Red Chalk 19
 Railroad Chalk 19
Pencils in Color 20
 Colored Pencils 20
 Watercolor Pencils 21
 Pastel Pencils 22
Crayons 24
 Drawing Crayons 24
 Lithographic Crayons 24
 Fine Art Color Crayons 25
 Specialty Crayons 26
 Schoolyard Crayons 26
Oil Pastels and Oil Sticks 28
 Oil Pastels 28
 Oil Sticks 28

Pens 30
 Dip Pens and Holders 30
 Crow Quill Pens 30
 Fountain Pens 31
 Technical Pens 31
 Ballpoint Pens 33
 Rolling Ball Pens 34
 Fiber-Tip Pens 34
 Markers 35
Brushes and Brush Pens 37
 Brushes 37
 Brush Pens 37
Inks 38
 India Inks 38
 Sumi Inks 38
 Inks for Technical Pens 39
 White Inks 39
 Colored Drawing Inks 40
Papers and Supports 42
 Glossary of Paper Terms 42
 Sketchbooks 44
 Drawing Papers 45
 Printmaking and Watercolor
 Papers 45
 Colored Papers 47
 Vintage Papers 49
 Traditional Japanese Handmade
 Papers 50
 Indian Handmade Papers 51
 Other Handmade Papers 51
 Specialty Papers and Boards 52
 Papers and Films for Ink 53
Silverpoint and Scratchboard 54
 Silverpoint 54
 Scratchboard 54
Tools and Supplies 56
 Sharpeners 56
 Erasers 57
 Blending Tools 58
 Drawing and Drafting Accessories 59
 Creative Alternatives 60

Drawing and New Technology 62
 Xerography 62
 Videography 63
 Computer Imaging 63

DRAWING WITH LINE AND TONE 66

Thinking on Paper 68
 The Scribble, the Sketch,
 and the Study 68
The Eloquent Line 71
 Linear Pencil Drawings 71
 Linear Ink Drawings 74
The Value of Value 75
Tonal Effects in Pencil 76
 Sampler of Pencil Marks 76
Hatching and Cross-hatching with Pencil 80
 Demonstration 81
The Dry Wash Technique 84
 Demonstration 86
Drawing with an Eraser 88
 Softening Tone 88
 Smearing 88
 Lifting Out Highlights 88
 Demonstration 90
Dark Tones with Graphite 92
 Demonstration 93
Working Wet with Pencil 95
 Demonstration 96
Tonal Effects in Charcoal 99
 Demonstration 100
Tonal Effects in Ink 102
Stippling with Ink 104
 Demonstration 104
Hatching with Ink 106
 Demonstration 106
The Subtlety of Ballpoint 108
 Demonstration 109

DRAWING WITH COLOR 112

Color Basics 114
 The Color Wheel 114
Working with Crayons 116
Neutral Color 118
 Demonstration: Yarka Sauce 118
Black and White on a Colored
 Ground 120
 Demonstration: Litho Crayon
 and China Marker 121
Building Color Gradually 123
 Demonstration: Conté Crayons 124
Dry Color: Pastels and Pastel
 Pencils 126
 Demonstration: Pastels 128
 Demonstration: Pastel Pencils 130
Colored Pencils: Wet and Dry 132
 Demonstration: Colored Pencils 136
 Demonstration: Watercolor
 Pencils 138
Stippling with Colored Markers 140
 Demonstration 141
Drawing with Paint 144
 Demonstration: Oil Pastels 146
 Demonstration: Oil Sticks 149

FROM DRAWING TO PAINTING 152

Drawing for Composition 154
Painting from Drawings 156
 Demonstration 156
Value Analysis 162
 Demonstration 163
Drawing to Resolve a Painting 166
 Demonstration 166

List of Suppliers 172
Index 173

INTRODUCTION

At first I was seduced by color. I wanted to be a painter and had absolutely no use for drawing. For me, the *act* of painting was where all the excitement took place. Like a musician taking a solo on stage, my heart was captured by the spontaneity of "action painting" and the zest of improvisation.

I learned much from nonrepresentational painting—much about composition, rhythm, and color—but very little about drawing. For years I perfected my reasons for not drawing: "It interferes with the spontaneity of painting. It is boring and unimportant. It is only preliminary to the real thing, painting." Though these points can be argued successfully, I slowly came to realize that they were merely excuses I used to mask the fact that I did not know how to draw.

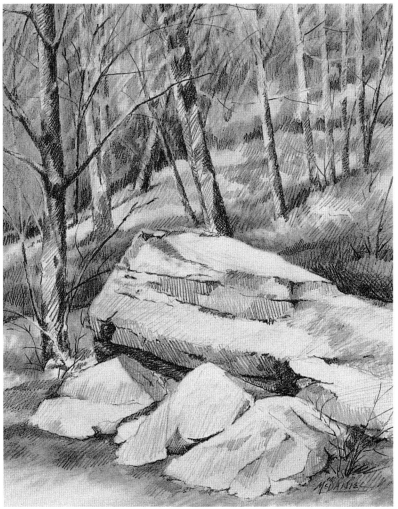

GRAY ROCKS ON WOODED SLOPE
Pencil on museum board, 9 × 7" (23 × 18 cm).
From *Catskill Mountain Drawings* by Richard McDaniel (1990).

While I continued to make nonobjective art for more than a decade, I ultimately needed a new challenge in my work. I needed to draw. Subsequently, I investigated linear perspective, proportion, and figurative rendering in painting *and* drawing—all that stuff I had avoided earlier. However, when I began teaching I was still only partially interested in drawing. It was in the classroom that I finally became a convert. As I taught students not to dread drawing, I found that I didn't dread it myself. In an effort to convince them that drawing is valid, necessary, and enjoyable, I convinced myself. Every time a student raised an objection to drawing, it sounded embarrassingly familiar. But when told, "Drawing interferes with the spontaneity of painting," I would reply, "On the contrary, drawing helps you become familiar with the subject. It releases you from working out so many things on canvas, and thereby *increases* your freedom as a painter."

No stranger to the fear of drawing, I tried to shoot holes in the excuses offered by students who were unwilling to try. The solution is simple: Don't resist—just draw. I've discovered that drawing makes you look intently, and with purpose. It makes you see differently. Soon it becomes clear that the most important step to take is the first one. Just draw.

A work of art has traditionally been classified as a drawing if a significant portion of the ground is visible and plays an integral part in the design. Usually, drawings (whether quick sketches or fully articulated compositions) are two-dimensional images executed with a dry medium, most often in black and white. Pencil on paper fits this basic description; pen and ink enlarges the definition to include a liquid medium. The addition of color expands the boundaries further, ranging from an easy scribble with a single colored pencil to a full chromatic treatment with pastels or oil sticks, just two of the so-called "bridge" media. With them, drawing is hardly distinguishable from painting.

We should also consider drawing by its function rather than by the materials used. To that end, it is frequently said that drawing is a preliminary investigation of an artistic idea, a sort of visual exploration. Consequently, a quick sketch may serve as an arena in which to work out compositional thoughts before turning to painting. If this "exploratory" element is part of our definition of drawing, then it follows that someone may draw in the dirt with a stick, by waving a flashlight in the dark, with a video camera, and by countless other means.

Drawing is intimate, possessing a directness that is often viewed as an artist's private note-taking, yet it can also refer to elaborate works intended for exhibition. But it is important not to get sidetracked by definitions. Louis Armstrong, when asked the question, "What is Jazz?" said, "Man, if you don't know, don't mess with it." Likewise, it is far more important to draw than to isolate the precise meaning of drawing.

This book begins with a comprehensive review of the drawing materials and accessories currently on the market. The sections that follow demonstrate and explain a range of drawing techniques in a variety of media. The final section examines the critical link between drawing and painting, and describes the ways in which drawing can serve as a tool for developing and refining a painted image. These examples are intended to provide you with insights into several working strategies and enable you to discover new attitudes toward and methods of application for your own work.

SAFE HARBOR
Silverpoint on Karma
Claycote, 5 × 9"
(13 × 23 cm).

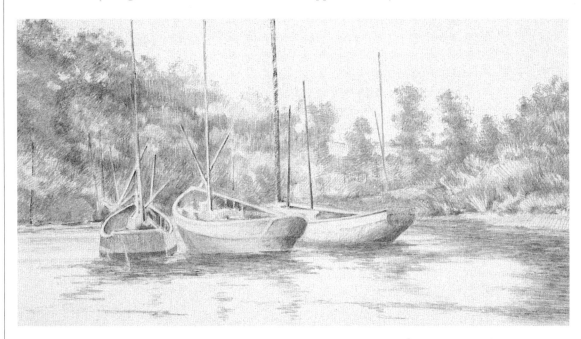

NEW SHOOT
Charcoal and white chalk
on Ingres paper, 13 × 18"
(33 × 46 cm).

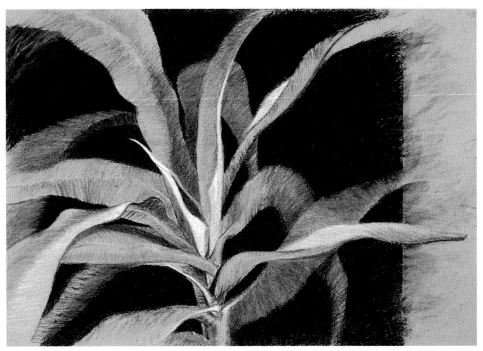

MATERIALS AND TOOLS

Any choice of drawing materials is ultimately based on personal preference. Some artists work so efficiently with one medium they find little need to explore alternatives, while others continually search for materials and techniques with which they feel comfortable. Many of the most accomplished artists constantly expand their knowledge by employing a wide range of techniques.

The act of drawing has two material requirements: something to draw *with* and something to draw *on*. Within those two categories, the possibilities are nearly limitless. You could use a dry medium (such as pencil, chalk, or charcoal), a greasy medium (crayon, oil pastel, or oil stick), or something wet (ink, markers, or watersoluble pencils). You could work exclusively in black and white, use just a few muted colors, or embrace the full spectrum. And once those decisions have been made, you must then select a paper or support.

Having so many options to choose from can be confusing, but it also presents an opportunity to investigate an extraordinary assortment of possibilities. In the pages that follow we review many of the drawing materials currently on the market. This information is no substitute for hands-on experimentation, but is intended to help guide you through the maze of products and expectations. Perhaps this chapter will inspire you to try something new, or to reconsider a time-honored product you've never used.

PENCILS

The story of the modern pencil begins in England, during the reign of Queen Elizabeth. The year, 1564, was the year of Shakespeare's birth, and that of Michelangelo's death—a most remarkable coincidence, considering the pencil's dual role of writing and drawing.

Near the village of Barrowdale, in Cumberland, a tree was uprooted during a violent storm, exposing a large deposit of pure graphite. This dark, shiny substance resembled lead, and was originally called "plumbago," which was derived from the Latin word for lead, *plumbum*. It could produce rich, black marks, and satisfied a great need for writing and drawing implements.

Until then, most drawings were made with natural red chalk or ink. The newly found material from Cumberland, now called graphite, didn't spill like ink and was more versatile than red chalk. It was dark and easy to see on paper, could be shaped to a point, and yielded a fine, durable line. At first, fragments of graphite were wrapped in string to keep the fingers clean. Later, chunks were used in a metal holder, but both methods were a bit awkward by today's standards, and there was no accurate system for designating hard or soft graphite.

Toward the end of the 18th century, Nicolas Jacques Conté was asked by Napoleon to make improvements to the pencil. Conté combined powdered graphite with clay, which was added to regulate the hardness of the pencil. The more clay in the mixture, the harder the point, and the harder the point, the lighter the line. Thus, by varying the proportion of clay and graphite, a whole range of pencils was developed. This mixture was then formed into thin strips and baked, encased in wood, and *voilà!*

A contemporary of Conté's, Joseph Hardtmuth, founded a pencil manufacturing company in Prussia that would become known worldwide as the Koh-I-Noor Hardtmuth Corporation. In 1850 his grandson and successor, Franz von Hardtmuth, was trying to decide upon a distinctive color for the wooden casing of his company's pencils. Glancing out the window at the Prussian flag, he made his decision, and the familiar yellow pencil got its start—through a gesture of patriotism.

The shape of a pencil is one with which we are all familiar, and is one of the basic tool shapes of humanity. The source of the word "pencil" is the Latin *penicillus*, meaning "little tail." This term originally referred to a small brush used by the Romans, and now applies to any number of writing or drawing implements of a slender, cylindrical shape. Although pencils may contain a variety of marking substances, such as carbon, charcoal, or pastel, the most common ingredient is graphite.

Most pencil manufacturers make pencils in varying degrees of hardness. At times a soft lead pencil will be more suitable than a hard one, or vice versa. It is best to learn the characteristics of each, and use them accordingly.

Pencils of the same degree made by different companies are essentially the same, but they are *not* identical. Each manufacturer has access to different raw materials and uses proprietary formulas to produce its pencils. The most noticeable difference among pencils of the same degree is the amount of resistance, or *drag*, that occurs when the lead is drawn across paper. This disparity is a result of variations in the quality of the ingredients and how finely an individual mixture is ground. Consequently, a 3H pencil is always harder than a 2H pencil made by the same company, but isn't necessarily the same hardness (or smoothness) as a 3H made by another manufacturer.

Other minor variations such as barrel color, diameter, or labeling may also influence your opinion. A round pencil and a hexagonal pencil feel almost the same in the hand, but the latter will not roll off your table so readily. You should enjoy the feel and performance of your pencils. Shop around until you are satisfied.

GRAPHITE PENCILS

Although graphite is a form of carbon and chemically unrelated to lead, the term "lead" continues to be applied to the thin rod of graphite used in pencils today. A system of numbers and letters has been developed to represent the entire range of hardnesses available in graphite. A maximum of 20 degrees of lead ranges from 9H to 9B. The "H" stands for "hard," and the higher the number the harder the lead, hence the lighter the pencil's mark. Similarly, "B" stands for "blackness," and the higher the number the softer the lead, so the blacker the mark.

Pencils with soft leads produce a rich dark line and are ideal for quick sketching and expressive drawing. Since the B leads are comparatively soft, they do not hold their points long and tend to become dull if you aren't careful. Personally, I

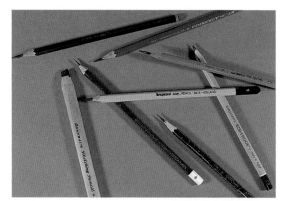

GRAPHITE PENCILS. Clockwise from top: Castell 9000, Kimberly, Berol Turquoise, Koh-I-Noor, Bruynzeel, Design, Utrecht, and General's Sketching.

ND Derwent Graphic	9H
ND Derwent Graphic	8H
ND Derwent Graphic	7H
D Derwent Graphic	6H
ND Derwent Graphic	5H
ND Derwent Graphic	4H
D Derwent Graphic	3H
ND Derwent Graphic	2H
ND Derwent Graphic	H
D Derwent Graphic	F
ND Derwent Graphic	HB
ND Derwent Graphic	B
D Derwent Graphic	2B
D Derwent Graphic	3B
D Derwent Graphic	4B
ND Derwent Graphic	5B
ND Derwent Graphic	6B
ND Derwent Graphic	7B
ND Derwent Graphic	8B
ND Derwent Graphic	9B

COMPLETE RANGE OF 20 DERWENT PENCILS

love the intense darkness of these pencils, and have found several ways to keep them sharp. (See "Sharpeners," page 56.)

Hard leads contain a greater amount of clay than soft ones, and yield a lighter line. They stay sharp and don't smudge much. The H pencils are well-suited to detailed or technical drawing such as architectural rendering and drafting.

Just to confuse matters a bit, an F ("firm") degree was produced early in the 20th century to accommodate the needs of secretaries using shorthand. The F's lead is slightly softer than the H's but firmer than the B's.

A few manufacturers use a simplified numbering system to rate their pencils. It's quite easy to remember: No. 1 is soft; No. 2 is medium-soft; No. 3 is medium-hard; and No. 4 is hard. Most people are familiar with the good old yellow No. 2 (see below). It is an extremely popular and useful tool, with an abundance of applications.

Shown at left is a sampling of select graphite pencils. They are all produced by skilled craftsmen using the best ingredients. A few of the companies that manufacture pencils of consistent quality are Berol, Bruynzeel, Derwent, Eberhard Faber, and Koh-I-Noor.

YELLOW NO. 2 PENCILS

The ubiquitous yellow No. 2 is by far the least pretentious of all art materials, and it is my favorite. Intended for general writing purposes, this pencil is remarkable in its versatility. The common and unassuming No. 2 can create drawings of great character and variety. Its point is soft enough to produce a legible line without much effort, yet hard enough to stay sharp for a long time between sharpenings. A wide range of light to dark lines is possible simply by varying the amount of pressure and the angle at which the pencil is held. The line of the No. 2 is roughly equivalent to that of a B or 2B.

This humble tool is easily affordable by everyone. In fact, the modest purchase price of a No. 2 pencil may be irrelevant, for no doubt you already have several in your household. They are durable as well, with a write-out span of approximately 50 kilometers. That's enough graphite in each pencil to draw a line equivalent to the entire route of the Boston Marathon— with plenty left over to sign autographs.

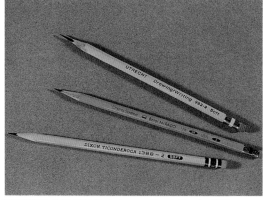

YELLOW NO. 2 PENCILS. Top to bottom: Utrecht Drawing/Writing, Berol Mirado, and Dixon Ticonderoga.

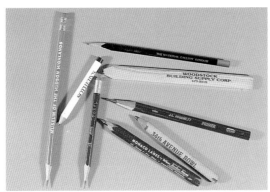

CASUAL PENCILS FROM ASSORTED MERCHANTS, MUSEUMS, AND BOWLING ALLEYS

CASUAL PENCILS

The most economical of all, casual pencils are the ones that somehow just seem to turn up in our possession. Businesses frequently distribute pencils emblazoned with their company's name. Golf pencils are usually too short to consider seriously for drawing, but bowling pencils are great. They often contain soft dark leads of a large diameter that I find ideal for sketching. Casual pencils are perfectly suitable for fine arts use. There's no reason you can't create a masterpiece with a pencil that promotes "Weeping Willie's Ice Cream Parlor."

SOFT-LEAD PENCILS

In general, softer leads are more appropriate for drawing and sketching than for writing. A soft-lead pencil is capable of making the darkest marks with ease and is responsive to the slightest undulations of hand movement. Artists frequently make "wristy," expressive strokes, and a soft pencil is ideal for capturing the personality of each sketcher's action. Nearly every pencil manufacturer makes a complete range of soft-lead pencils.

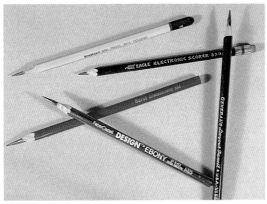

SOFT-LEAD PENCILS. Bruynzeel 6B, Berol Electronic Scorer, General's Layout Pencil, Berol 314, and Design Ebony Drawing pencil.

EXAMPLES OF SOFT-LEAD PENCILS

- *"B" pencils* in the standard range extend to the *very* soft 9B, although I've found that in most cases a 5B is sufficiently soft to make the darkest marks. Pencils such as the Venus Drawing 5B or the Koh-I-Noor 5B are frequently used by artists for rapid and forceful sketching. The Bruynzeel 5B Design Pencil, made in Holland, deserves special mention. Its mark is similar to the others' in appearance, but its point glides across the paper so smoothly and effortlessly that it is indeed a tactile treat.
- *Berol Electronic Scorer,* one of my favorite pencils, was originally intended for marking computerized multiple-choice tests like the S.A.T. While its line is not as black as the Ebony Drawing Pencil's (see below), it produces a full range of darker values and is a pleasure to use for drawing.
- *Design Ebony Drawing Pencil,* which is lauded by its manufacturer, Faber-Castell, as "Jet Black, Extra Smooth," effortlessly fulfills those claims.
- *General's Layout Pencil* is intended for quick composing, where bold lines and the rapid filling-in of tones are needed. Although General's is the most widely available brand of layout pencil, you should experiment with others.

WOODLESS PENCILS

In addition to the standard wood-cased pencil, there are three other ways in which a graphite rod is encompassed. A recycled fiber casing simulates the traditional wood barrel without actually containing wood; another method uses heavy paper tightly wrapped around the pencil lead, providing rigid support; and the third features a plastic coating around a thick rod of graphite. All three methods allow you to use graphite in a comfortable manner while keeping your hands clean.

EXAMPLES OF WOODLESS PENCILS

- *American EcoWriter,* manufactured by Eberhard Faber, looks and performs like any regular pencil, but the barrel is made from 100-percent recycled cardboard and newspaper fiber. No trees are required to make an EcoWriter, and it actually helps reduce the bulk in landfills. The EcoWriter sharpens just like any other pencil, and unless you inspect it carefully you probably

wouldn't notice that it isn't made of wood. Its eraser, appropriately enough, is green.

- *Blaisdell Lay-Out Pencil* features a thicker-than-standard strip of graphite (5 mm in diameter) and is wrapped with a continuous flat strip of heavy paper ⅛ inch (0.32 cm) wide. To expose more lead, remove a layer of the paper by pulling on the piece of string that's embedded below the outermost layer.
- *Pentalic Woodless Pencil* by Grumbacher consists of a round stick of graphite (7.5 mm in diameter) covered with a thin plastic coating. It is available in a range of hardnesses, from HB to 8B. The distinctive characteristic of this pencil is the thickness of its lead. It is almost like using a stick of graphite, but the plastic coating prevents messy fingers. In addition, its cylindrical shape allows it to be sharpened to a point like a regular pencil or worn down flat to use the maximum diameter of the lead. Several manufacturers offer similar items under their own trade names.

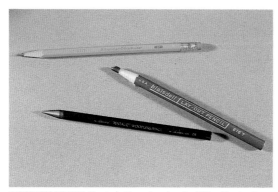

WOODLESS PENCILS. Top to bottom: American EcoWriter (Eberhard Faber), Blaisdell Lay-Out pencil, and Pentalic Woodless pencil.

WATERSOLUBLE PENCILS

A recent addition to the artist's drawing arsenal is the watersoluble pencil. Its lead functions like that of any other pencil when dry, but when a line is stroked with a wet brush its particles are released to create a graphite wash. You can lay down or lift off a tone with a brush, just like watercolor. Try dipping the point of a pencil in water for a bold, juicy line, or drawing on dampened paper for soft edges and deep tones. Several companies now offer watersoluble pencils in a range of values.

EXAMPLES OF WATERSOLUBLE PENCILS

- *Derwent Watersoluble Sketching Pencils* are available in three degrees: Light Wash (HB), Medium Wash (4B), and Dark Wash (8B).

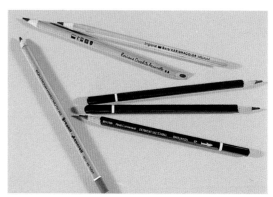

WATERSOLUBLE PENCILS. Top to bottom: Karisma (Berol), Derwent, and Koh-I-Noor Hardtmuth Aquarell.

Even the Light Wash pencil seems quite soft and can be used to make dark marks. All three grades become darker when wet.

- *Karisma Watercolor Pencils* by Berol are similar to Derwent's watersoluble line, but the leads seem harder, probably because they contain a greater proportion of clay in the graphite mixture. With the Karisma, details are easier to render and the points stay sharp longer.
- *Koh-I-Noor Hardtmuth Aquarell* is at the other end of the hardness scale, even softer than the Derwent. This pencil's tip glides across paper with ease. The three grades (HB, 4B, and 8B) are all extremely soft, with the 8B especially prone to breaking. If your technique exploits such softness, then this is the brand for you.

CARBON PENCILS

The leads in carbon pencils are a combination of soot and clay. Their performance traits lie midway between graphite and charcoal in that they produce a matte black of great intensity, but without the easy feel of graphite. Carbon pencils seem drier; they don't glide across the paper as smoothly as graphite pencils.

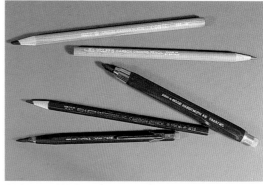

CARBON PENCILS. Top to bottom: Conté, Wolff's, and Koh-I-Noor; Koh-I-Noor and Caran d'Ache holders.

Wolff's, Conté, and Koh-I-Noor all make good carbon pencils in wood casings. They come in a modest range of degrees (2H to 2B for Wolff's, 2H to 3B for Conté, and a simplified 1 to 4 for Koh-I-Noor). If you like the matte finish and rich, dark capabilities of these pencils, you owe it to yourself to try a 3-mm carbon lead filling, shown on the preceding page in a Caran d'Ache lead holder.

A similar product, the Negro Pencil, is made by Koh-I-Noor. This remarkable variation on the traditional carbon pencil exhibits the highly pigmented darkness characteristic of carbon pencils, but the admixture of grease results in a smoother stroke. Negro Pencil lead fillings made to fit a 5.6-mm lead holder are also available.

MECHANICAL PENCILS AND LEAD HOLDERS

Mechanical pencils and lead holders are associated more with drafting than with freehand drawing. Nonetheless, they offer several features worth mentioning here. Since they are designed for constant use, most of them are quite comfortable, and some even feature knurled grips or rubberized barrels. The lead is retractable, so this tool travels easily and safely for informal sketching trips. Most brands have an eraser, and some even include a little sharpener for the lead.

Although *mechanical pencils* only accept thin, fragile leads (0.3 to 0.9 mm), *lead holders* are designed for much wider leads, and even some crayons. *Automatic pencils* store several rods of thin lead inside the hollow barrel of the pencil. These leads are automatically advanced by the click of a button. There is no need to open the pencil to retrieve extra lead and insert it into the clutch by hand.

There has been an absolute explosion of mechanical pencil styles over the past 20 years, and an abundance of clever variations has been successfully marketed by companies such as Koh-I-Noor, Pentel, and Tombow.

EXAMPLES OF MECHANICAL PENCILS
- *Graph 1000*, manufactured by Pentel, is my personal favorite. It has a lead-degree indicator and an eraser under the cap. I particularly enjoy its rubberized grip, whose eighteen little ribs fit my hand just right.
- *Monotech* by Tombow features a sharpener for 2-mm leads under the cap, a glare-resistant finish, and a handy setting-ring that indicates which degree of lead is in the holder. Tombow

also makes a Monotech for thin leads (0.3 to 0.9 mm), which instead of a sharpener includes an eraser under the end cap.
- *Quicker Clicker*, also by Pentel, is the best-selling automatic pencil in America. The lead advance button is located along the side of the pencil, allowing its user to propel the lead without changing hand position. Several spare leads can be stored inside the transparent barrel of the pencil.
- *Select-O-Matic*, a well-made lead holder by Koh-I-Noor, features a knurled grip, a lead pointer in the cap, and a lead degree reminder on the barrel.

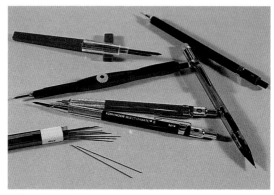

MECHANICAL PENCILS AND LEAD FILLERS. Top to bottom: Rotring 300, Quicker Clicker (Pentel), Monotech (Tombow), and Koh-I-Noor Select-O-Matics, with Koh-I-Noor Poly Max and Pentel Super Hi-Polymer leads.

LEAD FILLERS

As you might have imagined, many technological improvements have been made in the two centuries since graphite and clay were first combined (see page 12). With the introduction of polymers and other synthetic materials, the process has been refined considerably. It is now possible to produce leads that are strong, thin, uniform in size and hardness, and designed to meet a variety of specific needs.

EXAMPLES OF LEAD FILLERS
- *Koh-I-Noor Poly Max leads*, which are strong, opaque, and uniformly graded, are advertised as "the strongest, blackest, fine-line polymer lead available anywhere." Available in 17 degrees, the softer leads are slightly larger in diameter for greater strength.
- *Pentel Super Hi-Polymer leads* are made by mixing minute graphite particles with a polymerized bonding agent. The resulting product is very strong—a necessary characteristic, since the diameter of the lead is so small.

GRAPHITE PRODUCTS

The familiar pencil is but one way to use graphite. While the pencil is practical in that it keeps hands clean, cleanliness is often the least of an artist's concerns. Bruynzeel, General, and Koh-I-Noor are but a few manufacturers known for their graphite products.

GRAPHITE STICKS

These sticks are manufactured in varying degrees of hardness, just like pencils. They are 3 inches long × ¼ inch square (7.62 × 0.64 cm), or "double-wide" at 3 × ¼ × ½ inch (7.62 × 0.64 × 1.27 cm). Made specifically for sketching and shading, graphite sticks are a real time-saver for establishing broad areas of tone. The ends can be sharpened, rounded, or shaped to a bevel edge, while the flat sides can be drawn across the paper to leave a trail 3 inches wide.

GRAPHITE CRAYONS

These paper-wrapped crayons are larger than traditional graphite sticks. Their dimensions—4½ inches long × ½ inch in diameter (71.27 × 1.27 cm)—promote a loose and free application; it's hard to get fussy with these babies. Since some soot is mixed in with the graphite-clay mixture, the mark of a graphite crayon is blacker than normal graphite and has less sheen. Note that although the item shown in the photograph below is labeled as a "lumber crayon," it is a *graphite-based* lumber crayon, which is quite different from the greasy lumber crayons discussed later in this chapter (see page 27).

POWDERED GRAPHITE

Powdered graphite consists of a finely ground mixture of graphite particles that is not as dark as graphite sticks. Daubed onto a soft-textured paper or board, powdered graphite can be rubbed into the surface with a soft cloth, paper towel, or even fingers. Highlights can be created by lifting out the shapes with an eraser (see "The Dry Wash Technique," pages 84–87). For more textural results, powdered graphite can be poured onto a surface coated with glue or polymer medium. A number of mixed media effects can be produced with a little experimentation.

You can make your own powdered graphite by rubbing a graphite stick, or even a pencil point, against a piece of sandpaper or a file. For small applications this is sufficient, but it is a tedious process if you need a giant pile of the stuff.

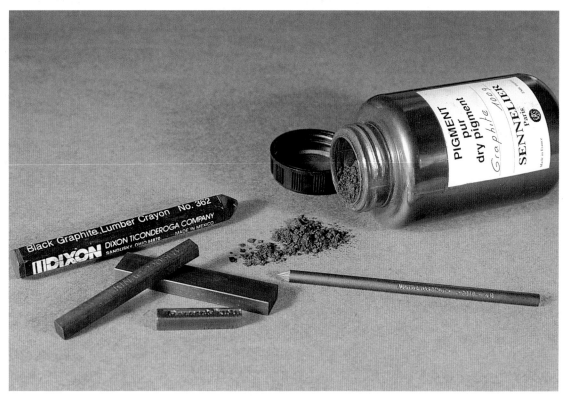

GRAPHITE PRODUCTS. Left to right: Dixon Graphite Lumber Crayon, General's graphite sticks, Koh-I-Noor graphite rod, Sennelier graphite powder.

CHARCOAL

A burnt stick was quite possibly the first drawing instrument. Soft particles of blackened wood left a visible trace of the arm's motion, and hence a record of the idea behind the movement. Ephemeral images previously drawn in the sand with a stick could now be drawn on a cave wall, and thus preserved.

Today, the descendents of that charred stick are available in four forms—stick charcoal, compressed charcoal, charcoal pencils, and powdered charcoal—each of which is easy to apply and manipulate. Charcoal is popular for its ability to render delicate shading or large, bold areas of blackness. Bruynzeel, General, and Sennelier are well-respected brands of charcoal products; Berol, Blaisdell, and Ritmo make widely available charcoal pencils as well.

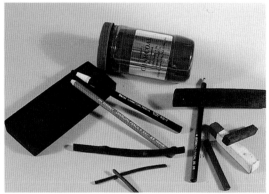

CHARCOAL PRODUCTS. Clockwise from left: Sennelier Bâton de Saule, General's charcoal pencil, Berol charcoal pencil, General's charcoal powder, Sennelier Maxi Decor, compressed charcoal, Ritmo charcoal pencil, and vine charcoal.

STICK CHARCOAL

As its name suggests, this form of charcoal is made from charred sticks, usually about 6 inches (15.24 cm) in length. The wood is carefully heated in kilns until the organic materials have burned away and only dry carbon remains. The thinnest variety, *vine charcoal*, is made from burnt limewood, birchwood, or, most commonly, willow. It is delicate and can be easily brushed away. Vine charcoal is therefore popular for preliminary sketching, when artists are searching for compositional forms, drawing, erasing, and redrawing.

Sennelier offers some unusual sizes of stick charcoal produced in the French tradition from pure willow. Two of my favorites are the 1-inch (2.54-cm) diameter "Maxi Decor," and the impressive "Bâton de Saule," which is a brick-shaped $5^{1}/_{2} \times 1 \times 2$ inches ($14 \times 2.54 \times 5.08$ cm).

COMPRESSED CHARCOAL

When charcoal is ground to a powder and then squeezed into chalk-like sticks, the result is compressed charcoal. A binder is mixed with the charcoal powder to achieve varying degrees of hardness and darkness. The more binder in the mix, the harder and paler the product. While the type of oil varies from brand to brand, linseed oil is often added to compressed charcoal. This aids in its adhesion to the paper and increases the darkness of the line. Although the presence of the oil makes erasing difficult, compressed charcoal is nonetheless versatile and easy to use.

CHARCOAL PENCILS

A charcoal pencil is simply a rod of charcoal sheathed in a paper or wood casing. Various proportions of clay are added as a binder and to regulate the hardness of the pencil. Since only the point is exposed, hands remain clean. The point can be sharpened easily, making a charcoal pencil a natural choice for details and linear drawing.

POWDERED CHARCOAL

The same material that is used for charcoal pencils, excluding the clay binder, is used to make artist-quality powdered charcoal, which consists of superfine pulverized charcoal made from charred hardwoods.

Powdered charcoal has several uses. The most common involves sprinkling it on paper and rubbing it into the surface where dark areas are desired, then lifting out highlights with an eraser. Also, charcoal sprinkled on an adhesive-covered surface yields a soft, furry tone that appears to hover above the drawing surface. Powdered charcoal is also popular with mixed media artists, who sometimes blend it with paint.

Another application of powdered charcoal—transferring an image from a working drawing to a new surface, especially a large one such as a sign or a mural—requires a pounce wheel and a pounce bag. Perforate the contours of the original drawing by tracing them with the pounce wheel, then lightly sand the back of the paper to eliminate rough edges where the pounce wheel has poked holes through the paper. Tape the drawing on top of the new support (paper, canvas, wall) and daub at the perforations with a pounce bag (or a sock) filled with powdered charcoal. Little grains of charcoal will pass through the small holes and mark the new drawing surface exactly where the perforations occur, repeating the precise contour of the original drawing.

CHALK

Chalk has been used as a marking tool since before recorded history. The word "chalk" was originally used to refer to soft limestone composed of marine shell fragments rich in calcium. Its color ranges from white to gray to pale yellow. As civilization developed a need for uniformity and marketability in materials, various ingredients such as talc and calcium carbonate or whiting were added to create some of the products we now know as chalk. Chalk became a commonly used art material in the 15th century and continues to be popular today. Be aware, however, that "chalk" is an imprecise term and that a fuzzy boundary exists between chalk and compressed white charcoal, pastel, and some crayons.

Fired chalk is harder but more brittle than chalk that has not been baked in an oven. Its particles sit on the surface of the paper, and therefore require a layer of fixative. *Unfired chalk* is more supple, with particles that penetrate farther into the tooth of the paper. Nonetheless, fixing is still recommended for proper protection. The addition of grease to a chalk mixture allows the particles to adhere more closely to the paper, precluding the need for fixative but making it difficult to erase effectively.

WHITE CHALK

Also known as *charcoal white*, this product consists of a mixture of unfired natural pigments and calcium carbonate. Best effects are obtained by using white chalk on tinted papers, either alone or with charcoal. In stick form, the tip of the chalk can be used for small areas, while the long side can be drawn across the paper's surface to create broad tonal masses.

WHITE PASTEL PENCILS

A white "pastel" pencil, which is actually made from chalk, is a convenient tool for drawing meticulous chalk lines and rendering details. It can be sharpened to a fine point, and its shape allows for easy line control. For a discussion of colored pastel pencils, which sometimes include chalk in their composition, see page 22.

RED CHALK

Often called *sanguine* (from the Latin *sanguineus*, "blood red"), this classic drawing material has been used by artists for centuries. Red chalk drawings by Michelangelo and Leonardo attest to the permanence of this material and its suitability for subtle renderings. Its warm color, which is derived from iron oxide, is particularly effective for portraits and sketches of the nude model.

RAILROAD CHALK

This product was originally manufactured for marking railroad ties, and it is still used throughout the wood industry. The Markal Corporation makes railroad chalk in white and four colors in a 1 × 4 inch (2.54 × 10.16 cm) tapered shape that is comfortable to hold. It has become a favorite with children and is also manufactured by Prang and sold as "Giant Sidewalk Chalk."

Nontoxic and nonpermanent, railroad chalk is clearly for ephemeral compositions. In fact, it should wash off any sidewalk in a rain storm. Nonetheless, sidewalk drawing can be liberating.

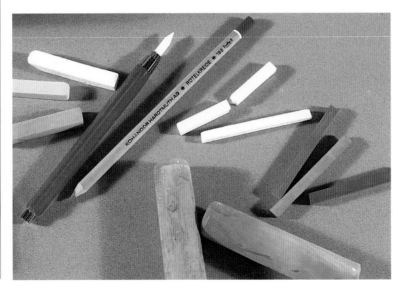

CHALK. Left to right: Alphacolor Hi-Fi, charcoal white rod (in holder), Koh-I-Noor red chalk pencil, General's Charcoal White, Koh-I-Noor red chalks, and railroad chalk.

Pencils in Color

Your experience with pencils need not be confined to the black marks of graphite or charcoal. Colored pencils, watercolor pencils, and pastel pencils can expand your creative possibilities by ushering you into the world of color. The convenient aspect of these pencils is their simple means of application; no paint to mix, no brushes to wash, just the natural, comfortable grip of a pencil and all the joys of color.

Colored Pencils

Since I first became aware of the existence of artist-quality colored pencils, I have come to realize that innovations in their manufacture have been astounding, relegating the low-grade pencils of the past, which were hard, gritty, and weakly pigmented, to a dim memory. Today a host of excellent products is available from a number of prominent manufacturers. The pencil brands vary in the thickness of their color rods, the softness of their points, and the intensity of their colors. Be sure to sample a few of the following brands before investing in a complete set, as you need to determine which is most suitable for your own working habits.

Berol Prismacolor

Prismacolor is the world's best-selling colored art pencil. The generous palette of 120 colors provides a wide spectrum of heavily pigmented pencils with thick (4-mm) leads. They are consistent in

BEROL PRISMACOLOR AND PRISMACOLOR ART STIX

texture and can be layered or blended for a variety of effects. The color pigments are suspended in a wax base, resulting in a very soft lead that covers the paper smoothly. You can even burnish the completed design with a soft cloth to bring up the luster in the wax. Prismacolor pencils are waterproof, but the pigment can be loosened with turpentine or a colorless blender (an alcohol-based clear marker; refer to page 35 for a discussion of this product). Dipping a pencil in turpentine before drawing deepens the color.

The same intensely pigmented color found in the colored pencils is also available in Prismacolor Art Stix. The waxy pigment is extruded in a 3-inch (7.62-cm) stick that is similar to a hard pastel. Art Stix can cover large areas quickly, or add a boldness of stroke to Prismacolor drawings. Color names and numbers are cross-referenced in both product lines so that the hues match perfectly. Unfortunately, only 48 of the 120 Prismacolor hues are manufactured as Art Stix. That's less than half the range, which for the most part includes common colors. The unusual colors are unavailable as Art Stix.

For precise rendering, Berol also makes a selection of Verithin colored pencils. The leads are firmer, thinner, and can be sharpened to a needle-sharp point. Verithin pencils are non-smearing and waterproof, but unless you really need them for greater definition, especially for design and drafting work, I recommend Prismacolor over Verithin for fine-art applications.

Bruynzeel

This Dutch company manufactures a number of high-quality products for professionals as well as hobbyists. Their colored pencils exhibit the same smooth consistency as their graphite pencils, with no gritty feeling whatsoever. Certainly they are one of the finest brands of colored pencils in the world. Lightfast, intensely pigmented, and velvety smooth, they come in a selection of 45 colors. The barrel of each pencil is the same color as the lead inside, making it easy to grab the right color while in the midst of a creative frenzy.

Derwent

Derwent offers two varieties of colored pencil, Studio and Artists. Both of these top-quality English products are available in a selection of 72 colors made from the finest lightfast pigments. The pencils of both lines contain a delicately balanced blend of pigment and wax to ensure solid coverage along with smooth handling.

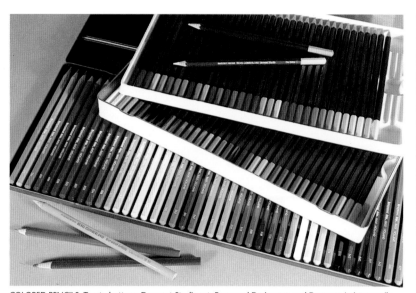

COLORED PENCILS. Top to bottom: Derwent Studio set, Bruynzeel Design set, and Derwent Artists pencils.

Derwent Studio Pencils have a soft responsive rod of color the same diameter as Bruynzeel's (3.5 mm), but just a bit firmer. These pencils' hexagonal shape prevents them from rolling, and each end cap is color coded. They are strong, water resistant, and hold a point well. Derwent Artists Pencils contain a thick, 4-mm color strip for a wider line and greater speed in coloring large areas. They are geared toward a looser style, and exhibit highly saturated color of great opacity.

OTHER COLORED PENCILS

Several other manufacturers produce premium colored pencils for today's artist. Caran d'Ache makes an impressive line of 120 colors based on the chromatic color circle developed by Friedrich Ostwald (1853–1932). They are soft, quite blendable, and water resistant. Faber-Castell makes an erasable colored pencil, Col-erase, which is very popular with architects. Although most other brands can be erased to some extent, Col-erase pencils erase with ease. Conté colored pencils are a bit grainier than the others, but are still colorful, blendable, and intensely pigmented. Eberhard Faber markets some fine pencils called Design Spectracolor. Their vivid colors are similar to Prismacolor's in softness and strength of pigment. The 60 colors are waterproof but soluble with turpentine or colorless blender (see page 35).

WATERCOLOR PENCILS

The latest innovation in colored pencil technology is a remarkable product that combines artist-quality pigments with watersoluble binders. Watercolor, or aquarelle, pencils look like regular colored pencils and can be used dry for the same results, but touch a moistened brush to the paper and they behave like watercolor. This makes for an extremely versatile medium, for you can use them dry, dip the points in water before drawing, draw on wet paper, or brush up a dry drawing with water. You can even make a little pool of watercolor to use as a wash or use a wet brush to collect color from the tip of a pencil held in your other hand. Most of the companies that manufacture colored pencils now offer a watersoluble line as well.

These pencils work exceptionally well over regular watercolors. Lay down a wash with a wide soft brush, or even complete most of an image in a traditional watercolor technique, then apply a final layer of color with watersoluble colored pencil. Another technique worth investigating is misting an image in watercolor pencil with a spray bottle. After you've built up the surface with dry color, mist water over the drawing (a plant sprayer or ironing sprayer works nicely). The water gently dissolves the particles of pigment, creating an effect distinct from that of a brushed wash.

Keep in mind that watercolor pencils can only be erased when in their dry form. Once the pigment has been moistened, the color particles fuse with and stain the paper, making complete erasure no longer possible. Some of the pigment, however, can be "lifted" by applying clear water and then blotting the area with a sponge or absorbent cloth. Virtually any paper will work with watercolor pencils when used dry. However, once wet, a thin paper can wrinkle and tear. It is wise to use thicker paper, or wiser still, watercolor paper.

Watercolor pencils are just one of several hybrid media that straddle the boundary between drawing and painting. Experiment with them. You will find these versatile pencils lend themselves to a number of techniques.

BRUYNZEEL DESIGN AQUAREL

Made in Holland, this line of watersoluble pencils combines the control of a pencil with the blendability of watercolor. Each box contains 45 silky colors that seem to flow onto the paper—even when dry. The barrel of each hexagonal pencil is color coded for quick identification. Both Bruynzeel and Karat (see page 22) dissolve more completely than other brands.

CARAN D'ACHE SUPRACOLOR

Typical of the quality associated with this Swiss company, Supracolor watersoluble pencils exhibit an easy-gliding softness with colorfast pigments. Their large assortment of colors—120 in all—is a real bonus.

CONTÉ AQUARELLE

The Conté Aquarelle line consists of 48 colors. The thick, highly pigmented leads are smooth and vibrant. Because the color does not dissolve as completely as with other brands, pencil lines remain visible even after water is applied.

DERWENT WATERCOLOUR PENCILS

These professional English watersoluble pencils, developed in conjunction with members of the Royal Institute of Painters in Watercolour, come in hinged-lid tin boxes in sets of 12, 24, 36, or 72. They are also available in an elegant hardwood case with brass hardware. The watercolor pencils can be used with Derwent Artists or Studio pencils, as the colors match exactly.

DESIGN SPECTRACOLOR

Of all the brands I've tried, these feel the softest and creamiest when in their dry pencil state. They react instantly to water, and disperse quickly and evenly. Design Spectracolor pencils are made in 48 colors.

KARAT

This line of watersoluble pencils, made by the German company Staedtler Mars, are available in 48 brilliant, fade-resistant colors. Their thin yet strong color strips are soft enough for free-flowing color, yet hard enough to retain a sharp point for details. Along with Design Spectracolor, the Karat pencils have the greatest tinting strength of the brands mentioned here.

KOH-I-NOOR CYKLOP

The Cyklop pencils are a bit different from the rest in that they are completely woodless. Covered with a thin plastic coating, the large-diameter (7.5-mm) leads promote expressive, painterly strokes. Unfortunately, the Cyklop line currently includes only 12 colors.

Koh-I-Noor makes another unusual yet logical product line: 5.6-mm colored watersoluble leads that fit in lead holders. Be advised that under humid conditions these colored leads can soften and disintegrate, making a real mess.

PASTEL PENCILS

Pastel pencils are a "bridge" medium between drawing and painting. The nature of pastel itself is often debated, as there are pastel drawings *and* pastel paintings. The distinction between the two is generally considered to be that a pastel drawing uses less pigment and leaves more of the support exposed. (For a more in-depth discussion on the differences and relationship between drawing and painting, see "From Drawing to Painting," pages 152–171.)

For a comprehensive overview of the pastel medium, refer to *The Pastel Book* by Bill Creevy (Watson-Guptill, 1991). In brief, pastel is pure pigment mixed with a dry binder, gum tragacanth, then rolled or pressed into sticks. When applied to a surface with a receptive texture (such as charcoal paper, sanded paper, or La Carte Pastel), the pigment is held by the tooth of the paper. Though some artists casually (and mistakenly) refer to their pastels as "chalks," the two are quite different in their composition. The dye-impregnated limestone of chalk can seldom compare with the permanence and color intensity of pastel's pure pigments. I frequently use pastel as a painting medium, and enjoy it thoroughly. The colors are clear and strong. No allowances need to be made for drying times as with oil paints, and the action of applying the color is closer to drawing than to laying down paint with a brush.

Pastel pencils offer basically the same quality of color as pastels, but are shaped into a thin rod like a traditional wood-cased pencil. As a drawing tool, pastel pencils respond much

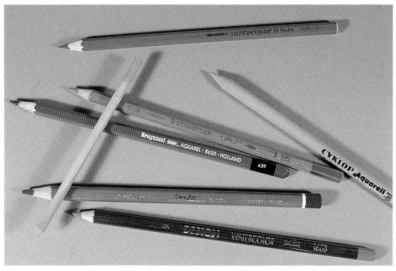

WATERCOLOR PENCILS. Top to bottom: Caran d'Ache Supracolor, Koh-I-Noor Cyklop, Karat (Staedtler Mars), Bruynzeel Design Aquarel, Conté Aquarelle, Design Spectracolor, and a Koh-I-Noor watercolor lead.

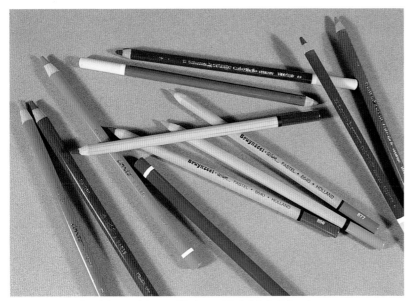
PASTEL PENCILS. Left to right: Conté, Bruynzeel Design, and Carb-Othello (Schwan).

like carbon or charcoal pencils, but with a full range of color. The pencil shape is easy to control for drawing details and making corrections or adjustments. They are handy for precise work since they can be sharpened to a fine point.

Pastel pencils are also used to blend color in a pastel painting. Instead of softening (and blurring) a tone by smudging with the fingers or a paper stump, many artists tie colors together by superimposing a new layer of hatched strokes with a pastel pencil. This procedure blends color between two areas with vitality. The result is a much fresher-looking image.

BRUYNZEEL DESIGN
This Dutch company makes the best pastel pencils on the market. Packaged in metal boxes of 12, 20, 30, or 45 brilliant colors, these pencils are as smooth as can be. Their luscious colors glide on the paper effortlessly, making them a joy to use. In addition, they are "aquarellable," which means that they are watersoluble and can be manipulated with several watercolor techniques.

CARB-OTHELLO
Manufactured in Germany by Schwan, these pencils have a creamy feel and come in a range of 80 colors. They are advertised by the manufacturer as "colored charcoal" but are entirely lightfast. Forty-eight of the 80 colors are also produced in a stick form, similar to hard pastels.

Carb-Othello pastel pencils can be mixed with water to create washes and other watercolor techniques, but make sure that you use them with the right paper when you use them in this way. The surface of sanded paper, for example, is damaged by contact with water.

CONTÉ
The pastel pencils made by Conté are a bit thicker than other brands because they accommodate a thicker rod of pastel lead. Although the wider diameter puts more color on the paper with each stroke, these soft pencils don't hold a point very long and thus require frequent sharpening. Unfortunately, the wider barrel won't usually fit into a standard pencil sharpener, and the soft color rods break easily in response to the sharpener's cutting action. Hand shaping with a razor blade or knife is a safer method. With pastel pencils—especially with the soft Conté—you must develop a delicate touch when sharpening.

Although soft enough to work easily, Conté pastel pencils have a slight grittiness, like charcoal pencils. Compared to the previously mentioned brands, they do not feel as creamy when applied to paper.

DERWENT
Derwent pastel pencils are produced in a range of colors typical to the needs of a pastellist. Their 90-pencil line consists of 30 full-strength hues, 30 medium tints, and 30 light tints. Derwent pastel pencils are made from the highest quality pigments for maximum purity and lightfastness.

The use of these pencils is a pleasing visual experience, but it is also a welcome tactile sensation. The color strips are velvety smooth, so the act of drawing *feels* good.

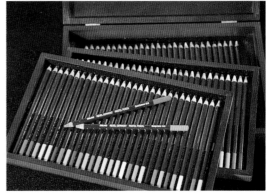
DERWENT 90-COLOR SET OF PASTEL PENCILS

CRAYONS

Crayons refer to far more than the waxy, colorful playthings we remember from childhood. Although our word "crayon" is derived from the French *crayon*, meaning "pencil," it has generally come to mean a marking tool with a somewhat waxy component. Schoolyard crayons definitely fit into this category, but so do fine art crayons such as Conté and Caran d'Ache, specialty crayons for lithography, and even some marking crayons manufactured for industrial use.

DRAWING CRAYONS

Although you can draw with any crayon, there are certain kinds that have been traditionally employed by artists for fine-arts use. These crayons are noteworthy for their superior ingredients, consistency of manufacture, and their capacity to produce a sophisticated range of marks and subtle shadings.

CONTÉ CRAYONS

Conté crayon is a medium that produces line and tonal qualities that lie between those made by charcoal and wax crayon. Made of compressed pigment, water, and clay, and available in soft, medium, and hard grades, Conté crayons are semi-hard, smooth, and richly pigmented. Their shape is that of a squared stick, $1/4 \times 1/4 \times 2^1/2$ inches ($0.64 \times 0.64 \times 6.35$ cm). Originally developed in France, Conté crayons have been used for nearly two centuries. Masters like Degas, Renoir, and Cassatt, and later Picasso and Chagall, have enjoyed these crayons for their smoothness and strong color. Traditional Conté crayons are available in black, white, sepia, and sanguine. The latter continues to be popular for figure drawing,

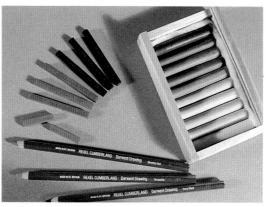

DRAWING CRAYONS. Conté crayons, Derwent Drawing pencils, and Yarka Sauce.

as its warm color beautifully complements the human form. Although Conté crayons are thinner and harder than pastels, they share a few of the same working properties. Large areas can be shaded quickly by using the side of the crayon. Also, the corners of the long edge can be drawn laterally across the paper to create sharp lines and the ends can be sharpened to a chisel tip for detail work.

DERWENT DRAWING PENCILS

Derwent Drawing Pencils are similar to Conté crayons but are made in pencil form. Clay, pigment, and gum are combined and then soaked in wax. This procedure accounts for their smoothness and velvety finish, eliminating the chalky and dusty qualities of pastel pencils or charcoal. Each wide color strip (5.5 mm thick) is encased in a barrel made of California incense cedar. These pencils are made in 4 earth colors, plus black and white.

YARKA SAUCE

Recent changes in global trade policies have lead to the emergence of products from formerly remote markets. Yarka Sauce is the brand name of the "classic crayons" made in Russia by Podolsk. They are the same dimensions as Conté crayons but are rounded instead of squared. Also, they are a bit softer, with a stroke quality that is something of a cross between Conté crayons and regular pastels. Packed in a little wooden box, Yarka Sauce crayons are available in a selection of 8 subtle earth colors, white, and black. They are made from a blend of high-quality natural pigments, industrial carbon, and Chasov Yar clay.

LITHOGRAPHIC CRAYONS

Just as many of the finest drawing papers are those that were originally manufactured for printmaking or watercolor, there are several wonderful tools from other areas of the visual arts that can be appropriated for use in drawing techniques. A prime example is the lithographic or litho crayon.

Lithography is a form of printmaking in which the artist makes a drawing *(graph)* on stone *(litho)*. In 1798, Alois Senefelder, a French printmaker working in England, chanced upon an eventful discovery. The story is now legend: Lacking a handy scrap of paper, Senefelder wrote his laundry list on a smooth stone with a greasy pencil. Out of curiosity he wetted the

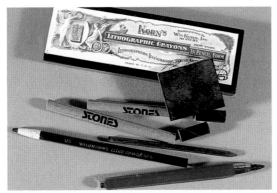
LITHOGRAPHIC CRAYON PRODUCTS. Korn's Lithographic tablet, pencil and crayon; Stones Lithographic Crayon in a Koh-I-Noor holder.

stone, then inked it, finding that the ink stuck to the greasy pencil strokes but not to the rest of the stone. Lithography was born. Since then, the craft has undergone countless modifications but the basic principle has remained the same.

To make a design adhere to a very smooth stone, a crayon or other marking device with a greasy component must be used. Crayons made especially for drawing on stone have been manufactured since the beginning of the 18th century. These crayons also work wonderfully on paper and board but are not erasable. Litho crayons can produce the entire value range, from subtle grays to deep blacks.

KORN'S LITHOGRAPHIC CRAYONS

The foremost manufacturer of lithographic crayons, Wm. Korn, Inc., was established in New York in 1880. Korn's lithographic products are the most expensive, but they are unsurpassed in quality and reliability. Their lithographic crayons are $1/4$ inch (0.64 cm) in diameter and generally require a holder if used for drawing. Wm. Korn also offers a paper-wrapped litho pencil made of the same material as the crayon; by unraveling a section of the paper winding, the crayon point is conveniently exposed. It is available in five degrees, from #1 (soft) through #5 (hard). Lithographic tablets, which are approximately 2 inches square × $1/4$ inch thick (5.08 × 0.64 cm) and thus well suited for making broad marks, are compositionally the same as the crayons and pencils (much like Senefelder's original mixture of wax, soap, and lampblack).

STONES CRAYONS

A less costly alternative to Korn's lithographic products is available in four shapes and seven degrees of hardness from Stones Crayons. The $1/4$-inch (0.64-cm) diameter crayons are meant to be used in a holder and can be sharpened with a razor blade or a simple handheld sharpener. Stones Giant Specialty Crayons' jumbo size—6 inches long and 2 inches in diameter (15.24 × 5.08 cm)—is useful when "bigger is better," especially for large-scale, expressive drawings.

FINE ART COLOR CRAYONS

If you enjoyed schoolyard crayons when you were a child but have abandoned them for materials of greater permanence, here is some good news. There are colorful crayons on the market that are made of the finest pigments and have superb handling characteristics. Some of them are even watersoluble, and can be modified with a wet brush or can be used on wet paper for intriguing effects.

CONTÉ COLOR

The widespread popularity of traditional Conté crayons prompted the addition of new colors by the manufacturer. To date, 48 vibrantly colored Conté crayons have been introduced. They are composed of fine pigment in a kaolin clay base, and handle much the same as the traditional crayons.

CARAN D'ACHE NEOCOLOR

The Swiss firm of Caran d'Ache manufactures a number of crayons of the highest quality. The company philosophy is one of integrity, environmental consciousness, and insistence on superior products. Their Neocolor I line consists of wax/oil-based crayons with exceptional covering power: They can be used to completely hide a light color with a dark one, and vice versa (if you've ever tried this with schoolyard crayons you know the difference). They are soft enough to smudge with fingers, yet they are not sticky or sloppy.

Reflecting ongoing developments in crayon technology, Caran d'Ache also offers a watersoluble line of crayons, Neocolor II. They are available in 84 colorfast hues, and can be manipulated with a wet brush, used on wet paper, or dipped in water before drawing. These unctuous crayons are easily blended and can be combined with Neocolor I for added capabilities. By using both types of Neocolor crayons, you can create resist drawings by laying the watersoluble Neocolor II over the water-resistant Neocolor I.

NOUVEL CARRÉ

Many of the properties of Conté Color crayons are shared by Nouvel Carré, which are made by Sakura, a Japanese company. They are semi-hard, dustless, and need no paper wrapping to keep fingers clean. They are available in a broad spectrum of 150 colors, including fluorescent and pearlescent hues. One quality that sets Nouvel Carré crayons apart is their watersolubility. Drawings may be brushed up or spattered, or the crayons may be scraped into a powder, mixed with water, and applied in a watercolor wash.

STABILOTONE

Schwan-Stabilo of Germany makes extra-thick (10-mm) wax crayons. The 60 lightfast colors are fully soluble in water, and can be used with wet brush or wet paper. Because of their wax content, an image made with these colors can even be buffed with a soft cloth to produce a glossy surface. Also, try warming the pencil tip with a hairdryer. The wax-rich color will slither on to the paper, simulating the ancient technique of encaustic.

Stabilotones can be sharpened with a knife or with their own special handheld sharpener. The thick wood barrel is easy to hold, but I prefer the Caran d'Ache products.

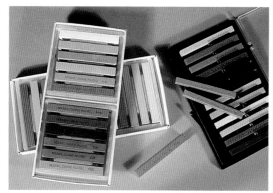

NOUVEL CARRÉ AND CONTÉ COLOR FINE ART COLOR CRAYONS

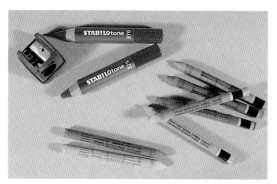

STABILOTONE (AND SHARPENER), CARAN D'ACHE NEOCOLOR I (WATER RESISTANT), AND NEOCOLOR II (WATERSOLUBLE)

SPECIALTY CRAYONS

A wide assortment of specialty crayons is produced for use in various industries but also used by artists. Although not all of these crayons are permanent or lightfast, many are. It is best to ask the manufacturer, or to test any materials with which you're unfamiliar. For example, if a crayon is greasy, examine the paper surrounding its mark. Do excess oils seep out and stain the paper? If so, it would be advisable to coat the paper first with gesso, in order to isolate the paper fibers from the oil.

The following is a list of some crayons you may wish to try. They are not usually found in art supply stores, but a little searching will turn them up. Most of them have a wax base that makes them difficult to erase. They can usually be scraped off smooth papers, and some can be covered over with a new color, but a regular eraser will just smear the paper without removing any pigment.

CATTLE MARKERS

The Markal Company, a division of LA-CO Industries, makes a substantial array of commercial and industrial marking products, including lumber crayons (see opposite). They also manufacture fine art items for other companies, such as Shiva, for whom Markal makes Paintstiks (see page 29).

Although not commonly found in art supply stores, a few of the Markal products have become popular with artists. In particular, I have seen powerful work executed in a medium referred to as "Cattle Markers" displayed in college and museum exhibitions. Cattle markers are sold in the farming community as "All-Weather Paintstik Livestock Markers," and are also known as "Branding Paint Sticks." Designed to mark wet or dry skins, hides, and pelts, these markers are nontoxic and resist fading in all sorts of weather.

When marking your cow or other support, scrape off the dried film from the tip of the marker to expose the oil-based "paint" within. You can build up layers of pigment to an impasto thickness, then loosen the color with turpentine. Be aware that the oil will leach out of the paint onto paper, so a protective layer (such as gesso) is necessary.

Cattle markers are not labeled archival, but I've spoken to artists who support the manufacturer's claim of lightfastness. The All-Weather Paintstik comes in 8 regular and 3 fluorescent colors. Metal

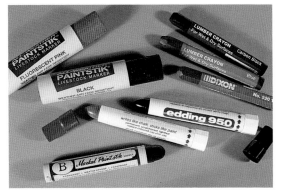

SPECIALTY CRAYONS. Left to right: Cattle markers, Markal Paintstik, Edding 950s, Dixon Lumber Crayons.

tube-style holders are available to fit the markers, and 2- or 3-foot (60.96- to 91.44-cm) extensions can be specially ordered to fit most holders, great for large gestural drawings—or tall cows.

Another Markal product used by artists is the "B" Painstik Marker, an all-purpose lead-free marker composed of real paint in stick form. The "B" marks on nearly any material with a surface temperature of –50 to 150°F (–45.6 to 65.6°C), including metal, wood, plastic, concrete, rubber, glass, cardboard, paper, or canvas. The nontoxic markers come in 13 colors in sticks of $^3/_8$, $^{11}/_{16}$, and 1 inch (1, 1.75, and 2.54 cm) in diameter, and will fit Markal metal holders.

CHINA MARKERS
Made by Dixon, these paper-covered markers feature the same self-sharpening system as a Korn's Lithographic Pencil (see page 25) or a Blaisdell Lay-Out Pencil (see page 15). China markers are intended for writing or drawing on glass, porcelain, and other slick surfaces, but also work well on paper. Inexpensive and long-lasting, they come in 6 colors plus black and white. Many artists use the white China marker combined with litho crayon on colored paper.

EDDING 950 INDUSTRY PAINTERS
The Edding 950 is a marking crayon that "writes like chalk, sticks like paint." Its viscous, opaque paste, which is fed forward in its plastic tube by turning the bottom cap clockwise, applies easily even to rough surfaces, dries quickly, and is waterproof and lightfast. The Edding 950 is available in red, blue, yellow, black, and white.

HYDRO MARKERS
The distinguishing characteristic of Hydro Markers is their watersolubility. They are similar to China markers in that they are paper-wrapped and adhere to most surfaces including glass. Use them directly on wet paper, or stroke into a Hydro Marker drawing with a wet brush. The tonal gradations and wash effects contrast nicely with the bold marking strokes of these crayons. These markers come in black and white only.

LUMBER CRAYONS
Lumber crayons, which are also referred to as keels, were originally developed for the logging industry and are also used by surveyors, masons, and chimney sweeps. Once artists discovered these little gems, they soon found their way into art schools and university art departments. They are reasonably priced and long-lasting, two attributes that encourage experimentation and freedom of application. Made in Mexico for Dixon and in the United States by Markal, lumber crayons are not as waxy as other crayons but are still soft enough to mark rough surfaces.

SCHOOLYARD CRAYONS
We are all familiar with the inexpensive wax crayons made for children. For many of us, these crayons evoke memories of our first contact with picture making. They are reasonably clean and easy to use. However, the extenders present in this type of crayon make it difficult to produce rich dark colors and to build up layers of pigment. Nonetheless, many sensitive drawings have been made with these humble tools.

Crayola, a subsidiary of Binney & Smith, has set the industry standard for schoolyard crayons for over 50 years. Two other large companies known for their schoolyard crayons are Prang and Sargent. Recent advances in manufacturing have produced a myriad of variations, including nontoxic, jumbo size, chunky, fluorescent, anti-roll, and erasable crayons, in nearly 100 colors.

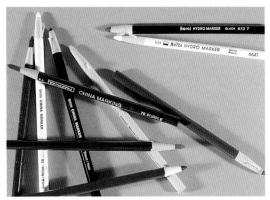

DIXON CHINA MARKERS (LEFT) AND BEROL HYDRO MARKERS (RIGHT)

OIL PASTELS AND OIL STICKS

Oil pastels and oil painting sticks are each formulated with a different kind of oil and a distinctive type of wax. *Oil pastels*, which contain a *nondrying* oil and a higher proportion of wax, do not dry completely and do not form a durable paint film. Conversely, *oil sticks* are formulated with a *drying* oil and contain only enough wax to produce their crayonlike form. They dry to a hard film just like oil paint, and can be used on any surface that is prepared for oil paint. Oil sticks can be used in combination with tube oils or any standard oil medium.

OIL PASTELS

Oil pastels were the first step in creating a product that combined the lushest colors of paint with the convenience of a crayon. They are a combination of pigment, oil, and wax that has been molded into a crayon or pastel shape. Oil pastels are opaque, adhere to almost any surface, and offer a great range of permanent colors, especially deep, rich darks. They possess a notable capacity for slurring colors together to achieve painterly effects.

CRAY-PAS

Cray-Pas is the trade name of a product introduced by Sakura in 1925. These oil pastel crayons are composed of pigment, wax, and oil, and were first called "oil colors in stick form." Cray-Pas have been used with great delight by illustrators, children, and hobbyists for generations, but have routinely been overlooked by professional artists. Perhaps their low price and popularity among amateurs have contributed to this neglect. Made in 72 colors, Cray-Pas are permanent, nontoxic, and easy to use.

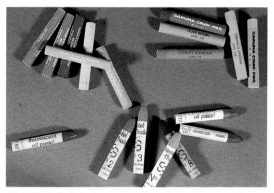

OIL PASTELS. Clockwise from top left: Caran d'Ache, Cray-Pas, and Sennelier.

NEOPASTELS

Made by Caran d'Ache, these oil pastels are a bit stiffer than Sennelier's (see below) but offer sensational handling properties. The strong covering power and intensity of the 96 thoroughly lightfast colors make Neopastels well suited for drawing on black paper or other dark surfaces. Thick encaustic-like layers can be obtained by placing the paper on a heat source (such as a hot plate) and melting Neopastels on the paper. The drawing can then be worked with a palette knife or a metal spatula.

SENNELIER OIL PASTELS

Sennelier oil pastels have a reputation among artists as the best on the market. Pablo Picasso asked art materials merchant Gustav Sennelier if it were possible to develop an oil-based drawing stick with the same color strength as oil paint. The resulting oil pastels are made from the finest pigments and oils. They are full-bodied, intensely saturated with color, and extremely lightfast. They can be thinned with turpentine and are compatible with oil paint. Sennelier oil pastels are acid free and adhere to almost any surface. Seventy-eight traditional colors are currently available, plus 27 metallic, iridescent, and fluorescent colors.

To satisfy the professional requirements of several prominent artists, Sennelier introduced Giant Oil Pastels. Each giant pastel is 4 inches long × 1 inch in diameter (10.16 × 2.54 cm), and is equivalent in mass to 18 traditional oil pastels. The giant size is available in 96 colors.

OIL STICKS

This medium is the ultimate link between drawing and painting. While the process of applying them to paper or canvas is akin to the act of drawing, oil sticks come as close as possible to producing a painted image. In fact, they offer the immediacy of drawing with all the advantages of working in oil.

Oil sticks can be used exclusively as a drawing tool or to establish the initial stages of an oil painting. There is no potential conflict in mixing disparate materials when painting begins. For example, you can start with a line drawing in oil stick, then expand the line drawing into an underpainting with turpentine and brush. You can then proceed with the full execution of the painting using oil sticks or tube oils and brushes. Furthermore, you can use oil sticks on top of painted layers to lend a calligraphic accent to the rest of the painting.

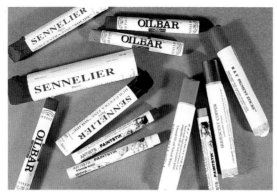

OIL STICKS. Sennelier Oil Sticks, Winsor & Newton Oilbars, Shiva Paintstiks, and R & F Pigment Sticks.

All the brands discussed below are fully compatible with tube oil paints, oil solvents, and mediums, and should be used on surfaces suitably prepared for oil painting. Before using, just wipe off the surface film that covers the end of the oil stick to enjoy one of the most immediate and tactile of drawing or painting experiences. Unlike the traditional oil paint and brush, an oil stick eliminates the need to stop and reload, allowing both the line of the image and the creative impulse to flow without interruption. For sketching in the field, oil sticks provide an oil painting experience, but with less gear. A few brushes and some turpentine will enhance the painterly qualities of this medium without the need for a complete oil painting set-up.

R & F PIGMENT STICKS

Introduced in 1990 by R & F Encaustics, a small company that produces handmade paint sticks for professional artists, R & F Pigment Sticks are made from only the finest ingredients—genuine permanent pigments, refined linseed oils, beeswax, and natural plant waxes—with no driers or additives of any kind. The proportions of ingredients are individually formulated in small batches to obtain maximum color saturation, since no two pigments are identical in tinting strength. As of this writing, the product line includes 67 colors, although another dozen or so will be added soon. Each hue is carefully selected, milling is slow and deliberate, and proportions are delicately balanced. R & F uses a greater percentage of oil and a better quality of wax than is used for most art crayons, and the resulting product is lipstick-soft, fully saturated with color, and the slowest-drying brand on the market.

It is important to note that because R & F Pigment Sticks are made for the professional artist rather than for the mass market, the warning

on the label—"These paint sticks are intended for use by professional artists and are not safe for use by children"—should be strictly observed.

SENNELIER OIL STICKS

Sennelier Extra-Fine Oil Sticks come in an assortment of 55 colors, including the traditional painter's palette. Pure pigments are combined with nonyellowing vegetable oils and mineral wax to form a colorfast stick with a creamy consistency. No fillers or dryers are used, so the paint film takes approximately 2 to 7 days to dry.

The regular size (38-ml) oil stick, which is 5 inches long, is usually large enough for most applications. Since the very use of this medium promotes a free gestural style, it follows that there would soon be a need to make larger oil sticks for very large canvases. Sennelier responded to this need, and now offers a 96-ml size. If you want to involve your whole body in the drawing process, to swing your arm in a great arc of color, try some of these.

WINSOR & NEWTON OILBARS

These were developed by artists for artists at the well-respected house of Winsor & Newton. All 35 professional colors, available in 3 sizes—"original," at $7/8 \times 5^7/8$ inches (2.22×14.92 cm); "slim," at $5/8 \times 4^1/4$ inches (1.59×10.8 cm); and "stump," at $1^3/4 \times 6^1/2$ inches (4.45×16.51 cm)—are fully miscible with tube oil paints, alkyds, varnishes, gels, and turps. Pure pigments and linseed oil are blended with selected waxes to provide the richness of oil color with the directness of a crayon. As with Sennelier oil sticks, Winsor & Newton Oilbars contain no fillers or driers and take approximately 2 to 7 days to dry.

SHIVA PAINTSTIKS

Paintstiks are the least expensive and have the firmest consistency of all the oil sticks. They contain a higher proportion of wax and drying oils, which causes most of the colors to dry overnight to a flexible film. They are manufactured for Shiva by Markal, the company that also makes several other lines of industrial-use markers like lumber crayons and cattle markers.

Paintstiks are self-sealing. After each use, a thin film forms on the end of the stick within 24 hours, so the color won't dry out. To resume working, just peel off the film to expose fresh color. These nontoxic painting sticks are available in 50 colors, plus 6 fluorescent, 16 iridescent, and 12 student-grade colors.

PENS

The selection of pens on the market today is tremendous. Any good art supply store will carry a large assortment of pens, holders and nibs. The next few pages describe the features of many pens; however, you should rely on your personal preference and research to lead you through the labyrinth of choices. You need not try them all, since sampling just a few will give you a good idea of the great possibilities this medium has to offer.

Of course, long before steel pens had been invented, artists dipped sticks, reeds, and quills into ink. A sharpened stick is still a popular tool in art schools, as it is inexpensive and encourages a loose, experimental attitude toward drawing. Reed and cane pens are made from the hollow stems of reed grasses or from bamboo. They each make a heavy, rigid line that in the hands of a skilled draftsman produces images of considerable power. Van Gogh and Rembrandt are two artists whose reed pen drawings show great vigor and personality. Quills from turkeys, geese, or other large birds are flexible and produce lines that are responsive to each artist's creative inclination. Wing quills are larger and more suitable for pens than quills from the tail. They are easily shaped with a knife and can be cut to any angle or point width. However, they are soft and need to be reshaped periodically.

DIP PENS AND HOLDERS
The reed and quill pens of antiquity have by and large been replaced by pen nibs made of steel. Although the former are useful for certain expressive techniques, steel points are much more durable, easier to maintain, and are manufactured in a broad range of sizes, shapes, and degrees of flexibility. For a comprehensive discussion of this topic, refer to *The Pen & Ink Book* by Jos. A. Smith (Watson-Guptill, 1992). In most cases an artist will need just a few different pen points, each in its own holder. The nibs are easy to change and reasonably priced, so you should keep extras on hand. Experimentation is the best way to learn which points are best for you, so try several, and from time to time try a few more.

Manufacturers of dependable metalpoint pens include Gillott, Hunt, Esterbrook, and Brause. Each makes a wide range of points that vary in width of line and flexibility of tip. These and other companies, such as Platignum and Osmiroid, also sell nibs specifically designed for lettering or calligraphy. The calligraphy tips are rigid and broader than regular drawing nibs, sometimes with a markedly chiseled tip. Although they are not primarily intended for drawing, they work well with a variety of techniques.

It is also important to have more than one pen holder on hand, as you may require a few different nibs in the same drawing. Each artist's hand possesses individual characteristics, and a pen holder that is comfortable for one artist may seem awkward for another. Select some that feel balanced and comfortable.

Always keep your pens clean. Wipe them occasionally during use and clean them when you've finished for the day. If residue builds up on the nib it will interfere with the free flow of ink and your line will not be consistent. If ink dries on the nib it must be cleaned off. Also, a nib that is "broken in" will perform better than a brand new one. Ruining your nibs, discarding them, and starting with new ones will not give you the same results as maintaining your pens and using the same nibs for years. Brand new nibs have been factory-coated with an oily protective film that must be removed before you use your pen. Boiling water, ammonia, commercial pen cleaner, saliva, and the flame from a match have all been recommended for removing this coating.

CROW QUILL PENS
One of the most useful artist's pens is the crow quill, which was designed to imitate the delicate

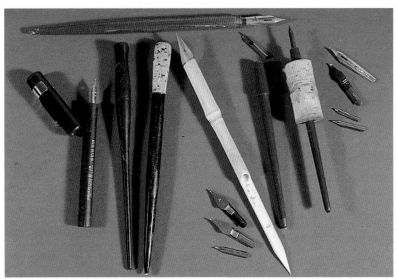

DIP PENS. Left to right: pen holders, nibs, reed pen, and crow quill pens (one with wine cork sleeve).

line of natural quill pens while providing the durability of a flexible steel nib. This type of pen produces an extremely fine line whose width can be controlled through variations in hand pressure. The holder for a crow quill nib is usually narrow, which may cause you to grasp the pen in a cramped or tense manner. For this reason, many artists force a pierced cork down the penshaft to provide a more comfortable grip. I use a merlot cork myself (Clos du Bois, 1990), but I suppose any cork will do. Those of you in the upper crust may wish to try the cork from a Chateau Margaux. And if all you want is your cork, please contact me about the contents of the bottle.

FOUNTAIN PENS

When introduced early in the 19th century, the modern fountain pen was a great step toward portability and convenience. No longer was an artist or scribe required to carry fragile pen points, holders, and a bottle of spillable ink. Fountain pens, therefore, have become prized by artists who sketch in the field.

Nib selection is more limited than with dip pens, but there are many fountain pens well suited for sketching. Several pen companies make superior fountain pens with gold nibs. Gold doesn't rust, glides smoothly on paper, and promotes excellent ink flow. A gold nib wears to the style of its user. Your pen becomes an extension of your hand, your touch. Don't lend your fountain pen to someone else. Live by the adage "Lend a hand, but not your pen."

The type of ink you prefer to use should also be considered. Most fountain pens will not work with waterproof ink, as the binder that makes the ink waterproof (usually shellac) is nearly impossible to clean out of the pen. But if you don't need to use waterproof ink, a fountain pen can become a favorite drawing tool.

EXAMPLES OF FOUNTAIN PENS

- *Osmiroid* has produced handmade pens in England since 1830. Their basic fountain pen accepts Osmiroid cartridge ink, or any nonwaterproof ink in its plunger-style ink converter. Quite reasonably priced, it is a good pen for a beginner. Osmiroid makes 26 nib units, some for left-handed users, all of which can be easily changed. The "copperplate" nib is best for sketching.
- *Pelikan MC 120* has been a popular pen with artists for many years. It is simple, well

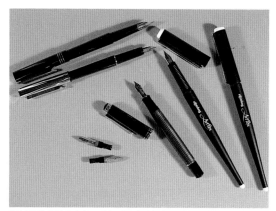

FOUNTAIN PENS. Left to right: Osmiroid, Platignum, Pelikan Souverän with extra nibs, and Rotring ArtPens.

balanced, and refills easily. The 7 gilded nibs made specifically for the MC 120 are all threaded and can be changed quickly with the provided nib key. Another good feature is a clear section in the barrel of the pen that indicates the supply of ink.
- *Pelikan Souverän M600* is an elegant and well-crafted fountain pen with a plunger-pump filling system and a solid 18k gold nib accented with rhodium. It is available in 8 nib sizes and will accept fountain India ink, but should be rinsed after each use.
- *Platignum* pens, which are made in England, are primarily designed for calligraphy. The Platignum Sketch Pen is a cartridge fountain pen fitted with a stainless steel nib for sketching. Ink cartridges, nibs, and barrels are interchangeable among Platignum pens, and an ink converter can be used in place of the cartridge.
- *Rotring ArtPen* by Koh-I-Noor can be used with calligraphy, lettering, or sketching nibs. With its long handle, the balance of the versatile ArtPen is more like a dip pen than a regular fountain pen. Its comfortable grip, along with the convenience of prefilled ink cartridges, make this pen worth investigating.

An ink-filler converter will permit greater latitude in your choice of inks. Although some waterproof inks dry too quickly for the fine nibs, Koh-I-Noor makes a latex-based waterproof ink (#3085) that is recommend for use in the sketching ArtPen.

TECHNICAL PENS

A technical pen is a type of fountain pen that was developed specifically for precise inking. It is most beneficial when consistent line width

and density are favored above an expressive line. The lines produced by such a pen are so uniform that different nibs are required for different line widths.

The function of a technical pen is the result of a radical departure from conventional nib design. The principle comprises a fine wire filament inserted within a metal tube. The exterior surface of the tube remains free of ink so the pen point can be drawn along the edge of a T-square or triangle without smearing. Until recently it was necessary to hold a technical pen at 80 to 90 degrees to the paper, but new advances in nib design now allow many of these pens to be held at a natural sketching angle.

The points are delicate, must be kept clean, and work best on smooth, hard papers or drafting film. In some ways they are like fine-tuned sports cars: They have a specific purpose at which they excel, but must be well maintained or they won't work at all. If a technical pen is clean, it will produce a line of the utmost precision.

EXAMPLES OF TECHNICAL PENS

- *Koh-I-Noor Rapidograph pens* set the industry standard. The Rapidograph is the best-selling technical pen in the world, and the only one made in the United States. Stainless-steel drawing points are available in 13 line widths, from a minute 0.13 mm to a broad 2.0 mm. All nib sizes are also sold in a tungsten-carbide point for drafting film, and a long-lasting sapphire point that will last up to 30 times longer than any stainless-steel nib. Rapidograph pens have an airtight "Dry Double-Seal" cap that prevents leakage and keeps the point from drying out. The refillable cartridge provides flexibility in ink choice. Koh-I-Noor makes specialty inks for paper, film, and cloth for their Rapidograph pens, including Ultradraw, a waterproof black India ink specially formulated not to clog technical pens.

- *Pentel Ceramicron* features a durable ceramic tip with excellent line quality. Ceramicron pens are made in 4 sizes (0.1 mm to 0.4 mm) and use refill cartridge units with water-based ink. A new pen nib is attached to each ink cartridge, so by refilling the ink you replace the nib. Ceramicron pens can be used at a natural sketching angle, but perform more efficiently at a near perpendicular angle.

- *Reform Refograph*, made in Germany by Alvin, is an inexpensive yet well-made technical pen. It has a refillable reservoir and replaceable points in stainless steel and tungsten. The nib design allows for improved drawing angles, but not as wide as those possible with the Rapidoliner (see below). Ink cartridges for the Refograph contain waterproof black ink.

- *Rotring Rapidograph*, the Rotring version of this famous technical pen, uses a prefilled disposable cartridge with a capillary ink flow system. Instead of a normal reservoir arrangement, this Rapidograph uses a cartridge with a double-rotating helix, which ensures a nonleaking, controlled-air breathing system with each new cartridge. The Rotring Rapidograph is practically maintenance free and comes in 10 nib sizes, with either stainless-steel or tungsten-carbide points.

- *Rotring Rapidoliner* is a technical pen that can also be used for loose sketching. It features a tubular point so that it can be used with a straightedge like any other drafting pen, but its radiused nib makes it easy to hold at any angle and still produce an even line. The point and the prefilled cartridge are a single unit that is discarded when the ink is depleted. The refill assembly includes a new nib along with waterproof pigment ink. The Rapidoliner is available in 4 sizes, from extra fine (0.25 mm) to broad (0.7 mm).

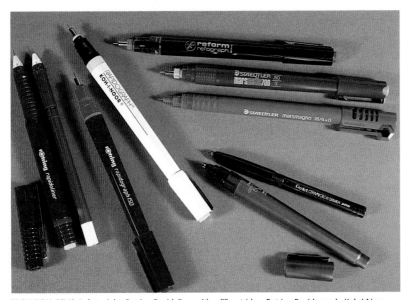

TECHNICAL PENS. Left to right: Rotring Rapidoliner with refill cartridge, Rotring Rapidograph, Koh-I-Noor Rapidograph, Reform Refograph, Staedtler Marsmatic 700, Staedtler Marsmagno, and Pentel Ceramicron with refill cartridge.

- *Staedtler Marsmatic 700* precision pen features a spring seal in the cap that prevents the point from drying out. Stainless-steel, tungsten, and polished-sapphire points are manufactured in 13 nib sizes.
- *Staedtler Marsmagno* is a completely disposable technical pen. It requires no refilling and no maintenance—a real time saver if you don't mind investing in a disposable product. I've discovered that the empty barrels also make acceptable pencil lengtheners.

KOH-I-NOOR RAPIDO-EZE TECHNICAL PEN CLEANING SET WITH CLEANING FLUID AND SQUEEZE-PRESSURE BULB

CLEANING A TECHNICAL PEN

Get in the habit of maintaining your technical pens and they will last for years. You can prevent most problems just by keeping your pens very clean. There is little tolerance in the precision ink delivery system, so any accumulated dirt or dried ink can inhibit the flow. Don't use a technical pen with soft paper, as dislodged paper fibers can clog the narrow tube. Also, avoid setting the pen down and leaving it unattended for any length of time, as the ink will dry and cause poor performance.

If you decide to take your technical pen apart and clean it by hand, there are a few things to keep in mind. Because the points are fragile, they can be bent with too vigorous a cleaning. Also, the commercial cleaning solutions that are specifically designed for the pens work better than plain soap and water.

Koh-I-Noor makes a pen-cleaning kit for its own Rapidograph pens, though it also works with several other brands. It includes a squeeze-pressure bulb that screws directly onto the nib. The suction it produces is strong enough to clean the delicate nib without damaging it. To use, screw the pen point into the end of the pressure bulb, then dip the nib into a liquid pen cleaner. By gently squeezing and releasing the

bulb, fluid is forced through the pen point, cleaning out the nib.

Another cleaning device is the ultrasonic cleaner, which works by vibrating the debris from the pen nib into a bath of cleaner fluid. Some models are large enough to insert an entire pen. An ultrasonic cleaner can be costly, but if you use technical pens frequently it is worth the investment.

BALLPOINT PENS

The regular old ballpoint pen has always been one of my favorite drawing tools. These ever-present pens are comfortable, convenient, and inexpensive. The marking point is a small rotating metal ball that recharges itself by making contact with an inner supply chamber of ink. By varying the angle at which the pen point touches the paper, it is easy to control the intensity of the line. In this manner, and through cross-hatching, a full range of tones is possible.

The ink in a standard ballpoint pen is formulated with wax so that it is fluid enough to flow down the tube yet not so liquid as to spill. Unfortunately, many of the pens are plagued by ink blobs or clotting, and only a handful contain ink that is lightfast. Although these issues are less important with inexpensive "throw-away" pens, most manufacturers have tried to develop "glopless" pens, and a few offer ballpoint pens with permanent ink.

Despite the fact that some manufacturers claim their inks are permanent, lightfast, or archival, the best way to make sure is to test them yourself. This is easily done by drawing a line or two with each ink in question on a piece of paper. Cover half the line with another piece of paper so that absolutely no light can reach it, then set the paper next to a window for a few months. After a time, you can compare the difference between ink that has, and has not, been exposed to light. Also keep this in mind: Artwork that will be reproduced for publication doesn't require permanent ink at all.

Above all the ballpoint brands on the market, I recommend the Illustrator by Griffin, which is available in three line widths. This pen, designed specifically for illustrating and general sketching, contains India ink and features a carbide ballpoint. Another good ballpoint pen containing permanent, water-resistant ink is the Stabiliner by Schwan. Both of these pens draw easily without skipping or clotting. The Illustrator's ink is a bit warmer in tone than

the Stabiliner's, but they are both good neutral blacks. According to my own fade test, the Stabiliner is not as lightfast as the Illustrator.

ROLLING BALL PENS

A cousin to the ballpoint is the rolling ball pen. The delivery systems are essentially the same (a rolling ball tip), but the ink in a rolling ball pen is more fluid and flows wet like a fountain pen. It is difficult to achieve the same sensitivity of tone as with the "wax and ink" ballpoints, but the rolling ball pens are delightful in their own way. The effortless flow of the ink promotes an easy, linear style of drawing.

EXAMPLES OF ROLLING BALL PENS

- *Permaroller,* developed by Pentel in 1986, is a permanent-ink pen that features a 0.25 mm microfine line and waterproof pigment ink. The manufacturer claims that "it won't smear, run or fade in sun or water."
- *Tombow* makes a series of pens that are refillable with their Roll Pen ink cartridges. Each cartridge contains permanent, waterproof, fast-drying pigment ink. The tungsten-carbide rolling ball point is available in 0.3 mm and 0.5 mm sizes. This refill fits all their Roll Pen models, including the unusual but fun-to-hold Zoom Pen.
- *Uni-Ball Deluxe Micro* by Eberhard Faber contains archival-quality, pigmented ink. Its 0.2 mm line is thin enough for detailed images, but the ink flow is substantial so that large dark masses can be built up quickly.

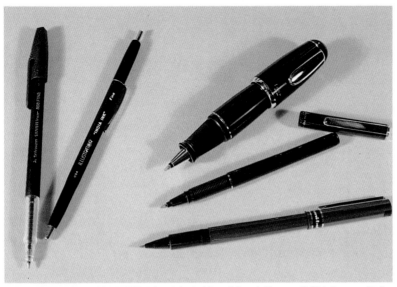

BALLPOINT AND ROLLING BALL PENS. Left to right: Stabiliner (Schwan), Illustrator (Griffin), Zoom and Roll Pens (Tombow), and Uni-Ball Deluxe Micro (Eberhard Faber).

FIBER-TIP PENS

In 1963, Pentel introduced the world's first fiber-tip pen. Recent advances in synthetic plastics such as nylon enabled Pentel to manufacture a product with a thinner line and greater ink flow control than the felt-tip pens and laundry markers then on the market. With a fiber-tip pen (as with a felt-tip), the ink is wicked through a porous fiber tip rather than passing down a tube and rolling onto the paper with the aid of a metal ball, as in a ballpoint pen.

Today porous-point pens are everywhere. They come in all shapes, sizes, colors, and a variety of ink types. A superfine tip with a metal protective sleeve will suit the engineer who needs precise inking, while a flexible nylon brush-tip is ideal for the sign painter or commercial artist. There is such a wide selection of versatile products in this category that only a fraction can be listed here. Take a trip to the art supply or office supply store and experiment with what you find.

EXAMPLES OF FIBER-TIP PENS

- *Itoya Finepoint* performs like a technical pen. I include it here because it has a plastic tip and can be held at a sketching angle. The Itoya comes in three sizes (0.1 mm, 0.3 mm, and 0.5 mm) and is filled with opaque black waterproof ink. This pen is self-contained, doesn't leak, and delivers a consistent flow of permanent ink. It also features a rubberized grip for greater comfort and control.
- *Penstix,* an Austrian-made pen by Alvin, is considered a graphic drawing pen for geometric and technical drawing. Its nylon tip, however, is more flexible than a standard technical pen nib, which makes Penstix a handy instrument for freehand drawing. The black ink is quite dense, like India ink, and there are three point sizes to choose from: Fine (0.7 mm), Extra Fine (0.5 mm), and Extra Extra Fine (0.3 mm). The feature I like most about this particular pen, in addition to the rich blackness of its ink, is its capacity to deliver a greater or lesser flow of ink, depending on the amount of pressure that is used. That is, if I press harder I get an intense black line, but if I gently run the penpoint across my paper I will get a faint gray line. This is the same touch-sensitive quality I enjoy with pencils or ballpoint pens.

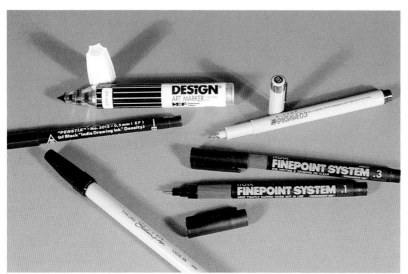

FIBER-TIP PENS. From top: Ultra Fine Design Art Marker, Penstix, Pigma Micron, Itoya Finepoint, and Pigma Sketch Pen.

- *Pigma Micron Pen* by Sakura, which is similar to the Itoya, is available in six sizes, from 0.005 mm to 0.08 mm. This pen is one of my favorites for outdoor drawing. I can climb around on the coastal rocks in Maine or California and then settle down with a sketchbook and my set of "Finepoints" or "Microns" to develop an image full of little dots, dashes, and cross-hatching.
- *Pigma Sketch Pen*, also by Sakura, features a chisel point. Variations in line width are determined by the way the pen is held or the direction in which the hand is moved, and the undulating line conveys movement and personality. All Pigma pens contain waterproof permanent ink that will not fade or discolor, dries quickly, and once dry will not bleed or smear. A Pigma sketch can be covered with watercolor almost immediately and still retain the crispness of the original line drawing.
- *Ultra Fine Design Art Marker* by Eberhard Faber is a bridge product between finepoints and markers whose line is just a bit broader than that of the Itoya. Eberhard Faber makes two more nibs that yield much bolder lines (see "Markers," below). The Ultra Fine Marker has a generous supply of xylene-based, waterproof ink (use with adequate ventilation).

MARKERS

The first commercial markers arrived on the scene in the early 1960s. Since then advances in technology and creative thinking have propelled markers into the worlds of art and design. No longer does "marker" automatically mean "laundry marker," for now there are many companies that produce marker pens of high quality and in a multitude of colors.

Art markers, as they have come to be called, have been virtually devoured by commercial artists and designers for two basic reasons: They dry quickly and are convenient to use. No brushes or mixing bowls are required, and cleanup is seldom more involved than replacing the caps on the pens. In design and advertising firms, where speedy visualization is a must, markers are right at home. With them, an artist can prepare a full-color mock-up for a client in a relatively short time. Permanence is not normally a prime consideration, since most of the artwork is created for reproduction or for exchanging preliminary ideas.

The chisel-shaped nib, which is the most common marker tip, produces the greatest variety of line width with a single nib. It allows you to switch from broad strokes to fine lines just by changing the angle at which the nib touches the paper. There are three other standard nib shapes: bullet tip, fine line, and the latest addition, the brush pen (see page 37).

Xylene, the solvent that was used in most of the early markers, is objectionable to some because of its harmful fumes, so adequate ventilation should be used. The odor is less offensive in alcohol-based markers, and there are now several water-based markers that are both nontoxic and odorless. Make it a habit to *always* recap your markers. The solvents evaporate quickly, drying out the marker tips. Keep some rubber cement thinner (or lighter fluid) on hand to use as a solvent; try adding a drop or two to a dried nib to revitalize a fatigued marker.

Several companies manufacture a product known as "colorless blender" under their own brand names. A colorless blender is essentially a marker with no color, just solvent (either xylene or alcohol) that is used to lighten colors, soften edges, and mix colors together. Colorless blenders also work quite well with colored pencils. The solvents break down the wax binder, and the result is a more painterly stroke.

EXAMPLES OF MARKERS

- *AD Marker* by Chartpak comes in 130 permanent xylene-based colors. Its unique, three-sided nib produces fine, medium, and broad strokes just by changing angles.

Chartpak also makes a marker that accepts interchangeable nibs, but changing nibs can be messy, and you must wait for the ink to wick into the new nib.

- *Design Art Marker* by Faber-Castell is available in 72 permanent colors, including pale tints and 12 values of gray. This xylene-based marker contains a generous supply of ink and comes in the traditional chisel tip, pointed bullet nib, and ultra-fine nib (see "Fiber-Tip Pens," page 34).

- *Design2 Art Marker*, also by Faber-Castell, is an alcohol-based marker available in 120 colors. The double-ended pen has a chisel tip on one end and a pointed nib on the other. The color from each tip is an exact match because both ends feed from the same ink reservoir. The Design2 color system includes 5 different values for each of 16 basic hues, 20 earth tones, and 20 grays. Faber-Castell also makes an alcohol-based colorless blender.

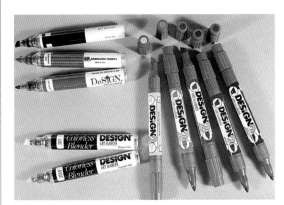

MARKERS. Design Art markers (top to bottom: broad nib, ultra fine nib, bullet nib); colorless blenders; Design2 Art markers (in a 5-value range of blue).

- *Dual Brush Pen* by Tombow offers a wonderful array of water-based, odorless, double-ended markers available in 144 colors, including 22 grays. Both ends are fed from the same ink reservoir. The fine nib can be used to make uniform lines for details, and the flexible brush tip can draw either wide areas or the thinnest of lines just by varying the pressure of the stroke. Dip this pen in water to extend its range of marking capabilities.

- *Mars Graphic 3000 Duo (Staedtler)* has many of the same features as Tombow's Dual Brush Pen. The water-based Mars Graphic is available in 80 colors, and is double-ended with a fine tip and a nylon brush tip.

- *Prismacolor Art Marker* by Berol comes in 144 colors, including some metallics and

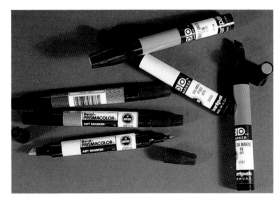

BEROL PRISMACOLOR MARKER (ALCOHOL-BASED) AND AD MARKER (XYLENE-BASED)

fluorescents. Each alcohol-based marker is double-ended, equipped with a broad tip and a pointed tip. Berol also makes a nontoxic colorless blender.

- *StabiLayout Marker*, manufactured by Schwan, features a flat, easy-to-hold shape that won't roll and allows improved control of the chisel-point nib. This shape also provides an indication of the relationship between the barrel of the marker and the orientation of the nib, so that you know without looking which face of the nib is addressing the paper. This water-based marker comes in 50 colors, a comparatively meager selection; however, the shape of this marker may be of significant interest to you.

- *Super Marker*, a broad-tip marker made by Pilot, contains xylene-based waterproof ink. It marks on any surface but is not archival. This marker is unusual in that it can be refilled. Just twist off the top to reveal the innards and refill with archival ink, or perhaps something that doesn't smell as nasty as the xylene, such as Speedball Non-Waterproof Drawing Ink (see page 41).

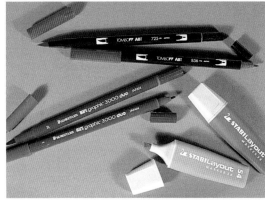

WATER-BASED MARKERS. Top to bottom: Dual Brush Pen (Tombow), Mars Graphic 3000 Duo (Staedtler), and StabiLayout markers (Schwan).

Brushes and Brush Pens

Many artists who work in ink favor a brush for its ability to create line and tone with equal grace. Brush pens combine the responsiveness of a brush with the convenience of a fountain pen.

Brushes

Use the best brushes you can afford. Red sable brushes, such as those used for watercolor, are responsive, have lots of spring, and maintain their shape well. They can render a delicate line and a broad stroke all with one sweep of the wrist. Kolinsky sable, which comes from the tails of Siberian martens, is the finest (and most costly) brush hair. The tail of the Asiatic weasel is the source of red sable brush hair, which is less expensive than Kolinsky but still very high quality and makes an excellent brush.

All good watercolor brushes are suitable for ink wash, especially when used with nonwaterproof ink. With proper care, fine brushes will last a lifetime. Waterproof inks, however, contain shellac or varnish that can be harmful to natural-hair brushes. Synthetic-fiber brushes are a better choice for waterproof inks. Regardless of which brush or ink you use, never let ink dry in a brush. Grumbacher, Isabey, Simmons, and Winsor & Newton all make first-rate brushes that are easily obtainable. For broad washes, there are several brushes to choose from: watercolor brushes, Japanese hake brushes, and a few good commercial brushes made especially for varnishing.

Sumi brushes are designed for calligraphy and Oriental styles of brushwork. They are made from natural hair and have long flexible points, usually attached to a bamboo handle. These brushes are strong and absorbant, yet supple.

Brush Pens

There are two types of brush pens. One is a marker whose nib is made from a flexible synthetic fiber (see "Markers," page 35), and the other is a fountain pen with a brush tip instead of a metal nib. Each produces a line of varied width just like a brush, but you don't have to dip them in ink.

Examples of Brush Pens
- *Kaimei brush pen* is a brush-tipped Japanese fountain pen and one of the nicest drawing instruments you can own. The pointed weasel-

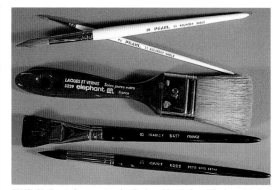

BRUSHES. Top to bottom: Pearl Kolinsky sables, Isabey "Elephant," Isabey pony hair, and Isabey squirrel hair.

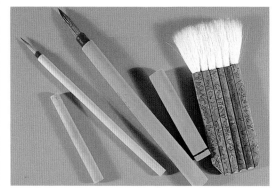

SUMI BRUSHES. Left to right: two Chinese bamboo brushes and a Japanese hake brush.

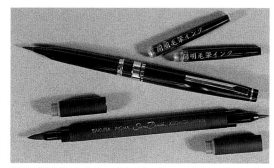

BRUSH PENS. Top to bottom: Kaimei brush pen with 2 cartridges and Pigma Sumi brush pen.

hair tip is perfectly suited for calligraphy and sensitive ink drawings. The Kaimei combines the suppleness of a brush with a steady ink supply. Nonwaterproof black ink comes in cartridges and the brush tip can be replaced if it wears out.
- *Pigma Sumi brush pen* by Sakura is a unique disposable pen. Each end of its barrel has a synthetic fiber brush: a standard-point brush for sketching, and a fine-point brush for details. Both brushes share the same ink reservoir so the color of each is identical. The pen is available with permanent, waterproof ink in 8 colors including black.

INKS

Since antiquity, artists have applied ink to a variety of surfaces by means of stick, brush, pen, and, more recently, airbrush. New technology has created both a need and the means for countless refinements and modifications in the manufacture of ink.

Today, inks can be found in all colors, in waterproof and watersoluble formulations, opaque and transparent, and in a number of other variations designed for specific applications. Technical pens, for example, require an ink that is ground extremely fine so as not to clog the narrow point of the pen. Airbrush also requires a finely ground, free-flowing ink for best results.

Inks differ greatly in their ability to resist fading. Three terms associated with this characteristic are permanent, lightfast, and archival. *Permanent*, which in some ways is a misleading label, indicates that a mark is still legible after a dozen launderings. *Lightfast*, a designation of greater concern to most artists, pertains to an ink's capacity to resist fading when exposed to light. *Archival* is the term reserved for materials of the highest quality. Artists who draw with archival inks on archival paper are increasing the odds of their work lasting for centuries.

Waterproof ink, as you might assume, is not affected by water once the ink has dried. This means that a drawing done in waterproof ink can be covered with an ink wash, or even watercolor, without being disturbed. *Nonwaterproof ink*, however, stays "open," which means that a dried drawing can be reworked or manipulated by rewetting the ink. A water-soaked brush can create soft edges or modify tonal areas. Nonwaterproof ink is more flexible if you intend to adjust the image; waterproof ink is more desirable if you intend to isolate it from subsequent washes.

INDIA INKS

First developed in China and incorporating pigments from India, India ink is a dark black liquid that is permanent and lightfast. Waterproof India ink contains a shellac binder that, once dry, keeps the ink from smudging or smearing. Other inks and watercolor can be washed over them without concern.

Nonwaterproof India ink replaces the shellac binder with a watersoluble vegetable gum. This ink is ideal for ink wash overlays since the value of the wash can be adjusted with a moistened brush. However, putting another wash on top of a watersoluble ink drawing can prove disastrous.

India ink is generally used with dip pens and brushes. Calli, Dr. Ph. Martin's, FW, Higgins, Pelikan, Speedball, and Winsor & Newton all manufacture good-quality India inks.

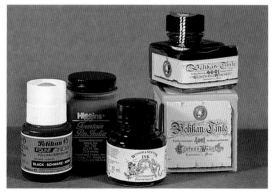

NONWATERPROOF INDIA INKS. Left to right: Pelikan Fount, Higgins Fountain Pen India ink, Winsor & Newton Liquid India Ink, and Pelikan 4001.

SUMI INKS

In the Orient, ink has been molded into solid sticks for centuries. The Japanese call these ink sticks *sumi*, a term that has been appropriated by the West to describe all Oriental painting, regardless of origin. In fact, Japanese, Korean, and any other ink painting of the Far East can be traced back to its wellspring in China. During the Sung Dynasty (A.D. 960–1280), the Chinese mixed pine soot and hide glue, ground the mixture into a fine paste, and formed it into ink sticks. When later mixed with pure water, these sticks yielded a thick black ink of great smoothness. Today ink sticks are made much in the same manner, and their preparation has become ritualized.

Good sumi ink cannot be made in a hurry. It takes patience and care, and has become a

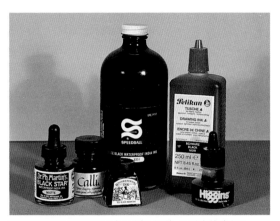

WATERPROOF INDIA INKS. Left to right: Dr. Ph. Martin's Black Star, Calli Non-Clogging Calligraphy ink, Winsor & Newton, Speedball, Pelikan Drawing A, and Higgins.

ceremony of preparing the mind for painting. Fresh ink is made for each painting session, and the slow deliberate rhythm that is required for the process serves as a meditation to set aside the distractions of the outside world. First, a few drops of clear water are placed on an ink stone. Liquid ink is made by rubbing the tip of the ink stick in the water on the stone, always in a circular motion and with gentle pressure. For best performance, the ink should be thick, black, and smooth, and dense enough to make the strongest black marks on the paper with a single stroke. For lighter values of gray, the ink is diluted with water.

Liquid sumi ink is available for those who do not wish to prepare their own from ink sticks. I'm sure some people make good use of this product, but it misses the point. Making your own ink is part of the creative process of sumi painting, and should not be eliminated from your routine.

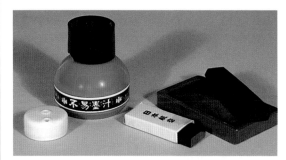

SUMI INK. Left to right: ceramic water container, liquid sumi ink, grinding stone, and two ink sticks.

INKS FOR TECHNICAL PENS

With the advent of the tubular nib and precision tolerances of the technical pen, smoother, more finely ground ink became necessary. Consistent flow is a major requisite for technical pen inks. Since minor clogging interrupts uniform ink flow and major clogging can ruin your whole day, ink makers have continually upgraded and refined their products. Finely ground inks are now specifically formulated to adhere to a number of surfaces, such as paper, drafting film, and clear acetate.

EXAMPLES OF INKS FOR TECHNICAL PENS

- *Koh-I-Noor Rapidograph Ultradraw* is designed for use on paper. It is waterproof, lightfast, and dries to a matte finish. Its dense black lines are ideal for photographic reproduction.
- *Koh-I-Noor Rapidograph Universal* is a versatile, fast-drying waterproof ink appropriate for paper or film. The black India ink is pigmented and opaque, while the 8 colors are transparent.

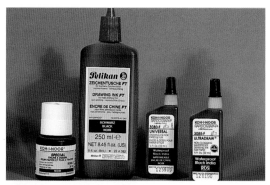

TECHNICAL PEN INKS. Left to right: Koh-I-Noor Rapidograph Special, Pelikan Drawing Ink FT, Koh-I-Noor Rapidograph Universal, and Koh-I-Noor Rapidograph Ultradraw.

Universal ink can be mixed to produce intermediate colors, and thinned with distilled water to make lighter tints.
- *Koh-I-Noor Rapidograph Special* is similar to Universal ink, but has a longer "open-pen" time, which means it doesn't dry as fast. It is permanent, waterproof, and resists fading. Special comes in black and 6 opaque colors.
- *Pelikan Drawing Ink FT* is made for use on drafting film. Non-fading, opaque and reproducible, Drawing Ink FT is waterproof when dry and will not etch into the film.

WHITE INKS

White pigments are suspended in a liquid base to produce opaque white drawing ink. This type of ink is manufactured in both waterproof and nonwaterproof forms, depending on the binder that is used. White ink can be used to add white lines and highlights to a darker drawing, or added to colored ink to lighten its value and render it opaque.

White ink is particularly suited to working on black paper, such as Arches Cover Black (see page 46). Thin washes produce subtle grays, and white used full strength sparkles against the black ground. Waterproof white inks can be washed over with color—a great way to create brilliant hues on the black paper.

Individual brands of white ink vary in their degree of opacity and their ability to resist bleed-through by dye-based inks. The following examples are all good inks, but differ in their covering power and bleed-through resistance.

EXAMPLES OF WHITE INKS

- *Dr. Ph. Martin's Bleed Proof White* and *Dr. Ph. Martin's Pen-White*, which are manufactured by Salis International, Inc., are both extremely opaque. Bleed Proof White is a thick watercolor

paste that covers dye colors and marker colors. Some watercolorists use it as a base to cover mistakes before repainting. Pen-White is made from titanium dioxide specially liquified for smooth pen flow. It is intended for technical pens and airbrush but also works well with dip pens and brushes. It resists bleed-through, adheres to acetate, and is archival.

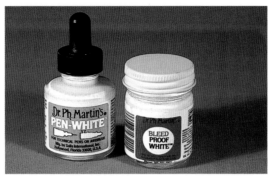

DR. PH. MARTIN'S PEN-WHITE AND BLEED PROOF WHITE

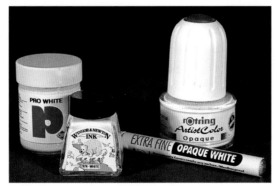

WHITE INKS. Left to right: Pro White (Daler-Rowney), Winsor & Newton Designers Liquid Acrylic White, Opaque White (Marvy), and Rotring ArtistColor.

- *Opaque White* by Marvy is a marking pen containing xylene-based white pigment. It is fairly opaque, waterproof, and permanent. Opaque White conveniently covers most surfaces, and is especially handy for making small white dots.
- *Pro White* by Daler-Rowney is sometimes used to cover up marks instead of removing them, which in certain cases is just as effective as erasing for obliterating unwanted lines in a drawing. Pro White can be used with brush, pen, or airbrush, and can be mixed with Daler-Rowney's Pro Black to create a complete range of opaque grays.
- *Rotring ArtistColor* is milled fine enough to use in technical pens and airbrushes. It is a waterproof lightfast ink that is advertised as opaque, though it is in fact only moderately

so, as dye-based inks and marker colors will bleed through.
- *Winsor & Newton Designers Liquid Acrylic* adheres to most surfaces and is suitable for dip pens and brushes. It is a creamy warm, nonwaterproof white that is reasonably opaque when applied on top of India ink, but marker colors will bleed through.

COLORED DRAWING INKS

Since the mid-1980s, advances in ink manufacturing have transformed the artist's selection of colored inks from a limited palette susceptible to the effects of light to an astonishing array of lightfast colors and performance properties. Liquid watercolor is an intense concentration of color that works with brush, airbrush, and technical pen. Liquid acrylic colors, dye composites, and pigmented inks are available in both waterproof and nonwaterproof formulations. Iridescent, metallic, and fluorescent inks can now be used without clogging sensitive pens.

Such an abundance of choices requires an artist to become a careful label reader. If you have doubts or questions about the characteristics or recommended uses of any product, simply call and ask a customer service representative of the company that makes or distributes it.

EXAMPLES OF COLORED DRAWING INKS

- *Calli* inks are designed specifically for use in calligraphy, where reliable flow characteristics for pen and brush are essential. Calli inks are acrylic-based, water resistant, and produced in a range of 6 intermixable colors.
- *Dr. Ph. Martin's Hydrus* by Salis International, Inc., is a line of a brilliant, completely archival concentrated watercolors made from the finest permanent pigments. Equipped with a convenient dropper in the cap, Hydrus can be used directly from the bottle or diluted with water to make wash tints. This product works

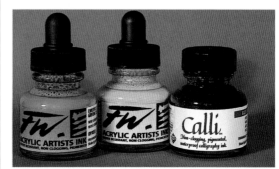

ACRYLIC-BASED INKS. FW Artists (Daler-Rowney) and Calli.

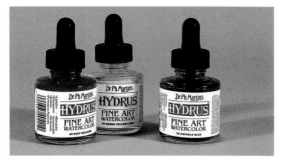

DR. PH. MARTIN'S HYDRUS LIQUID WATERCOLOR

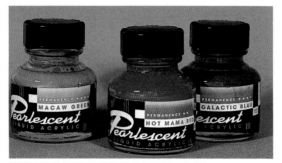

PEARLESCENT LIQUID ACRYLIC INK (DALER-ROWNEY)

extremely well in pens, and many watercolorists use Hydrus along with their pan or tube colors. In response to numerous artists' requests, Salis recently began manufacturing all 24 Hydrus colors in 8-ounce jars, which can be special-ordered directly from the manufacturer or through your local art supply dealer.

- *FW Artists Ink* is an exceptional colored ink made by Daler-Rowney of Great Britain, which also manufactures high-quality watercolors, pastels, oils, and other art materials. FW Artists Ink is acrylic-based and comes in 30 water-resistant colors. The lightfast hues have remarkable color strength and can be substantially diluted to create a variety of tints. Daler-Rowney's Pearlescent line of inks offers a range of 21 acrylic colors for brush or dip pen that produce a shimmering pearl effect when lit from different angles. More than half of the Pearlescent colors are lightfast.
- *Pelikan Drawing Ink* is a high-quality waterproof ink from Germany. It has been a popular choice among artists for years, and is designed for use on all papers. The dye-based ink flows freely through all pens, but cannot be exposed to direct sunlight without fading.
- *Rotring ArtistColor Acrylic* can be purchased in 24 transparent and 12 opaque colors, plus 5 metallic and pearlescent colors. This product is finely milled, with an average pigment particle size of less than 1 micron (one-tenth

the size of particles in most acrylics), making it ideal for technical pens and airbrushes. An accurate system for drop-by-drop color mixing is furnished with the pipette and dropper cap.

- *Speedball Non-Waterproof Drawing Ink* may be used with dip pens or brushes, but it is not recommended for technical pens. Considered lightfast, this ink is opaque and watersoluble. The 7 colors plus black and white can all be mixed to create intermediate hues.
- *Winsor & Newton Designers Liquid Acrylic Colour* is waterproof and contains shellac. (Make sure to wash pens and brushes immediately after use.) The 25 colors in this line are intermixable and may be thinned with distilled water to produce a full range of tints. Only the black and white are lightfast.

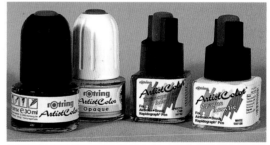

SPEEDBALL NON-WATERPROOF DRAWING INK AND PELIKAN DRAWING WATERPROOF INK

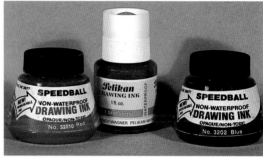

ROTRING ACRYLIC WATERPROOF INKS. Transparent ArtistColor and Opaque ArtistColor.

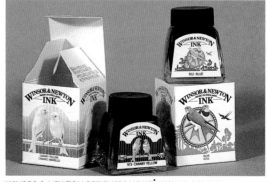

WINSOR & NEWTON DESIGNERS LIQUID ACRYLIC COLOUR

PAPERS AND SUPPORTS

In A.D. 105, during China's Later Han Dynasty, a man named Ts'ai Lun prepared a substance consisting of rags, hemp, and netting blended in water, then dried the mixture on a flat surface. He presented his discovery to the emperor, and soon the invention of paper was proclaimed throughout the land. Since that time papermaking has been refined and expanded, with countless creative variations developed from the original theme.

For thousands of years before the invention of paper, human beings left their marks and symbols on stone, bark, bricks, hides, and other surfaces. Papyrus and sheepskin parchment are two examples of ancient drawing materials that continue to be produced to this day. The great advantages of paper are its strength, its light weight, its uniformity in production, and the variety of specific purposes for which it can be manufactured. Since paper can be made in large quantities, its cost is relatively low as well.

This section examines the noteworthy characteristics of supports that are suitable for fine art applications; for readers who are unfamiliar with the language that is particular to paper, a glossary of paper terms (compiled with the help of Daniel Smith Inc.) is also included. The papers listed are by no means an exhaustive inventory, for there are hundreds of appropriate surfaces available for drawing; there simply isn't enough space to list them all. The list should serve as a guide, to give readers a general idea of the quality and diversity of drawing supports on the market today.

Paper suitable for drawing falls into several categories. Sheets of simple bond paper and butcher paper are useful for student work but cannot be expected to last as long as archival paper. Nor should scrap paper be considered for permanent work, although it is fine for rudimentary sketches or planning. I often use the back of junk mail or even brown paper bags for such preliminary work, but this "casual" paper is not chemically stable and should be avoided for serious work. Student-grade newsprint, oaktag, oatmeal paper, and slick fingerpaint paper, all familiar acquaintances from childhood, are fine for learning, but their most important feature is their low price. The secret to drawing, and parenthetically we might include all the fine arts, is practice. To learn how to draw, one must draw, draw, draw.

Inexpensive materials allow us to develop drawing skills through repeated practice without unlimited funding. Perhaps the lack of permanence of these papers is a blessing, since our early drawings on cheap paper don't stick around to haunt us. I often tell students that we all have a certain amount of bad drawings in us (alas, some more than others), and the sooner we get them out of our systems the better. The way to get them out is to draw, draw, draw. But once beginners have put in some time with student-grade materials, they owe it to themselves to become familiar with "artist-quality" supplies. There *is* a difference.

Sketchbooks are the most common surface for drawing, and there is a wide variety of papers included in the sketchbooks now on the market. They vary from inexpensive, impermanent paper to deluxe paper of the highest quality. However, since portability is a prime consideration, a sketchbook is usually limited in its size.

For work at the drawing table or easel, you will want reasonably sized sheets of good paper, perhaps 22 × 30 inches (55.88 × 76.2 cm). There are basically two types of paper: *machine-made*, whose quality and characteristics are predictable because it is made consistently by machine, and *handmade* and *mouldmade* papers, which are known for their individual and distinctive characters. The surface texture of a paper will affect the nature of your drawing. A *smooth* or *hot-pressed* finish allows for greater detail and precision. A *medium* or *cold-pressed* finish reveals more of the texture of the paper and lends itself to a looser, freer application. A *rough* surface has an assertive character that forces the artist into creating powerful designs that will not be overwhelmed by the paper's texture.

GLOSSARY OF PAPER TERMS

- *Acid-free paper:* A chemically stable paper containing no harmful acid and a pH of at least 6.5. The presence of a synthetic sizing material allows the paper to be manufactured with a neutral or alkaline pH.
- *Archival:* A term used to indicate the stability and resistance of a paper to physical changes over time. Agencies that govern large archives, like the Library of Congress, set standards for the collection and use of documents. Papers and inks that are considered to be the most permanent are classified as "archival."
- *Buffering:* A process that gradually neutralizes a paper's acidity by adding an alkaline

substance, such as calcium carbonate, at the pulp stage. A paper made in an acid environment can be buffered to obtain a neutral pH.

- *Cold-pressed (CP):* A mildly textured surface produced by pressing the paper through unheated rollers. Cold-pressed is the most popular watercolor paper, as pigments sink into the low parts of the paper, leaving less color on the "bumps" and producing the sparkle characteristic of the medium.

- *Deckle edge:* The natural, fuzzy edges of handmade papers, simulated in mouldmade and machine-made papers by spraying the edge of the sheet with a jet stream of water while the paper is still wet. Handmade papers have four deckle edges, while machine-made papers usually have two.

- *Grams per square meter (g/m² or GSM):* The metric measure of weight for artists' papers. It compares the weights of different papers, each occupying one square meter of space. *See also* POUNDS PER REAM.

- *Handmade paper:* A sheet of paper made individually, by hand. *Compare* MACHINE-MADE PAPER and MOULDMADE PAPER.

- *Hot-pressed (HP):* Paper that has been given a smooth finish by pressing it through heated rollers after the sheet has been formed. It is a standard surface for use with ink or pencil.

- *Laid paper:* Paper with a prominent pattern of ribbed lines in the finished sheet. This is attained in handmade paper with a screenlike mould of closely set parallel horizontal wires, crossed at right angles by vertical wires spaced somewhat farther apart. This texture is achieved in machine-made papers with the use of a device called a dandy roll.

- *Machine-made paper:* A sheet of paper produced on a rapidly moving machine called the Fourdrinier, which forms, dries, sizes, and smoothes the sheet. Uniformity of size and surface texture are the hallmarks of the machine-made sheet.

- *Mouldmade paper:* A sheet of paper that simulates the look of a handmade sheet but is actually made by a slowly rotating machine called a cylinder mould, which was first used in England in 1809.

- *pH:* A measure of hydrogen ion concentration denoting whether a substance is acid or alkaline. A paper's pH is measured on a scale from 1 to 14: the lower the number, the greater its acidity; the higher the number, the

greater its alkalinity. Papers with a pH of 6.5 to 7.5 are generally considered neutral.

- *Plate finish:* A very smooth surface found on paper that has been run under a calender machine one or more times.

- *Ply:* A single web of paper, used by itself or laminated onto one or more additional webs as it is run through the paper machine.

- *Pounds per ream:* The system of paper measurement used in the United States. For example, a paper noted as "140 lb." indicates that a ream (500 sheets) weighs 140 pounds, regardless of individual sheet dimensions.

- *Rag paper:* Paper made from fibers of non-wood origin, including cotton rags or pulp. Rags are processed clippings of new cotton remnants from the garment industry for use in high-quality papers. Rag papers contain from 25 to 100 percent cotton fiber pulp.

- *Rice paper:* A common misnomer applied to lightweight Oriental papers, referring to the rice straw that is only occasionally mixed with other fibers.

- *Rough (R):* The coarsest, bumpiest paper surface. Heavily textured papers are produced by minimal pressing after sheet formation. The rough surface is popular for certain watercolor techniques, acrylic, casein, and mixed media.

- *Sizing:* A material such as rosin, glue, gelatin, or starch that is added to a paper to provide resistance to liquid penetration. Paper may be impregnated with sizing at the pulp stage *(tub sizing)* or may be treated with a sizing material on the surface of the paper after the sheet is dry or semi-dry *(surface sizing).*

- *Sulphite:* Wood-based paper pulp. Depending on how it is processed for papermaking, it is either acidic or has a neutral pH.

- *Vellum finish:* Also known as *kid finish* or *medium surface,* a hard flat surface with a very fine, slightly "toothy," texture approximating the feel of parchment.

- *Watermark:* A design applied to the surface of the paper mould which causes less pulp to be distributed in that area and results in the transfer of the design to the finished sheet. The impression is subtle and usually only visible when the paper is held up to the light.

- *Wove paper:* Paper with a uniform unlined surface and smooth finish, imparted by a mould with a fine-screened mesh. Most papers produced are of this type. *Compare* LAID PAPER.

SKETCHBOOKS

Every artist should have a few sketchbooks. Small books can be carried everywhere to record ideas, both written and drawn, for future reference. Larger sketchbooks kept in the studio are practical for working out preliminary ideas and developing images. Many are spiralbound, which allows access to the entire sheet of paper. Hardbound sketchbooks feature neutral-pH drawing paper bound in long-lasting hardcovers. They store nicely on bookshelves for serious artists who want to retain sketches for their portfolios or libraries. Newsprint pads feature high-bulk, smooth to moderately textured papers that are meant for sketches and quick studies. Inexpensive and non-archival, newsprint is good for charcoal, crayon, or really soft pencil, and also works well with ballpoint pen.

Sketchbooks are convenient to use and easy to store. They can be examined through the years to observe artistic growth, relive creative moments, and refresh the memory. Some sketches will lie dormant for decades before they trigger an idea for a substantial composition, while others will be torn out and framed (or perhaps burned) immediately.

EXAMPLES OF SKETCHBOOKS

- *Derwent Sketchpad* is one example of a simple, all-around sketchpad of respectable quality. The English-made cartridge paper is a substantial 130 g/m² with a semi-rough finish appropriate for pencil, charcoal, and crayon.
- *Rives Bristol sketchbook* contains 130 g/m² Rives 1-ply soft white bristol paper, 100 percent rag and acid free. This pad is custom made by New York Central Art Supply, which offers several popular premium papers in sketchbook form (see List of Suppliers, page 172).
- *Sennelier D1 sketchbook* contains 60 sheets of lightweight pH-neutral paper for pencil or pen sketching. It is bound at the top with two chrome rings.
- *Sennelier D8 sketchbook* contains 28 spiralbound sheets of heavyweight bristol paper. It is pH neutral and has a very smooth surface. This pad is ideal for all dry media.
- *Strathmore Premium Recycled Drawing Pad* is a responsible, reasonably priced alternative for environmentally conscious artists. The medium-weight, medium-smooth paper is acid free and exceeds E.P.A. recycling guidelines. It works well with all dry drawing media.

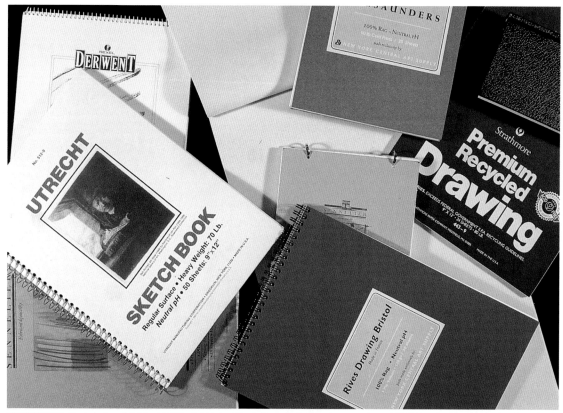

SKETCHBOOKS. Clockwise from left: Utrecht 70-lb. Artists' sketchbook, Derwent sketchpad, a newsprint pad, T. H. Saunders sketchpad, a hardbound sketchbook, Strathmore Premium Recycled pad, Sennelier D1 pad, Rives Bristol pad, and Sennelier D8 pad.

- *T. H. Saunders sketchpad* is a mouldmade, 100-percent rag watercolor paper. It is pH neutral and available in hot-pressed or cold-pressed pads custom made by New York Central.
- *Utrecht 70-lb. Artists' Sketchbook* is another all-purpose pad. The medium-weight paper is acid free with a regular finish suitable for pencil, pen, or crayon.

DRAWING PAPERS

Seldom will you find a high-quality paper that is marketed exclusively for drawing. In fact, many excellent drawing papers are primarily advertised for their use in printmaking or watercolor; they just happen to be great for drawing too. A few papers, however, do specify drawing as their fundamental use.

EXAMPLES OF DRAWING PAPERS

- *A/N/W Drawing and Framing paper* is machine-made in the U.S. This 100-percent cotton paper is suitable for all drawing media. Buffered to a neutral pH, it is also used as a barrier sheet for framing large works of art. Sheet dimensions are 20 × 30 inches (50.8 × 76.2 cm) and 32 × 40 inches (81.28 × 101.6 cm), and rolls are 60 inches × 20 yards (152.4 cm × 18.28 m).
- *Daniel Smith Archival Printmaking and Drawing paper* is a bit harder and more compact than regular printmaking papers, which makes it a great surface for drawing techniques. It is strong enough to tolerate a reasonable amount of erasing, and its slight texture is receptive to pencil. This is a good inexpensive paper for all-around use. It is 25 percent cotton and acid free.
- *Rising Drawing Bristol* is machine-made and contains acid-free wood pulp. It is recommended for all drawing media. The surface texture is either "plate" (very smooth) or "vellum" (a mild tooth). The plate finish is ideal for pen and ink or fine pencil work. The vellum finish will accept all other drawing media, including airbrush and light washes. The sheet size is 22 × 30 inches (55.88 × 76.2 cm) and is available in a range of thicknesses, from 1- to 4-ply.
- *Strathmore 500 Series Drawing Paper* has been recognized for almost a century as one of America's finest drawing papers. Acid free and 100 percent cotton, its durable surface can withstand repeated erasures and reworking without feathering or bleeding. Sheets of 30 × 40 inches (76.2 × 101.6 cm) are available

DRAWING PAPERS. Top to bottom: Strathmore 500, Rising Drawing Bristol, Daniel Smith Archival, and A/N/W Drawing and Framing.

in a regular surface designed for pencil, charcoal and pastel, or a plate surface more suited to ink or delicate pencil work. Strathmore also makes a lightweight (104 g/m²) 300 Series paper for students or for experimentation, and the popular 400 Series, which is a medium-weight paper (119 g/m²). Both are acid free.

PRINTMAKING AND WATERCOLOR PAPERS

Papers made for printmaking and watercolor are generally of very high quality, acid free, and strong enough to withstand the various procedures required for each technique. Coincidentally, these traits also qualify the papers as excellent surfaces for drawing. Many of the premium papers in this category are made by two distinguished French companies that have engaged in the business of papermaking for several centuries. Arjomari, located at Arches, France, maintains a tradition of excellence that began in the village of Archette in 1492. Factories that were formally established in 1748 continue to manufacture high-quality papers to this day under the brand names of Arches and Rives.

Since 1590 the Lana mill, located in the Lorraine province of France, has been producing fine papers. The mill has prospered for 400 years despite several major wars, and has earned a reputation for making superior cotton rag papers for discerning artists worldwide.

EXAMPLES OF PRINTMAKING AND WATERCOLOR PAPERS

- *Arches Cover* is one of the world's most widely used papers. It is mouldmade from 100-percent cotton fiber rag with a neutral pH.

ARCHES PRINTMAKING PAPERS. Top to bottom: Arches Cover, Arches Cover Black, Arches 88, Arches Text Wove, and Arches MBM.

Cold-pressed with a pronounced grain, Arches Cover is recommended for a variety of printmaking techniques and is popular for drawing as well.

- *Arches Cover Black* is a fine paper similar to Arches Cover in surface and feel. Containing no dyes or colorants, its black color is a result of a chemical reaction begun during the papermaking process. It is particularly suited to chalk, pastel, and crayon.

- *Arches MBM* is another mouldmade paper with a neutral pH. It is 75 percent rag with a laid surface appropriate for pencil, charcoal, and crayon.

- *Arches Text Wove* is mouldmade, pH neutral, and 100 percent rag. The surface has a uniform, unlined finish, and is fairly smooth. Calligraphers use this paper often, as it provides a receptive ground for ink. Pencil and crayon work equally well.

- *Lana Cover,* which is comparable to Arches Cover, is a versatile printmaking and drawing paper. It is mouldmade of 100-percent cotton, acid free, and buffered. The sheets are cold-pressed, giving them a slightly textured surface, and their dimensions are the same as those for Lana Royal Classic (see below).

- *Lana Royal Classic* is mouldmade but seems like a handmade paper. Similar to Rives BFK (see opposite) but with a warmer color, Royal Classic is 100-percent cotton, and acid free. Though this smooth-surfaced sheet is designed for printmaking, many art schools and universities use it for drawing as well. It comes in sheets of 22 × 30 inches (55.88 × 76.2 cm)

and 29 × 41 inches (73.66 × 104.14 cm), both with a crown watermark.

- *Lanaquarelle* is a fine example of a watercolor paper suitable for a number of drawing techniques. It is mouldmade from 100-percent cotton rag and hand-picked one sheet at a time. This process combines the look and feel of a handmade paper with the consistency of a machine-made sheet. Lanaquarelle is popular worldwide for its resilient surface. It can withstand wet lifting, rubbing and scraping. I find Lanaquarelle a useful surface for drawings that begin with an ink wash and then progress through a series of techniques, with lots of erasing and manipulation of tone. It is available in 3 finishes (cold-pressed, hot-pressed, and

LANA PRINTMAKING PAPERS. Top to bottom: Lana Cover, Lana Royal Bright White, and Lana Royal Classic.

LANA WATERCOLOR PAPERS. Top to bottom: Lanaquarelle rough, cold-pressed, and hot-pressed.

RIVES HEAVYWEIGHT (LEFT) AND RIVES BFK (RIGHT) PRINTMAKING PAPERS

STONEHENGE. Top to bottom: Fawn, Gray, and Warm White.

rough) and various weights, in sheets 22×30 inches (55.99×76.2 cm) and 40×60 inches (101.6×152.4 cm) and rolls of 51 inches \times 11 yards (129.54 cm \times 10.06 m).

- *Rives BFK* is a popular printmaking paper used extensively for drawing. Mouldmade from 100 percent rag and pH neutral, its smooth surface complements most drawing techniques. A full sheet of Rives BFK measures 30×44 inches (76.2×111.76 cm) and has 4 deckle edges. It is also available in rolls.
- *Stonehenge*, which is machine-made in the United States by Rising, is a printmaking paper often used for drawing. It is acid free, 100 percent cotton, and has a mild texture. Stonehenge comes in an array of subtle tints and various sheet sizes, from 20×26

inches (50.8×66.04 cm) to 30×44 inches (76.2×111.76 cm). It is also available in rolls (white and natural only) of 50 inches \times 20 yards (127 cm \times 18.28 m) or 50 inches \times 150 yards (127 cm \times 137.16 m).

COLORED PAPERS

The drawing experience need not be limited to black marks on white paper. Working on a colored ground opens up a whole new world of possibilities for expression. Not only does a colored paper contribute an overall mood to the drawing, the colored surface allows an artist to use white pencil, chalk, or crayon to suggest the effects of light in the composition. All the colored papers discussed below are available in sheets of approximately 20×25 inches (50.8×63.5 cm) and in a variety of colors and weights.

EXAMPLES OF COLORED PAPERS

- *Canson Mi-Teintes* is extremely popular worldwide. Composed of 67 percent cotton and 33 percent cellulose pulp, it is machine-made in France by Canson et Montgolfier. Mi-Teintes is a medium-weight sheet with a slightly textured surface. Many pastelists find this an indispensable paper for its wide selection of colors, 51 in all. It is suitable for most dry media, including pencil, crayon, charcoal, chalk, and pastel. It is sold in regular size sheets at 19×25 inches (48.26×63.5 cm), jumbo size at 29×43 inches (73.66×109.22 cm), large rolls at 59 inches \times 11 yards (149.86 cm \times 10.05 m), assorted pads, and mounted on an acid-free fine art board measuring 16×20 inches (40.64×50.8 cm).

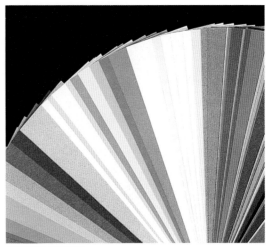

CANSON MI-TEINTES

- *Fabriano Roma* is a prime example of the excellent papers produced by the Fabriano paper mill of Italy, which has been in operation since 1585. Fabriano is world famous for its mouldmade and handmade papers, many of which offer distinctive watermarks and textures. Roma is an acid-free, laid sheet made of 100-percent cotton with four deckle edges. The watermark of Romulus and Remus is large and noticeable, and the chain laid texture is quite pronounced. Available in 8 colors, Roma lends itself to bold drawings that are enhanced by, and not overpowered by, the surface texture of the paper.

- *Ingres*, which today is used to designate any lightweight, laid, colored paper produced by a number of manufacturers, originally referred to a paper named in honor of the artist Jean Auguste Dominique Ingres (1781–1867) that is still made at the Lana paper mill in France. Lana Ingres is an acid-free, lightweight (100 g/m²) paper made of 25 percent cotton rag. Canson Ingres is similar in appearance to Lana Ingres, but is made of 65 percent rag. Fabriano Ingres is an acid-free sulphite paper made in both a regular weight and a heavyweight (160 g/m²) sheet. All Ingres papers are available in about 20 colors with a subtle laid texture on one side and a smooth finish on the other. Ingres papers have been used by generations of artists for charcoal, chalk, and pastel.

- *Ingres Antique* is manufactured in Germany by Hahnemuhle. It is an attractive mouldmade paper of high-alpha cellulose and is produced in 10 subtle colors. It is a superb surface for all dry techniques. Both Ingres and Ingres Antique are moderately priced.

- *La Carte Pastel* was originally formulated for use with pastels, but it is also a superb support for charcoal and chalk. It has a soft, slightly abrasive surface, similar to flocked wallpaper. This texture is the result of finely ground, pH-neutral vegetable fibers applied by hand to an acid-free 200-lb. board. The uniform

FABRIANO ROMA

INGRES PAPERS. Lana (left) and Fabriano (right).

LA CARTE PASTEL (SENNELIER)

MOUCHETÉ

STRATHMORE 500 CHARCOAL PAPER

tooth will hold pigments so well that fixative is rarely necessary. It is fade resistant, sturdy, and archival. Made in France and distributed by Sennelier, La Carte Pastel comes in a range of 14 colors.

- *Moucheté* is a beautiful handmade paper from the Larroque Mill, located in the Bordeaux region of France. The historic mill dates from the 13th century and still employs traditional papermaking techniques. The Moucheté papers are elegant sheets in 14 colors, enhanced with flecks of seeds, oats, or linen. Each sheet is acid free, 100 percent rag, and has four deckle edges. These papers are textural and organic—qualities that discourage delicate ink renderings but serve as a wonderful surface for bold, expressive drawings. The natural character of the paper and the soft but intense colors are an ideal complement for charcoal and white chalk.

- *Strathmore 500 Charcoal* is a versatile drawing paper. This 100-percent cotton fiber paper has a traditional laid pattern with a slightly raised surface ideal for charcoal, soft pencils, pastel, and crayon. Ten colors plus black and white are available. The paper is acid free and comes in standard sheets and spiral-bound pads of various sizes.

VINTAGE PAPERS

For some artists, nothing compares with the experience of working on old paper. Like rare, aged wine, this paper is prized by its owners and reserved for special occasions. Since longevity is a prime consideration when choosing paper anyway, why not work with a sheet that's 10, 20, 50 or 100 years old? Good-quality "aged" papers will not deteriorate if properly stored, and there is an added thrill in working with papers from years gone by. The year of one's birth, or the year of some historical event, can imbue a paper with special, albeit imaginary, character.

EXAMPLES OF VINTAGE PAPERS

- *Bodleian Handmade* is a particularly superb drawing paper with a very slight laid pattern and a cold-pressed finish. For nine generations the J.B. Green family skillfully made papers at the Hayle Mill in England. Though the mill closed permanently in 1987, many of its papers are still available. Sheets of this fine acid-free paper measure 20 × 28 inches (50.8 × 71.12 cm) and feature

four deckle edges. The sheet shown in the photograph below has a 1965 watermark.

- *Whatman papers* were made in England by the Whatman paper mill, which was established in 1740 by James Whatman. His papers were of such high quality that the reputation of the mill (and the "J. Whatman" watermark) were soon heralded throughout Europe. John Constable, J.M.W. Turner, and Winslow Homer were some of the distinguished artists who enjoyed Whatman papers. After 224 years of papermaking, the Whatman mill ceased the production of artists' papers in 1962. Many of their papers can still be found (New York Central Art Supply is a likely source), and the sheet pictured below is handmade, hot-pressed, with a 1956 watermark—the year Don Larsen pitched a perfect game in the World Series. All of the Whatman vintage handmade papers are fully sized with gelatin, making them well suited for ink and fine pencil drawing.
- *Wookey Hole vintage papers* were produced at the Wookey Hole Mill, in Somerset, England, which was founded in 1610. The original mill, which operated until 1972, is now a paper museum owned by Madame Tussaud. One of the notable papermakers to work at Wookey Hole was T. H. Saunders. The paper shown below is a Saunders mouldmade neutral-pH sheet made from 100-percent cotton, hot-pressed with a slightly laid surface. This particular sheet is fairly small, 14 × 16½ inches (35 × 42 cm), and is a warm cream color.

VINTAGE PAPERS. Left, top to bottom: 1965 Bodleian Handmade and 1956 Whatman. Right: Wookey Hole.

TRADITIONAL JAPANESE HANDMADE PAPERS

Japanese paper is unlike any other paper in the world. No other culture has used paper for as many different purposes, and specific papers have been developed for fans, lanterns, room dividers, toys, and artwork. The natural fibers used in Japanese papermaking—kozo, gampi, and mitsumata—are long and slender yet extremely durable, making the finished product one of the thinnest yet strongest papers on the market.

TRADITIONAL JAPANESE HANDMADE PAPERS. Top to bottom: Inomachi, Gampi Torinoko, and Iyo Glazed.

TYPES OF JAPANESE PAPERS

- *Gampi Torinoko* is handmade from 100 percent gampi fibers. Its smooth, hard surface makes it one of the few Japanese papers suitable for Western drawing techniques. It is available in sheets of 20 × 30 inches (50.8 × 76.2 cm).
- *Inomachi* (Japanese for "mother of pearl") is a beautiful silky paper that is handmade from 100 percent kozo (mulberry) fibers. At 180 g/m², this acid-free, 22 × 30 inch (55.88 × 76.2 cm) sheet is heavier than most traditional Japanese papers. For this reason it performs well with a variety of drawing materials. Try a soft lithography crayon or cattle marker. Be prepared to pay a premium price for this high-quality sheet.
- *Iyo Glazed* is an attractive medium-weight (95 g/m²), high-quality paper, handmade from 100-percent sulphite. The 17 × 22 inch (43.18 × 55.88 cm) sheets are rough on one side, smooth on the other. The smooth side works well for most drawing techniques, especially fine art crayon or ink.

INDIAN HANDMADE PAPERS. From top: Straw, Bagasse, Wool, Sea, and Tea.

INDIAN HANDMADE PAPERS

The papers of India are as varied as the culture that produces them. Most suitable for drawing are their simple sheets, which are utilitarian yet expressive. These papers, made by Indian Village, are all acid free and come in 22 × 30 inch (55.88 × 76.2 cm) sheets. They are all made by hand with the simplest of tools. The variety of surfaces and colors are produced by the inclusion of locally available materials such as tea, algae, and wool.

TYPES OF INDIAN PAPERS

- *Indian Tea paper* is made from cotton with tea leaves. It is pale gray with a cold-pressed finish.
- *Indian Wool paper* has fine threads of blue and red wool embedded throughout the sheet. Nonetheless it has a fairly smooth surface.
- *Indian Straw paper* contains small quantities of rice straw scattered throughout the sheet.
- *Indian Sea paper* is made from cotton and dried algae filaments. Its surface is smooth.
- *Indian Bagasse paper* has an attractive tan color due to the inclusion of jute and bagasse (sugar cane fibers) with cotton rag fibers.

OTHER HANDMADE PAPERS

Almost every culture has developed a tradition of handmade papermaking using indigenous materials and simple techniques. Africa, South America, and the Philippines export papers that offer unusual surfaces for drawing. A sampling of international papers is included here, along with an American handmade paper from Indiana noted for its extraordinary edges.

EXAMPLES OF HANDMADE PAPERS

- *Banana paper* is decorative paper from the Philippines. This unusual product is made from banana stalks and other natural fibers. Very thin, it has a pleasant woody aroma and a distinctive texture. It is delicate and will not survive rough scribbling or erasing.
- *Cogon grass paper* is also handmade in the Philippines. Made from 100 percent cogon grass—a strong natural fiber native to Southeast Asia and used especially for thatching—which is collected with the simplest hand tools, pulped in wooden mortars, and dried in the sun. This paper is acid free and has a warm straw color. It is available in sheets of 20 × 25 inches (50.8 × 63.5 cm).
- *Mexican bark paper* is produced by the Otomi Indians of Mexico from indigenous tree bark. It is made today as it was in pre-Columbian times, the result of the oldest papermaking technology found in the Western hemisphere. Bark paper is inappropriate for delicate pencil drawings, but works nicely for ink and crayon.
- *Papyrus* is the oldest paperlike drawing surface known, dating back at least 5,000 years. In fact, the very word "paper" is derived from its name. The papyrus shown on page 52 is made in Egypt from selected reeds that are thinly sliced, pounded flat, and soaked in water. Several layers are then pressed together at right angles and left to dry in the sun. Since papyrus is made by hand with the most basic of equipment, there are great

OTHER HANDMADE PAPERS. From top: Banana, Cogon grass, and Mexican bark.

variations in sheet color, size and texture. It is certainly less uniform than the machine-made paper so prevalent today, but that is precisely its charm.

- *Twinrocker White Feather* is a unique handmade paper. Made in rural Indiana by Twinrocker, White Feather is 100-percent cotton, acid free, and buffered. Much of its unusual beauty comes from the airy, feathery border created by its exaggerated deckle edges, which can extend up to an inch beyond the body of the paper. These are delicate papers that cannot withstand much erasure, rubbing, or scraping, though they are certainly stable if handled with reasonable care. You will want to "float-frame" drawings so the expressive edges of the paper are visible. Twinrocker papers come in a variety of colors and irregular shapes, including circles, hearts, and folded note cards.

EGYPTIAN PAPYRUS

TWINROCKER WHITE FEATHER

SPECIALTY PAPERS AND BOARDS

Many artists prefer to work on a rigid surface, and certain energetic techniques demand a more substantial support than paper. The following specialty papers and boards provide a receptive surface for a multitude of drawing techniques. They remain dimensionally stable throughout the working process, and can be framed with minimal backing material.

EXAMPLES OF SPECIALTY PAPERS AND BOARDS

- *Daniel Smith Multimedia Artboard,* also known as "Non-buckling Painting Board," is a stiff heavy paper saturated with epoxy resin, which protects the paper fibers from the rotting action of oil paint. It comes in standard-weight (white) and lightweight (ochre). It is extremely durable, though the standard weight is somewhat brittle and cannot be folded or rolled. The lightweight version is more flexible, similar to 2-ply bristol board. Multimedia Artboard requires no surface preparation and accepts a variety of media, including pencil, ink, oil, acrylic, and encaustic. I find it works particularly well with less delicate media, such as crayon, oil pastel, and oil stick. The lightweight sheet measures 18×24 inches (45.72×60.96 cm), while the standard is available in several sizes, from 8×10 inches (20.32×25.4 cm) to 30×40 inches (76.2×101.6 cm).
- *Letramax 4000 Illustration Board* is a premium acid-free illustration board made by Letraset. It is bright white, hot-pressed with a smooth surface designed for inking. Letramax 4000 is responsive and easy to rework, and is available up to 30×40 inches (76.2×101.6 cm).
- *Multimedia Artboard* by AHC is essentially the same as the Daniel Smith product. It is a neutral-pH, non-buckling board made of resin-impregnated cellulose fibers. Its sheet is 0.025 inches thick, like the Daniel Smith standard weight.
- *Museum board* is the generic name for a product manufactured by various companies such as Strathmore and Rising. Each is 100-percent rag and has a neutral pH. Museum board is intended for archival matting and mounting, but I think it has a fantastic surface for drawing. It is soft enough to permit deep dark pencil tones, and smooth enough to allow erasure and manipulation of lines. The board comes in 2-, 4-, and 8-ply thicknesses, with sizes up to 40×60 inches (101.6×152.4 cm).

SPECIALTY PAPERS AND BOARDS. Top to bottom: Museum board, Daniel Smith Multimedia Artboard (in white and tan), Letramax 4000 Illustration Board, and Strathmore 500 Illustration Board.

Since many drawings are matted and framed when complete, working on museum board offers another advantage. Not only is the material archival, it is also possible to match the color of the mat precisely to the color of the drawing surface. After cutting mats, I often use the center scraps of museum board for drawing, especially for outdoor work. The rigid board is unaffected by most wind, and no backing support or drawing board is needed.

- *Strathmore 500 Illustration Board* is made from acid-free, 100-percent cotton fiber paper that has been mounted on both sides of a high-quality white board. Mounting the paper on both sides creates an even tension between the two surfaces and thereby prevents warping. The hot-pressed board is smooth and will support the finest ink lines, while the cold-pressed surface has a slight tooth which is receptive to pencil, charcoal, and even pastel. These boards come in a variety of sizes up to 30 × 40 inches (76.2 × 101.6 cm), and are available in 10-ply (0.035 inches thick) or 24-ply (0.080 inches thick).

PAPERS AND FILMS FOR INK

Pencil, charcoal, and to some degree crayon, leave their marks on paper by an act of abrasion; that is, dry particles of the marking device are rubbed off onto the surface of the paper. A slightly rough or "toothy" paper helps to hold the particles and thus retain the mark. Ink is different: It flows onto paper wet, and then dries in place. While a toothy paper works fine for ink applied with a brush or dip pen, a smooth surface provides better results when using a delicate technical or fountain pen.

EXAMPLES OF PAPERS AND FILMS FOR INK

- *Canson Vidalon Pads* of smooth tracing vellum are machine-made in France by Canson et Montgolfier. The naturally transparent paper is strong and erases well. It is receptive to ink, markers, and pencil. The heavyweight (90 g/m²) is the most popular weight.
- *Dura-lene Ink Film*, manufactured by Seth Cole, is a synthetic paperlike film with a matte finish that accepts most drawing media. Dura-lene is made of an anti-static material with high dimensional stability that will not discolor with age. It is much stronger than vellum and can handle both water and solvents, yet accepts the finest ink line with fidelity.
- *Pearl Clear Acetate Pad* consists of 25 sheets of high-quality transparent film (5 mil thick) intended primarily for inking. It also accepts certain wax- or grease-based crayons and is useful for overlays or for overhead projections.
- *Pearl Marker Layout Pad* is a 100-percent rag graphic marker sketchpad. Each sheet is semi-transparent for tracing and visualizing while strong enough to avoid wrinkling from marker solvents. The underside of the paper is coated with a barrier to prevent ink from bleeding through to the next page.
- *Sax Pen & Ink Paper* is an inexpensive 100-percent sulphite paper. It is bright white, heavy, and has a smooth ledger surface that prevents feathering of ink lines.

PAPERS AND FILMS FOR INK. Top to bottom: Pearl Marker Layout, Pearl Clear Acetate, Dura-lene Ink Film, Sax Pen & Ink paper, and Canson Vidalon pad.

SILVERPOINT AND SCRATCHBOARD

Two distant cousins of pen-and-ink drawing are silverpoint and scratchboard. Silverpoint produces a delicate line by marking a coated board or paper with silver wire. The scratchboard technique employs a sharp tool to scratch white lines into a surface coating of dried ink.

SILVERPOINT

Artists were drawing with metal points on a variety of surfaces long before the introduction of the graphite pencil. Over the centuries, silver has proven to be the most satisfactory material to use for this type of drawing. A sturdy silver wire is inserted into some sort of handle (I find that a lead holder works perfectly) and filed to a sharp point. Silverpoint's initial line of gray, whose density is akin to that of a hard pencil, oxidizes to a warm gray brown with the passing of time. The drawing is made on a coated heavy paper or a panel coated with gesso. Tone is built up by cross-hatching or by grouping small marks close together. Silverpoint cannot be erased, so planning or preliminary sketching is helpful. If you like to systematically develop an image and render it with skill and control, try silverpoint. It can provide you with a drawing of exquisite sensitivity.

EXAMPLES OF COATED PAPERS FOR SILVERPOINT

- *Baroque Claycote* is an American machine-made paper available in sheets or pads. It is ivory colored with a fine clay coating.
- *Karma Claycoat* is a bright white acid-free paper with a smooth finish ideal for pencil, pen, and silverpoint. The clay coating provides an excellent surface for rendering precise detail.

SCRATCHBOARD

The scratchboard technique was devised in Austria in 1863 as a means of creating high-contrast black-and-white images for reproduction. The vast majority of book, magazine, and newspaper illustrations had previously been printed from wood engravings, which were expensive to produce, and scratchboard provided an economical alternative. Unfortunately, since this technique has been so closely associated with commercial illustration, artists have seldom considered it to be a "serious" medium. Nonetheless, scratchboard has a number of attributes that commend it as a fine-arts medium.

A sheet of scratchboard consists of a layer of cardboard heavily coated with white clay. India ink is brushed onto the surface, allowed to dry, and scratched through to reveal the white layer underneath. Scratchboard is available in different weights, and comes either pre-inked in black or uninked. If your image is primarily dark, use the pre-inked board; if white predominates, the uninked surface allows you to brush on ink only where you need it, thus avoiding the tedious process of removing black ink where a large white area is planned. A preliminary drawing can be transferred to the black scratchboard surface by coating the back of the drawing with white

SILVERPOINT WIRE IN STAEDTLER LEAD HOLDER

SCRATCHBOARD TOOLS. Left to right: nut pick, scratcher, dental picks, scratch points and pen holder, and twisted etching scribe.

COATED SURFACES FOR SILVERPOINT AND SCRATCHBOARD. Top to bottom: Baroque Claycote, Claybord, Essdee Scraperboard (uninked), Paris Scratchboard (inked), and Karma Claycoat.

chalk and tracing its lines with a pencil. White or yellow Saral Transfer Paper (see page 60) also works well for this purpose. Mistakes can easily be corrected by just brushing on more India ink, allowing it to dry, and reworking it.

Just about anything works as a scratching tool: pocket knives, kitchen items such as ice or nut picks, pins, printmaking and dentistry tools, and, of course, traditional scratchboard nibs. An all-purpose scratch knife, such as the Hunt No. 112, has a triangular blade designed for fine lines. The No. 113 has a point for fine lines and a curved blade for broader marks. Flat nibs and round nibs will fit in most standard pen holders. Made of a durable steel alloy, a scratcher is a practical addition to your supply kit. Seven different points can produce a variety of scratches, from a single line to a multi-grooved set of parallel lines $^5/_8$ inch (1.59 cm) wide.

EXAMPLES OF COATED SUPPORTS FOR SCRATCHBOARD

- *Claybord* consists of a thin, mineral-coated, pH-neutral clay surface on a rigid hardboard (such as $^1/_8$-inch [0.32-cm] Masonite) that will accept all media from pencil to oils. The non-yellowing surface has been lightly abraded to a fine-tooth matte finish that is extremely durable and requires no surface preparation. Claybord can be moistened and dried repeatedly without warping and is truly erasable. It can be scoured and scraped without damaging the coating. Claybord can also be used as traditional scratchboard. Simply apply any pigment to the board and, when dry, scratch through it to expose the white surface beneath. Also, by using 0000 grade steel wool, an artist can gradually remove surface color, maintaining absolute control of tonal relationships.

- *Essdee Scraperboard*, made in England, is considered the standard of excellence in commercial boards. The smooth clay-coated cardstock permits intricate scratch designs and textures with any scratchboard tool. It comes pre-inked (black) or un-inked (white) in a 12-point thickness, in 12×19 inch (30.48×48.26 cm) and 19×24 inch (48.26×60.96 cm) dimensions.

- *Paris Scratchboard* consists of a rigid, nonwarping board base with a heavy clay coating that comes white or pre-inked black. The stiff 40-point board can be purchased in two sizes: $12^3/_4 \times 19^1/_2$ inches (32.39×49.53 cm) or $19^1/_2 \times 25^1/_2$ inches (32.39×64.77 cm).

TOOLS AND SUPPLIES

Although the two absolute requirements for drawing are a mark-making tool and a surface to receive the mark, there is a myriad of useful supplies available for modifying the mark, the surface, or the tool. These are the supplementary materials that make the process of drawing more efficient and more enjoyable. This section concludes with a discussion of unorthodox tools often used creatively by artists, as well as a brief look at technological advances that apply to the world of drawing.

SHARPENERS

There are many excellent machines and devices on the market that make the task of pencil-sharpening easier (and perhaps more entertaining). Nonetheless, there is nothing like a hand-sharpened pencil point. There is no single method for sharpening a pencil by hand, but just as an artist may prefer to work in a particular medium or technique, some have their favorite ways of sharpening their pencils. See "Sharpening a Pencil by Hand," below, for my method.

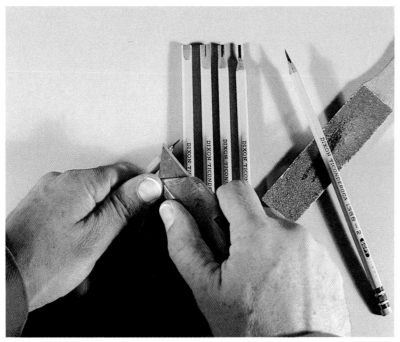

Sharpening a Pencil by Hand. *First remove about ³/₄ inch (1.9 cm) of wood with a sharp knife. I use a mat knife with a retractable blade and supply the force with my thumbs. I cut away the wood on all sides, gradually tapering to a point and exposing about ³/₈ inch (0.95 cm) of the graphite rod. Next, using a sanding pad (or a rock if necessary) I gently point the lead. Rotate the pencil for a conical shape, or rub back and forth in one spot to create a chisel point.*

TYPES OF SHARPENERS

- *Art knife blades or single-edge razor blades* are popular tools for sharpening pencils. The blades are small, inexpensive, and very sharp. If you keep them loose in your pencil box, cover their sharp edges. I like to use a mat knife with a retractable blade. I hold the pencil in my left hand and the knife in my right, but I supply the power and control with my left thumb.

- *Battery-operated sharpeners* offer the ease of electric sharpeners (see below) with the added convenience of portability. I use a Panasonic KP-2A, which runs on 2 AA-size batteries. Jack Beal once showed me a trick he uses to sharpen pastel pencils with this machine. Since fresh batteries make the sharpener so enthusiastic that it tends to break off the pastel tips, Jack uses old batteries that are weak, or rechargeable batteries without a complete charge. The sharpener is much gentler as a result, and sharpens pastel pencils with a minimum of breakage.

- *Electric sharpeners* make precise pencil points quickly and neatly. My Hunt-Boston Heavy Duty #41 is designed to withstand a lifetime of heavy use. Its powerful motor has a thermal overload function that automatically shuts off the motor if overheating occurs. Two rotary cutters provide 30 steel cutting edges, and the cutting action stops once a point has been made. There is an adjustable pencil guide that permits sharpening pencils of different sizes. Even if you're a confirmed knife-sharpener, if you place the #41 next to your drawing table it may soon become a good friend.

- *Hand-held sharpeners* have a single blade; the cut is made by rotating the pencil in the sharpening slot. They are small enough to fit in your pocket when you are out in the field, but a small knife works just as well—and can be used to slice an apple, too.

- *Lead pointers* are small sharpeners made to shape the points of leads held in drafting pencils or lead holders. Pointers are produced in a variety of configurations: a standard rotary design, an electric model, and even a lilliputian hand-held plastic version.

- *Mechanical or crank-model sharpeners* have been familiar objects in classrooms and offices for decades. They can be wall- or desk-mounted, and some even have a vacuum-mount base for temporary installation on any smooth

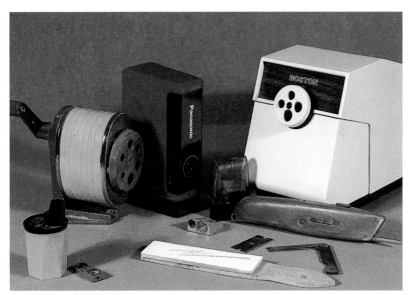

SHARPENERS. Clockwise from left: lead pointers, crank sharpener, battery-operated, hand-held, electric, blades, and sandpaper block.

horizontal surface. The cutting action is rotary, and a pencil opening guide allows you to sharpen pencils of all sizes.

- *Sandpaper blocks* are little pads of sandpaper that are fastened to a small flat handle. They help complete the procedure of hand-sharpening and are convenient for touching up points between sharpenings or for giving your pencil points a custom shape. When the sandpaper becomes too encrusted to use, just peel off the top sheet to expose a fresh piece of sandpaper underneath. An emery board makes a reasonable substitute.

ERASERS

From time to time I hear a student repeat advice received previously: "Never use an eraser!" To this I must reply: "Nuts." Opinion varies widely on the subject of erasers. Some believe that the use of an eraser hampers the development of an artist's skill. Rubbing out a line, changing it, rubbing it out again, over and over, does not support the learning process, and focuses instead on the negative aspect of "correcting a mistake." Nor is it wise to fixate on fastidiousness and correctness to the detriment of kinetic rhythm, the organic evolution of an image, happy accidents, and improvisation.

But an eraser is far more than a utensil for correction and cleanup. It adds enormously to an artist's potential for mark-making. Don't let some "rule" remove the erasers from your pencil box. True, an eraser deletes mistakes,

but it is also a powerful drawing tool for creating light marks, softening lines, and modifying tone.

TYPES OF ERASERS

- *Art gum erasers* disintegrate as they gently abrade the graphite away from the paper, but leave a lot of crumbs in the process. You must be careful when removing these crumbs or you might smear part of your drawing. Try using a soft brush to wipe away the debris, although I find it easier just to use another type of eraser.
- *Bread*—yes, bread—is what artists used before vinyl, kneaded, and electric erasers were invented. Next time you tear open a baguette to enjoy with your pâté, wine, and cheese, rub some soft, doughy bread into a ball and use it to remove lines in a pencil or charcoal drawing. Apparently bread was commonly used in this manner at the French Academy. But even in Paris it seems a shame to waste good French bread. I suggest you eat the bread and use a kneaded eraser (see below) on your drawings.
- *Electric erasers* provide artists with a different kind of erasing tool. I recommend the Sakura Electric Eraser, which, unlike its bulky predecessors, is compact and battery-operated. There is no annoying power cord to fuss with, and the whole unit weighs only 2.4 ounces, including the batteries. It fits in the hand like a fat ballpoint pen, and starts with just the light touch of a button. The Sakura was not designed for heavy use (batteries don't last forever, and the replaceable eraser points are small), but if used sparingly it's a gem. For artists with substantial erasing needs, there are larger models that run on AC power. These use standard 7-inch (17.78-cm) erasing strips, available in 11 different types.
- *Erasing shields* are made of thin stainless steel with cutout openings of various sizes and shapes through which you can selectively erase small or confined areas. They are a must with an electric eraser, and I use one whenever I need to make precision erasures. I also use a regular index card as a template for erasing straight edges, or cut curved shapes along the edge of a card for a curved template (a manila folder works well for shapes up to 1 foot wide).
- *Kneaded erasers* are my personal favorites. These puttylike erasers can be molded into any shape, from a fine point for picking out

details to a big flat blob for lightening tonal areas. They are soft and nonabrasive, so papers are seldom damaged by their use. The basic principle involved in using a kneaded eraser is that it picks up graphite and charcoal rather than rubs the tone off paper. This eventually soils the eraser's exterior, which merely needs to be stretched and kneaded with your fingers to present a clean surface. Incidentally, you will want to wash your hands from time to time, since the act of kneading transfers some of the graphite to your fingers. Also remember to wash your hands after eating greasy foods like pizza, as any oils on your fingers will be picked up by the eraser and transferred to your paper.

- *Pencil-shaped erasers* come in two forms: paper-wrapped eraser pencils and retractable erasing strips that come in a special holder. Each allows you to erase as though holding a pencil. Of all these I prefer the Nocks (by Sakura) or the Tikky (by Rotring). Essentially the same, they both contain a 7-mm erasing strip that is advanced by pushing a button. Their pencil shape provides good control for erasing, drawing, and smearing.
- *Pink Pearl erasers* (and those little arrowhead erasers for the ends of pencils) are much firmer than kneaded erasers. They are general-purpose erasers that work especially well for graphite. I have a friend who sharpens her Pink Pearl to a point with a bread knife. This enables her to draw/erase fine lines such as

grasses and twigs. Although a kneaded eraser can be pinched to a point for this purpose, a sharpened pink eraser is more rigid.
- *Vinyl or plastic erasers* were designed for vellum or drafting film but work fine on paper too. Some are even saturated with erasing fluid, or "imbibed," to chemically dissolve ink from drafting film without damaging the surface. Vinyl erasers do not absorb the natural oils from your hands, and for some this is a real bonus.

 Vinyl erasers are also less abrasive than the pinks, and consequently don't pick up graphite quite as fast. In most cases this makes little difference. However, when a drawing has a very dark passage that is suffused with graphite or charcoal, vinyl will become coated after a few swipes. Wipe off the eraser if you wish to erase cleanly; leave it alone if you wish to smear. A dirty vinyl eraser will push the graphite around, dragging dark marks into blank areas of paper. I enjoy this effect and use it often. Perhaps I use vinyl erasers as "smearers" as much as anything else. There are variations from brand to brand. Koh-I-Noor, for instance, makes a "soft vinyl" pencil eraser that works very well. Eberhard Faber's Design 2000 plastic eraser, which is firmer, doesn't erase as well but makes a great smearer.

BLENDING TOOLS

There are several ways to soften edges, and if done sparingly, blending can unify a composition and breathe life into a drawing. Regardless of the tool you use, avoid the temptation to overblend, as this will make an image look dreary.

Lots of readily available materials can be used to blend and soften an image, or to move charcoal around on the paper. The fingers and the heel of your hand should not be overlooked as tools for softening tone. Of course you'll get dirty, but so what? The hand should be part of an artist's natural repertoire of techniques, particularly for those who work in charcoal. Kleenex and paper towels will work, although they leave paper crumbs. Cotton balls and swabs are useful for small areas, and rags work well too. A soft glove functions like a rag that fits on your hand.

TYPES OF BLENDING TOOLS

- *Chamois* (pronounced SHAMMY) is the name of a soft, pliant leather made from sheepskin or the skin of the chamois, which is a small, goatlike antelope. A chamois skin is an excellent blending tool, especially for charcoal.

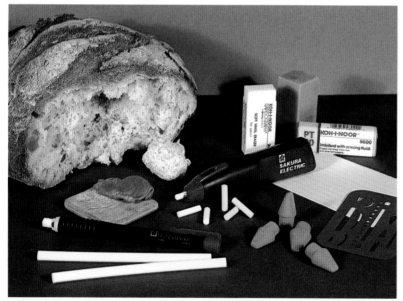

ERASERS. Bread, kneaded eraser, Nocks pencil-style eraser (with refills), Sakura battery-powered (with refills), arrowhead erasers, vinyl eraser, art gum eraser, imbibed eraser, erasing shield, and index card.

BLENDING TOOLS. Left to right: chamois, paper stump, tortillons, and hand.

It can create a variety of very soft tones, and almost functions as an eraser. When a chamois gets dirty it can simply be washed in warm soapy water.

- *Lint-free cotton wipes*, such as Webril Wipes, which are designed for printmaking, have superior wet strength. Try them for rubbing powdered graphite onto paper.
- *Paper stumps* are made of tightly wound soft paper. Pointed at both ends, they are about 5 inches (12.7 cm) long and range from $1/4$ to $1/2$ inch (0.64 to 1.27 cm) in diameter. When rubbed into graphite or charcoal, they pick up a bit of the tone and smear it into areas of blank paper. This allows the artist to make subtle adjustments to the quality of the tone, either clarifying a form or making an edge less distinct.
- *Tortillons* (pronounced tor-TEE-yuns) are similar to paper stumps. They are made of spiral wound paper with one pointed end and one flat end. When they get too soiled they can be "cleaned" by sanding the tone off their point. This will make the tip a bit furry, but you can usually rub it back to a good point.

DRAWING AND DRAFTING ACCESSORIES

The office supplies used by professional drafters are valuable aids to those who draw freehand as well. Other supplies, such as fixatives, transfer paper, and tape, can be extremely useful in developing an image. Some supplies, such as masking fluid or liquid frisket, are borrowed from a watercolorist's toolbox but are right at home when used to create ink drawings.

TYPES OF DRAWING AND DRAFTING ACCESSORIES

- *Artist's bridges* help keep your drawings free from smears and smudges, one of an artist's chief concerns. If your hand rubs across a portion of the design as you work, you might smear the image. These inch-high horizontal platforms on which you rest your hand and arm can be made simply and easily out of scrap lumber. Transparent plastic or lucite bridges, which give you a greater view of the overall composition while you work on a small area, can be ordered from art supply catalogs. You can also protect your drawing by positioning a sheet of scrap paper beneath your hand. I usually fold up one corner of the scrap to use as a little handle when I need to move it around.
- *Cookies* fall into the category of treating yourself nicely. Drawing is a mysterious activity. It is important to know about materials and techniques, but it is equally important to relax and let the magic happen. It's serious business, but don't get too serious. Have a cookie. Now get back to work. Use a draftsman's duster for the crumbs.

 Incidentally, I've discovered that if you put Fig Newtons in the freezer, they don't freeze solid. They get nice and *chewy*.
- *Draftsman's duster* quickly whisks away eraser crumbs without smearing or smudging drawings. If you try to blow crumbs away, you run the risk of spitting on your drawing, and if you wipe them away with your hand you might very well smear it.
- *Fixative* is used to preserve or isolate a layer of a drawing before completing work on a design, or to protect a drawing that might be smudged if it is rubbed or carelessly handled.

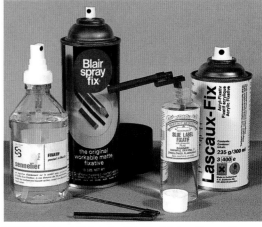

FIXATIVES. Left to right: Sennelier, Blair, Blue Label, and Lascaux-Fix.

Traditionally artists used a liquid formula of alcohol and shellac, applying it to a drawing with the aid of a mouth-operated atomizer. Today the same formula comes in pressurized spray cans and plastic pump sprayers that are much easier to use. Acrylic-resin fixatives that are waterproof, lightfast, and dry clear are also available. Although glossy "permanent" fixatives are available, I find that quick-drying, matte-finish "workable" fixatives are the most useful. They prevent a drawing from smudging while providing a receptive surface for subsequent layers of pencil, charcoal, or pastel.

- *Foam pencil grips*, which help to reduce finger fatigue, have made their way onto many of my pens and pencils. They come in assorted colors, which can be used as a coding system to instantly identify pencils of various hardnesses.

- *Masking fluid or liquid frisket* is a solution of ammonia and natural rubber latex that is primarily used by watercolorists, but also works well with ink wash drawings. Apply it with a brush or a pen, let dry, then lay down a wash on top of the design. Remove the mask by rubbing it with your finger or an eraser. The areas that were covered by the masking fluid will be unaffected by the wash.

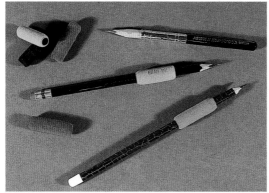

PENCIL LENGTHENER AND PENCIL GRIPS

- *Pencil lengtheners* enable you to use your favorite pencils right down to the stump. The holder by Koh-I-Noor features a nickel-plated ferrule with a sliding ring that adjusts to hold round or hexagonal pencils, providing a good grip and improved balance. Look for homemade substitutes too. I have a few caps from old discarded pens that are a perfect fit for pencil stubs.

- *Tape* can serve many uses, from holding your paper to the drawing board to masking out shapes within a drawing. Drafting tape, which

DRAWING ACCESSORIES. Clockwise from left: Saral Transfer Paper, masking fluid, draftsman's duster, drafting tape, artist's tape, artist's bridge, scrap paper, and cookies.

comes on a 3-inch (7.62-cm) cardboard spool, resembles ordinary masking tape but has a gentler adhesive that won't damage paper. Artist's tape, which also comes on a 3-inch core, is generally white, opaque, and acid free. It can be used for holding down artwork, masking, or framing, and is easy to write on. It is specially designed to adhere well, yet it peels off easily without tearing paper or leaving a residue.

- *Transfer paper* is used to duplicate all or part of a drawing onto another surface or to incorporate several sketches into one composition by means of a tracing. Saral Transfer Paper, a wax-free paper coated on one side with graphite, can be used like carbon paper to transfer a design. The lines that result are not greasy and can be completely erased or inked over. Saral paper comes in a 12-inch × 12-foot (30.48-cm × 3.66-m) roll, and is available in black, white, red, blue, and yellow.

 You can make your own transfer paper by rubbing a graphite stick or soft graphite pencil on a piece of paper. Place your prepared sheet, graphite side down, on top of another sheet of paper, then place your original sketch on top. Trace over the lines of your sketch and the image will be transferred to the sheet of paper beneath.

CREATIVE ALTERNATIVES

Artists have always been an inventive group, invariably and irreverently exploiting anything and everything they can get their paint-spattered hands on. While traditional uses of time-honored materials are well worth understanding, sometimes the window of creativity opens a bit wider when experimentation with materials is given free reign, allowing the imaginative person to appropriate familiar materials for unconventional uses.

Good improvised music relies both on a player's mastery of an instrument, and on his or her flexibility and ability to cope with the unexpected. A flexible attitude toward drawing is one that is open to spatial improvisation but also open to unorthodox applications. Creative drawing is "visual thinking," and it need not be confined to pencil on paper. As we continue our creative growth we should be prepared to step aside from expected patterns. Try new techniques, new tools. Try old tools in a new way. Experimentation will not necessarily produce good drawings, but a new tool will often help you break old habits. You will need to use your hands differently, and frequently that enables you to use your mind differently as well.

Technique is not "style." It is merely the method for completing an idea. Consequently, we should create techniques of our own that will best express our individual ideas. All materials, both new and old, have their place. The following are a few unexpected materials to consider. It is a deliberately short list so that it can easily be expanded. Keep in mind that everything is fair game. See that stick outside your back door? Pick it up, sharpen it, and dip it in ink. See that sock on the floor . . . ?

EXAMPLES OF CREATIVELY USED MATERIALS

- *Coffee sticks* are wonderful drawing tools. These wooden stirring sticks are more supple than popsickle sticks and porous enough to hold ink nicely. Dip them in water for a few minutes if you want a more flexible stick.
- *Eyedroppers* can be filled with ink, water, or solvent, and used to dribble little splotches and drips on your drawings. Although the goal is usually to avoid splotches, every once in a while this special effect provides just the right accent.
- *Solvents* like turpentine or lighter fluid can be used in a number of ways. A solvent breaks down pigments and binders into a fluid state, allowing mixing and blending. A pencil line altered by turpentine, for example, is blacker than a dry line. Another use for solvents is the "solvent transfer technique." Dampen a newspaper or magazine page with lighter fluid, place it face down on a piece of drawing paper, and rub the back of the magazine page with the bowl of a spoon. The solvent dissolves the ink on the source paper, and the rubbing transfers the image to the drawing paper. The strokes of your spoon will be somewhat visible, revealing your own "handwriting." Use the transferred image as a starting point to begin a drawing.

- *Spray guns and airbrush* use compressed air to apply a fine spray of paint or ink to a surface. Although invented in the late 19th century and customarily used to create elaborate illustrations of fluid color, airbrush has only recently been adopted by artists as a drawing tool. With the new 0.18 mm needles that are now available, it is possible to get a micro-thin line with no overspray. In fact, an airbrush line can look just like a fine pencil line, and airbrush is often used to make preliminary outlines that are subsequently filled in with traditional airbrush coloration. With its capacity for subtle gradation in tone, the airbrush is quite a flexible medium, equally at home spraying large backgrounds of color or finely articulated line drawings.
- *Tennis balls* are like giant felt-tip pens. Dip the tennis ball into a saucer of India ink and work on large paper. The shape and size of this "marker" forces your arm into making large movements with almost dancelike rhythms. Also, try dipping a gloved finger into the ink. It won't really keep your fingers clean, but the glove will hold more ink than your skin. For an interesting variation, use an ink stamp pad. Poke your fingers into the pad and make "thumbprint" drawings.
- *Toothbrushes* have been used for years by artists for a spatter technique. Dip the tip of the brush into ink or paint and then scrape a knife, stick, or finger across the bristles. They will spring back immediately and flick little drops of pigment on your drawing. Practice on scrap paper first. Used sparingly, this technique can add visual texture to an otherwise flat and static form.

CREATIVELY USED MATERIALS. Clockwise from left: tennis ball, eyedropper, toothbrush, turpentine substitute, and coffee sticks.

DRAWING AND NEW TECHNOLOGY

As I consider the history of art, I am reminded how technological advances have continually provided new products for artists, and how these materials helped shape both the artists and their art. As new materials are invented and marketed, artists embrace them with gusto, often finding creative (sometimes unorthodox) uses. In today's technologically fertile environment, the market is awash in drawing materials of every description, providing the means for every drawing application you can imagine.

But we should not overlook some recent developments of a less-than-traditional drawing character. A survey of contemporary drawing materials would be incomplete without a mention of photocopiers, video cameras, and computers. They are the new tools of this generation, and artists are always quick to usurp new tools for their own creative needs.

XEROGRAPHY

When I first began using a photocopy machine as a drawing tool, the technology was not nearly as sophisticated as it is today. Still, the process was captivating. A drawing is copied by the action of light on a photoconductive surface, and the latent image is developed with a resinous powder or *toner*.

The instant, inexpensive duplication of a design allows you to explore several graphic variations on copies before returning to work on the original drawing. Since some clarity is lost with each succeeding copy generation, you can watch a drawing "mutate" by making copies of copies. It is a good stimulus for investigating form, especially if you draw on each new copy and add to the design.

In the 1980s, color copiers were introduced to the photocopying marketplace. They use four toners—yellow, magenta, cyan blue, and black—from which the entire spectrum can be mixed. In addition, color copiers can alter the image during the copying process. For example, my local photocopy store has a Canon Color Laser Copier 300. It can make black-and-white or color copies on a variety of papers, including transparency film, and it provides all the standard copier functions, such as auto feed, enlarging, and reducing. It can stretch an image along the X or Y axis of an image area, copy an image at an optional slanted angle, or print out multiple images on the same page. You can change the color balance by accentuating or

I put the original drawing (see page 125) into the copier and enlarged the height while reducing the width. The image that resulted is stretched along the vertical axis. It also looks funny the other way, stretched sideways.

A drawing can be slanted when copied, to the right or to the left, at varying rates of pitch. This example is slanted 45 degrees.

When an image is scanned by the laser, the copier determines the quantity of each toner color needed to reproduce the design. In this case I programmed the copier to reverse the colors completely.

weakening any of the four colors, or even reverse the colors in the copy.

A photocopy machine can also be useful as a composing tool. I know artists who will make a laser copy of a painting in progress, or part of a painting, and then cut out portions of the copied design and move the cutouts around on their original painting to evaluate alternate placement of shapes. One friend in particular was curious about the position of a flock of birds in one of her paintings. By cutting out some of the birds in a photocopy of the painting and repositioning them on her original, she was able to visualize a few alternate groupings of the flock. She determined her favorite arrangement with the copied cutouts before returning to her brushes.

VIDEOGRAPHY

One might easily omit a video camera from consideration as a drawing medium. We must remember, however, that one of the definitions of drawing that is central to this book is that it is a process of visual exploration.

A still camera works fine for composing in the viewfinder and for collecting source material. In contrast, a video camera, or camcorder, allows greater convenience and creative possibilities. The "film" is a reusable videotape that you can record on and erase again and again. This eliminates cost consciousness that might otherwise prevent you from shooting anything and everything you see. If you decide to film your refrigerator for two hours, go ahead—you can always record over it later.

Since a video camera makes a continuous recording of 12 frames per second, it can capture evolving images with ease. This recorded motion may be central to your drawing research, since it provides a selection of slightly different still images from which to choose. This also means you won't miss the "perfect" shot, since there will be a number of sequential frames recorded. The viewfinder of a camcorder shows the image in black and white only. This in itself can be a wonderful compositional aid, for it helps clarify value relationships. Another major advantage of the video camera is its ability to record and play back immediately. You needn't wait for photographs to be developed, and improper focus or exposure settings can be identified and corrected instantly.

A video camera is naturally suited for experiments with color balance and exposure. While filming a subject, gradually adjust the controls until the image is abstracted beyond recognition, then slowly readjust the controls to normal. When played back, the tape may suggest a number of interesting graphic concepts. This is an important drawing application of video: the recording of visual data to generate aesthetic ideas.

COMPUTER IMAGING

A computer may be more complicated than a pencil, but it is still just another tool. The art of the computer depends on the creative mind of the person who uses it, just as a pencil has no aesthetic claim without being guided by the hand of an artist. To deny the impact of the computer on drawing today is unrealistic and short-sighted. Your computer will not replace traditional drawing materials, but will take its place alongside charcoal, crayon, and ink.

Every day there seems to be a new advance in computer technology, with graphic programs becoming increasingly sophisticated and easier to use. Although an artist's basic creativity cannot be replaced, computers and their peripheral equipment now offer an abundance of time-saving and thought-provoking features.

You can create a design directly on your computer, or you can scan in a previously drawn image. Any design made with traditional materials can be scanned into a computer, and if you have a video camera, any image on videotape can be fed into a computer as well. The visual information is stored digitally, and is represented as a series of minute dots known as *pixels*. Each pixel is assigned a specific location on the computer screen, or *monitor*. Once in the computer's memory, there is a new world of artistic manipulation awaiting the design. The character of each pixel, or group of pixels, can be easily altered with a simple command. Countless varieties of linear and tonal distortion are at your disposal, along with a multitude of sizes and colors.

One piece of peripheral equipment of special note for drawing enthusiasts is the Wacom Digitizing Tablet. It is a pressure-sensitive electronic tablet upon which you use a cordless, penlike stylus. As you move the stylus on the surface of the tablet—using the same motion as in drawing with a pencil—the path of the stylus is recorded on the monitor. By selecting various line widths or other characteristics (pencil line, brush line, spray paint line, and so forth), you have a wealth of visual effects at your fingertips. If you find drawing with a computer mouse too clumsy (like drawing with a bar of soap), try the Wacom Digitizing Tablet and stylus. It is the most natural way to draw on the computer.

FEBRUARY
Charcoal on museum board, 11 × 8" (28 × 20 cm).
From *Catskill Mountain Drawings* by Richard McDaniel
(1990). Collection of C. David Piña.

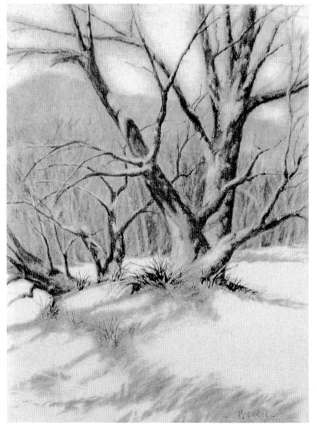

These images present only a sampling of the limitless manipulations possible with a single black-and-white drawing. My original charcoal drawing (above) was scanned into a Macintosh IIfx computer. A list of equipment used to recreate the drawing in digital form includes a Wacom ARTZ Digitizing Tablet, a Radius monitor, a NewGen laser printer, and Adobe Photoshop 3.0 (with plug-in filters). The image after scanning (left), and in the following textures (opposite): "Graphic Pen"; "Crystalize"; "Spatter"; "Pixelwind"; "Poster Edges"; and "Dry Brush." Computer digitizing courtesy of Piña Design.

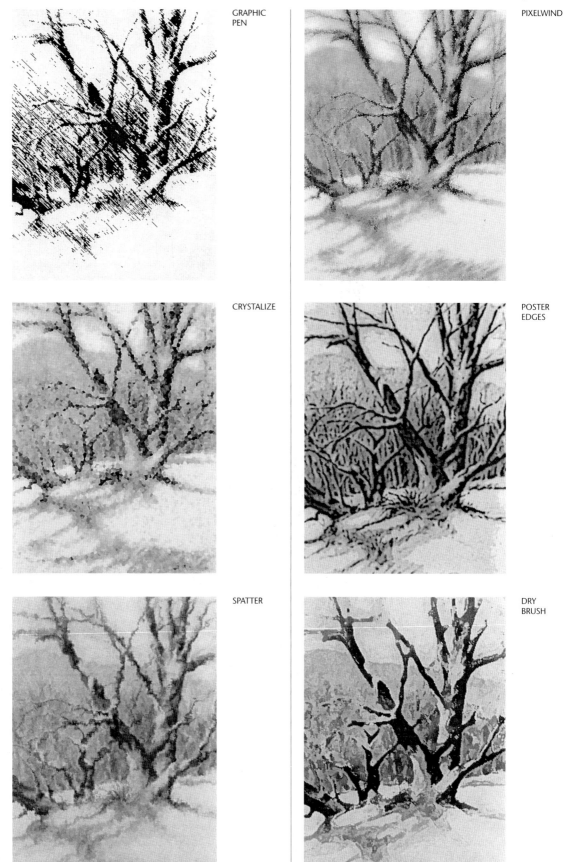

GRAPHIC
PEN

PIXELWIND

CRYSTALIZE

POSTER
EDGES

SPATTER

DRY
BRUSH

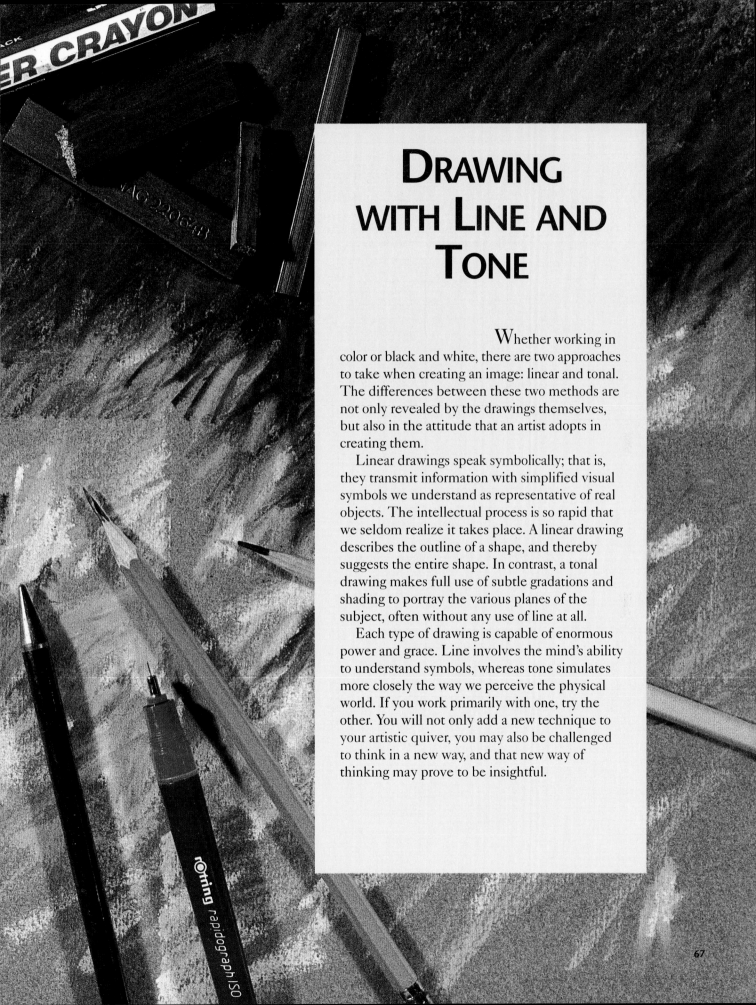

DRAWING WITH LINE AND TONE

Whether working in color or black and white, there are two approaches to take when creating an image: linear and tonal. The differences between these two methods are not only revealed by the drawings themselves, but also in the attitude that an artist adopts in creating them.

Linear drawings speak symbolically; that is, they transmit information with simplified visual symbols we understand as representative of real objects. The intellectual process is so rapid that we seldom realize it takes place. A linear drawing describes the outline of a shape, and thereby suggests the entire shape. In contrast, a tonal drawing makes full use of subtle gradations and shading to portray the various planes of the subject, often without any use of line at all.

Each type of drawing is capable of enormous power and grace. Line involves the mind's ability to understand symbols, whereas tone simulates more closely the way we perceive the physical world. If you work primarily with one, try the other. You will not only add a new technique to your artistic quiver, you may also be challenged to think in a new way, and that new way of thinking may prove to be insightful.

THINKING ON PAPER

For many people, drawing is the means by which they first work through their ideas. Drawings needn't be mere illustrations of visual concepts, but frequently serve as the primary means for discovering and clarifying them. Not all artistic ideas are fully formed at the outset. Many need to evolve on paper before they become clear. Still others don't even come into existence until the process of drawing begins. This is known as "thinking on paper." It is a procedure for exploring concepts, techniques, and imagery that is quick and direct, as well as private, flexible, and inexpensive. Some artists say that the tactile sensation of sketching itself is enough to "get the creative juices flowing." Much of this is due to the visual stimulation of seeing marks that suggest shapes, that in turn suggest compositions.

THE SCRIBBLE, THE SKETCH, AND THE STUDY

The scribble, the sketch, and the study are all handy procedures to know and use. They are especially helpful as preparatory drawing techniques, and for thinking on paper. Never forget that a vital part of the drawing process is the act of searching. Searching leads to discovery, discovery leads to understanding, and understanding leads to mastery.

A *scribble* is wonderfully active and fluid. Often the artist makes no great attempt to accurately describe the material world with a scribble. Rather, these drawings have an intrinsic logic that is not necessarily linked to realism. They grow from within, and can be an abundant source of ideas and images. While a scribble is quick and hasty, a *doodle* is a bit more relaxed, more like wandering around than dashing about.

A scribble, whether hurried or meandering, is remarkably free from the restraints of precise representation. This allows the mind (and hand) to roam at will. Sometimes abstract or nonrepresentational images are discovered in this manner, and at times the chief benefit is that of mental and manual relaxation.

A *sketch* is a compositional drawing that explores the artist's initial creative impulse. Spontaneity and originality are the dominant characteristics of a good sketch. A small version, or *thumbnail sketch*, is an uninhibited drawing in which one can quickly investigate compositional ideas. Within a few moments it is possible to jot down the basic shapes of a design, and in a few moments more it can be tried again, with new variations.

The goal in a sketch is to get the germ of the idea down on paper. Details are not overly important, and can be addressed later. The object is to concentrate upon the feeling of the image, and the overall organization of the composition.

A *study* differs from a sketch in that it is a carefully observed detail rather than a broadly considered whole; it is a slow and deliberate examination of some particular portion of the design. For example, a sketch might be a quick drawing of a baseball player that concentrates on the angle of his stance or the gesture of his swing. It is not precise, but conveys the general action of the athlete's pose. A study, however, might be a close-up rendering of his hands, and how they grip the bat. A study, as the name implies, requires a close scrutiny of the subject.

QUACK, QUACK, QUACK
Pencil on sketchpad,
7 × 12" (18 × 30 cm).
Collection of Woodstock
Historical Society Museum,
Woodstock, New York.

Here, I made a series of rapid line drawings as a duck nonchalantly paraded by. This scribble is not concerned so much with anatomical accuracy, but rather with the whimsical nature of the subject.

THE SEINE AT VERNONNET
Pencil on sketchpad,
5 × 8" (13 × 20 cm).

In this small landscape sketch of the French countryside, I concentrated on a general impression instead of specific details. Sketching enables me to "get acquainted" with the subject visually and allows me to jot down compositional ideas quickly. A sketch also helps trigger my memory of the scene at a later time.

This compositional sketch was hurriedly scrawled on a piece of cardboard with a laundry marker. These few lines are simply a quick recording of the initial idea.

HICKORY STUDY
Pencil on museum board, 9¹/₂ × 8" (24 × 20 cm).
Collection of Fairfield University, Fairfield, Connecticut.

In contrast to a scribble or sketch, this study required a very slow pace as I examined a shagbark hickory tree behind my studio. I sharpened a handful of yellow No. 2 pencils and used them exclusively throughout.

Compositional, or thumbnail, sketches are invaluable when planning a drawing or painting. With just a few strokes, and in just a few seconds, you can capture the salient features of a scene and decide how you want to design the picture. A few strokes more and you have another version. It's a speedy way to test out ideas and become familiar with the subject.

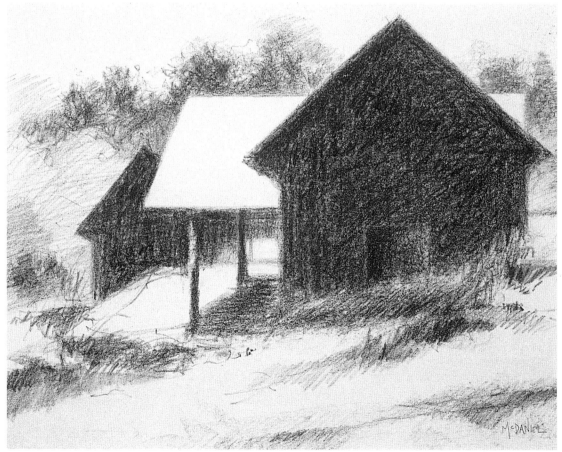

BYRDCLIFFE BARNS
Conté crayon on
sketchbook paper,
8¹/₂ × 11" (22 × 28 cm).

A student in my landscape class was intrigued by these barns but couldn't quite get her painting started. I suggested some exploratory drawing and we each drew a few quick sketches. In so doing I clarified their most striking features, mainly the interplay of light and dark roof shapes. My final drawing (and the student's painting) proceeded easily after this preliminary research.

THE ELOQUENT LINE

There are two formal categories of drawing: linear and tonal. Linear drawings are largely dependent upon symbols. The viewer understands that the lines in the image are merely indications of intersecting planes, suggestions of surface detail, or the exuberant rhythms of expression. The artist draws a simple squiggle and the viewer understands it as a nose. This understanding is based in some measure upon universally accepted symbols for each culture, and also upon the artist's ability to suggest form with line. The line itself would have no descriptive meaning if taken out of context. The squiggle might not represent a nose at all if it were isolated from the other lines that indicate a face.

The personal "handwriting" of every artist is quite evident in a line drawing. The line of Matisse differs from that of Van Gogh. The hand of Picasso is distinct from that of Dürer. The serious Kandinsky defined a line as "the work made by a dot put into motion," while the more playful Klee said a line was "a dot going out for a walk."

LINEAR PENCIL DRAWINGS

Since pencils can make continuous lines with ease, they seem a natural tool for linear drawings. Indeed they are, although another medium frequently associated with line drawings is ink. The line made by a pencil can be eloquent. Graphite is very responsive to variations in pressure; the resultant line can dance and skitter across the paper, or it can rest on the page, solid and passive.

It is wise to develop an arsenal of pencil lines and strokes to use in your work. Practice by drawing lines and changing the force with which you touch lead to paper. Hold the pencil loosely so that only the weight of the pencil causes the mark to be made. Gradually exert more pressure until you achieve a solid black mark. Go ahead and break the pencil point. Now you know what "too hard" is, so don't do it again.

Another extreme to avoid is the tearing or embossing of the paper. Some papers are stronger than others. The goal is to deposit graphite on the paper, but not by pushing so hard as to dent or scratch the drawing surface. It is better to use a softer lead if you need a really dark mark.

A soft pencil (such as a 4B or so) will give you a dark line without much effort, but it requires a very gentle touch to create uniform light tones. On the other hand, clean and consistent light areas are easy to achieve with a harder pencil (like a 4H or so), but very dark lines are impossible.

Pencils of medium hardness, from F to 2B (and the common yellow No. 2), are popular for their ability to easily produce a range of both light and dark lines. Most artists prefer a softer pencil for the bulk of their work, with the periodic use of hard ones for light passages and crisp detail.

As you draw a line, stay conscious of the strength of your grip. Variation in the pressure you use will give the line character and movement. An indication of light falling upon a form can be as simple as employing a very faint line to describe the lighted side of an object and using greater force with the pencil as the line travels to the portion of the form in shadow.

The top line was drawn with a 3B pencil with uniform pressure. It is dead. The line on the bottom was drawn with the same pencil, but with varying pressure. It has life.

Try drawing two circles as if they were the beginnings of oranges. Draw the first circle with even pressure all the way around. For comparison, draw the second circle with barely any force at all to describe the top side of your orange, and push hard at the bottom of the circle to portray the weight and shadow at the bottom of the orange. Although this exercise seems basic it bears repeating, for line variety is one of the best ways to put movement and interest into your artwork.

The circle on the left was drawn with a 3B pencil, with uniform pressure. It is a flat circle and does not suggest mass or spatial orientation. The circle on the right was drawn with the same pencil, but with varying pressure. Just the simple change in line width and density, the result of increased pencil force, helps this form to indicate a sphere with volume, and illumination from above.

There is a world of difference between a line drawn with uniform pressure and one drawn with "touch." If you think in terms of music, it's one thing to get the notes right, but another thing entirely to utilize the dynamics of loud and soft notes. It's not enough just to put the line in the right place; it's also important to consider the *quality* of the line.

In addition to achieving line diversity by varying the pressure of your stroke, try rotating the pencil in your hand as you draw. Graphite is soft, so it wears down as it travels across the paper. Many years ago I learned a drafting trick for maintaining a line of uniform width when drawing against a straightedge. By slowly revolving the pencil while creating a straight line, the conical point of the lead wears down evenly, producing a consistent line. This technique takes a little practice but soon becomes second nature. Of course, pulling the pencil along a straightedge prevents any wavering of the line as you twist the pencil. Freehand, though, the line tends to wobble all over the place. But with some practice, and if used with discretion, this "organic" line can be of great use.

When speaking earlier of the soft "B" pencils, I alluded to the difficulty in keeping them sharp. One way to sustain a point is to rotate the pencil occasionally. This can be done between strokes, when the pencil is lifted up from the drawing surface. I am in the habit of twisting the pencil about a quarter turn every few seconds. It has become automatic, part of my personal drawing rhythm, and it keeps the point sharp a bit longer.

If you prefer a chisel-shaped point on your lead for a broader line (see "Sampler of Pencil Marks," pages 76–77), don't twist the pencil. Instead, keep a scrap of paper or fine sandpaper to the side of your drawing. Every once in a while a little scribble on the scrap paper will touch up your point.

The best (and easiest) advice I can give you on pencil sharpness is this: Before you begin a drawing, sharpen several pencils to the point you desire. Always pay attention to your point, and as soon as it becomes necessary, switch to a new pencil. After you've used up the sharp points on all five pencils, it's time to take a break anyway. Resharpen them and begin again after your cookie.

Far too many drawings have started out clear and decisive, only to deteriorate into vagueness from the continued use of a pencil that has become dull. Stay aware of your pencil's point. If you want a dull point for a soft line, that's another story. But never use a dull point if you really want a sharp one (and vice versa).

Another type of linear drawing results from holding two or three pencils in your hand at once. The parallel lines thus produced reinforce each other visually and exhibit their strongest personality during abrupt changes of direction. These lines may seem playful or suggest movement or afterimages. Different colors or a mixture of media can heighten the effect. Try pencil with ballpoint pen, or charcoal with chalk.

Speaking of playful or unusual lines, consider the use of your opposite hand. If you are right handed, throw that pencil over to your left hand and begin to draw. You will have less control, but your "untrained" hand is also free of some bad drawing habits. You may be surprised at the results. After some practice you may develop a new dexterity with your opposite hand, or you may discover a looseness you wish to adapt to drawing with your dominant hand. Sometimes the mind begins to think in new and creative ways when the hand uses new tools, or uses familiar tools in new ways.

Speed was important in capturing the gestural pose of these deer. Notice the initial searching lines. No real attempt was made at rendering a refined composition; it is a quick contour drawing to gather information about the posture of the animals.

There is no shading in this contour drawing. However, weight and rhythm are indicated by the variations of line width. This is a preliminary drawing for Three Apples, which appears on page 131.

LINEAR INK DRAWINGS

You can create a line with virtually any medium. Historically, however, those artists who specialize in line drawings have repeatedly selected ink as their medium of choice. This is due in part to the solid darkness of an inked line. It stands out clearly on the paper, making it easy to see and easy to reproduce. Once dry, ink does not smear like pencil or charcoal. A crisp dark line stays that way.

The appeal of linear ink drawing lies in its distilled simplicity. You must evaluate the form and reduce it to its most essential components. This intellectual filtering process goes hand in hand with your skill in drawing the line—not just any line, but the right line, without the complications of tone or color.

The character of an ink line varies considerably: from thick to thin, fuzzy to clear, or sloppy to precise. It may be continuous and uniform, as that produced by a technical pen, or sketchy and erratic. It may also be broken, fluid, sweeping, agitated or placid.

Practice, patience, skill, and discipline are the requirements for successful line drawing in ink. A meandering line is effective for some drawings, but in most other cases linear ink drawing requires a bold and confident touch. Each stroke should be right the first time. Seldom is it worthwhile to make corrections. They disrupt the natural rhythm of your hand, alter the creative flow, and much of the time the corrections are obvious. Of course there are exceptions when judicious editing is the answer, but it is usually a better use of your time to begin again rather than fuss over an early slip of the pen.

TROOPER
India ink on Rives BFK paper, 12 × 20" (30 × 50 cm).

This is an example of a line drawing in which the only indication of tone is due to the closeness of lines in a few areas (such as the foliage and the grille of the truck). No attempt was made to render shading or dense tonal mass, yet the vehicle is recognizable as a three-dimensional form.

HOUSEPLANT
Penstix on Arches 88 paper, 22 × 17" (56 × 43 cm).

Arches 88 is an absorbent paper, so the ink tends to bleed out from the pen stroke ever so slightly. The tendency for the ink to bleed into the paper by capillary action is a trait that can be used to great advantage if you so desire. With certain papers the effect can be extreme, so make a test stroke in the margin before you begin. Although ink bleed is hardly noticeable here, it does soften the line in this image.

THE VALUE OF VALUE

Value is the term used by most visual artists to denote degrees of light and dark. White under full illumination is the lightest, and is considered the highest value. Black in shadow is the darkest, or lowest, value. Falling between white and black is a range of intermediate grays. The lighter of these gray variations, those that are closer to white, are called *high-value grays*. The darker grays, those descending the value scale toward black, are known as *low-value grays*.

Value also refers to the relative lightness and darkness of a color. Pink, for example, is a high-value red. Maroon, on the other hand, is a low-value red. The degree of value is determined by the relative lightness or darkness of an object, and also by the amount of illumination that falls upon the object. Thus, an apple whose local color is red may appear maroon in shadow. By using different values in a drawing or painting we are able to describe the local colors of objects, but we are also able to convey the effects of light and atmosphere.

Several important functions are served by value. It may suggest volume, depth, or pattern. And, through strong contrasts of light and dark, value can create dramatic interest. When looking at artwork, the eye travels first to the areas of greatest contrast. You can therefore direct the viewer's attention to the significant portions of a drawing merely by increasing the contrast in those areas. In other words, light and dark can be manipulated to create points of interest.

A passive, subdued drawing generally employs a narrow range of values. A drawing becomes more powerful and commands more attention as its range of values is expanded. By becoming thoroughly familiar with the value scale, an artist learns to see subtle variations in light and dark. With practice, each artist develops skill in the use of value for description and for expression.

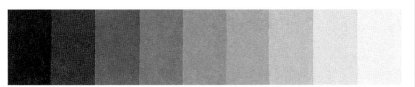

This value scale shows 9 gradations of gray, from a dark, low-value gray to a light, high-value gray.

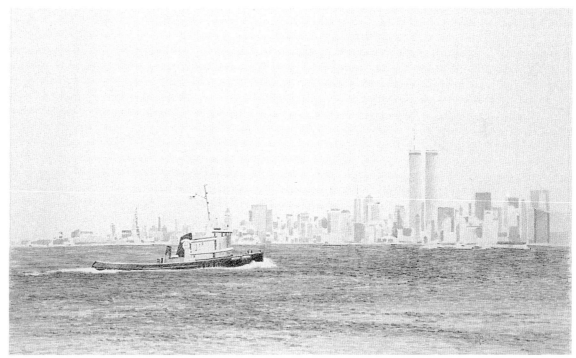

NEW YORK HARBOR, UPPER BAY
Pencil on museum board, 11 × 17" (28 × 43 cm). From *Hudson River Drawings* by Richard McDaniel (1994).

I was busy making a drawing of the harbor looking north from Staten Island when this Turecamo tug entered the scene. I couldn't resist. I blocked in the shape and took a photograph as reference so I could fill in the nautical details correctly. Note how contrast plays a vital role in directing your eye to the tugboat. The lightest and darkest parts of the drawing are adjacent to each other and command attention. The Manhattan skyline is so active it would compete with the tug if it weren't for this difference in contrast.

TONAL EFFECTS IN PENCIL

To take full advantage of the properties intrinsic to the pencil, one must consider drawing with tone. Graphite is malleable, makes a range of light and dark marks, and can easily be applied to paper in a variety of tonal shapes. A pencil held at an angle will expose the maximum surface of graphite, thereby making the thickest line. By scribbling back and forth a few times, a tone quickly appears on the drawing surface.

Some artists like to soften this tone by blending and rubbing with the fingers or a paper stump. Be careful not to overblend, though. It will make the drawing look weak and vague. A soft passage is most effective when seen in contrast to sharp areas in the same composition. A skilled hand can lay down areas of reasonably even tone without the need to blend. The result is usually a tone that looks fresher and cleaner. Practice. It gets easier.

The natural range of tones produced by three pencils of differing degrees: 4B, HB, and 4H.

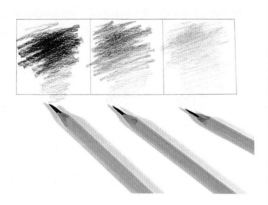

SAMPLER OF PENCIL MARKS

A pencil is a simple tool, and one with which we are all familiar. Yet it is extremely versatile, and can respond to each artist's personality with an assortment of lines and shapes. Simply varying the pressure while drawing can bring life to a line. Interesting tones result from layering, blending, or cross-hatching. An even greater range of marks can be produced by scraping, erasing, and using solvents. A few of these possibilities are shown in the following illustrations.

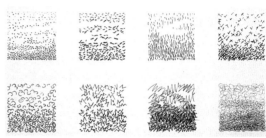

You will find it a great advantage if you develop a wide range of pencil marks to create tonal mass. These eight squares show a small sampling of dots, dashes, lines, and squiggles. Create some yourself and see how easy it is to add visual texture to your drawings.

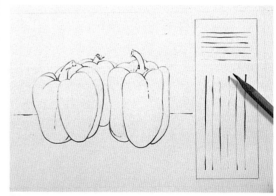

Line variety. A lively line results from changing the amount of force applied with the pencil point. Line width increases with more pressure, adding weight and emphasis to specific areas of a drawing.

PENCIL HARDNESS SCALE		
HARDER, LIGHTER	9H 8H 7H	**VERY LIGHT:** Extremely hard lead, with a large percentage of clay. These pencils are most useful for technical drawings and engineering and architectural plans.
	6H 5H 4H 3H	**LIGHT:** These grades are also quite hard, and good for thin lines. Sometimes I use this range for very pale passages or fine details.
	2H H F HB B 2B	**MEDIUM:** In the middle, with qualities of both hard and soft. With light pressure these pencils produce a fine, light line and hold their point well, and with greater pressure they make moderately dark lines.
	3B 4B 5B 6B	**DARK:** A versatile range, particularly well-suited for sketching. They provide rich dark tones, yet with light pressure create delicate passages as well.
SOFTER, DARKER	7B 8B 9B	**VERY DARK:** These grades are almost pure graphite. They produce the deepest of dark marks, but are very soft and seldom stay sharp long. They can be of particular benefit when creating large areas of darkness.

Broad stroke. By wearing down the pencil point at an angle, the maximum diameter of the lead is exposed. Drawings created with such a point exhibit vitality and boldness. Broad stroke is ideal for quick sketching.

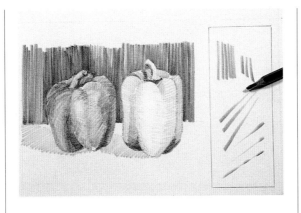

Hatching and cross-hatching. Hatch lines are parallel strokes drawn close together, giving the appearance of a tone. Cross-hatching employs multiple layers of hatch lines drawn at differing angles that "weave" a tone.

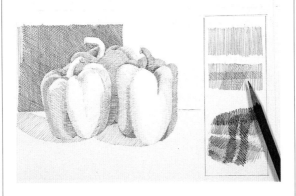

Blending. Although accidental smudging is considered a nuisance, it can also add softness to an image. Use a blending stump, tortillon, or your fingers to blur outlines and soften edges.

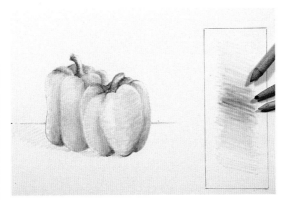

Erasing. An eraser can do so much more than correct mistakes. It softens and blends, and creates highlights or light lines in a dark area. A kneaded eraser can be shaped to a fine point for detail work, or can gently lift out broad passages of tone.

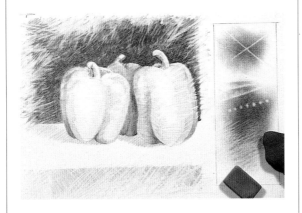

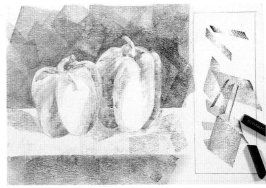

Graphite stick. Using a beveled graphite stick will produce a broad mark, while the sharp edge of a stick will give a thin line. The flat side makes powerful wide strokes. Used on textured paper, a graphite stick is ideal for dragging and scumbling effects, sweeping across the surface of the paper and accentuating its texture.

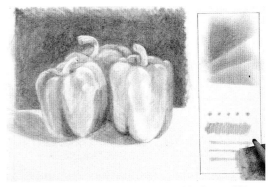

Dry wash. A soft, even tone is achieved by first rubbing a cloth onto a separate, graphite-covered piece of paper, and then gently rubbing the darkened cloth onto the drawing surface. This tone can be deepened with repeated applications, or adjusted with an eraser. Details can be rubbed in with a blending stump or a cotton swab, and highlights can be lifted out with an eraser.

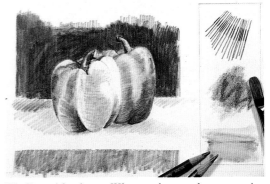

Working with solvents. When a solvent such as turpentine is combined with a regular pencil drawing, the surface changes considerably. Used sparingly, this technique adds vitality and depth to an image. A similar effect results from using watersoluble pencils.

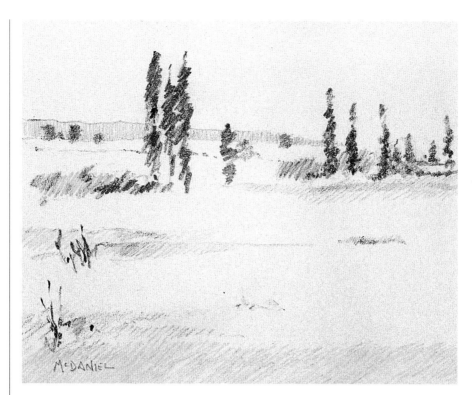

PRES DE CHARMONT
Bowling pencil on
Strathmore sketchpad,
4¹/₂ × 4" (11 × 10 cm).

*Often while walking
in the country, I stop
briefly to jot down
a quick impression.
This drawing is
extremely abbreviated,
yet it contains a
sufficient amount of
compositional
information should
I someday choose to
develop the image
into a painting.*

INDIAN POINT NUCLEAR FACILITY
Graphite on Fabriano paper, 8 × 10"
(20 × 25 cm). From *Hudson River Drawings*
by Richard McDaniel (1994).

*I find that a tonal drawing such as this seems closely related to painting, since it
uses a full range of values and is more dependent upon tone than line.*

PARADISE
Pencil on paper,
12 × 18" (30 × 46 cm).

This is a drawing of a drawing. I hastily sketched the original on a brown paper bag while waiting for a friend to get off the phone. A template of scrap paper helped me create the straight edges, incorporating a variety of pencil and eraser marks. The drawing uses a combination of tonal areas and strong contour lines.

HATCHING AND CROSS-HATCHING WITH PENCIL

Hatch marks are basically parallel lines spaced close together. Their proximity to each other creates the illusion of a solid tone, but with more crispness since the lines are distinct. Cross-hatching is the layering of additional parallel lines (each layer at a different angle) over the initial hatching. In this manner, dense tone is built up gradually.

Cross-hatching is an old technique used in printmaking and ink drawing. It is a way of producing areas of tone without using a solid pool of ink, which is sometimes difficult to print evenly. The process of etching, for example, depends upon the ink residing in little grooves on the etching plate, since it is not possible to print a consistent tone from a large pool of ink. However, many little grooves, closely spaced, will hold the ink nicely and transfer a dense black tone to the paper. Cross-hatching is a classic way of producing tones with ink that can be equally effective with graphite.

In pencil drawing I like to use cross-hatching in a loose manner, but I twist my pencil every few strokes to keep the point sharp and the lines crisp. I use an eraser to soften edges and at times to hatch a few erasure lines into the tone.

As in line drawing, each artist's personality becomes quite apparent in his or her method of cross-hatching. Some are meticulous and precise, others loose and expressive. My style falls somewhere in between, and I vary it from drawing to drawing, depending upon the visual effect desired (or perhaps on the amount of patience I have on any given day).

STRIPED SHIRT
Pencil on Domestic
Etch paper,
17 × 22" (43 × 56 cm).

Parallel lines, when closely spaced, form a tone. In this drawing the lines are clearly visible as they shade in an area; they perform the dual function of suggesting tone while remaining a cluster of distinct lines.

DEMONSTRATION

This is probably my favorite way of working in pencil. I find that cross-hatching allows me to build up tone bit by bit, as I feel my way through the design. Seldom do I have more than a general idea of the value placement when I begin a drawing. I let the image evolve by allowing the location of light and dark areas to be directed by the organizational needs of the composition. Cross-hatching is well suited to pencil drawing, since it is tonal yet retains a linearity due to the distinctness of the individual pencil strokes.

Before building up too much hatching, I intensify a few lines by increasing the pressure on my yellow No. 2 pencil. This helps to differentiate the forms of the trunks from the hatch lines in the background.

To begin a crosshatch pencil drawing, I generally lay out the basic composition first, like a roadmap with a few "landmarks" to guide me. There's no sense getting too involved with detail in one portion of the drawing if the entire composition is not blocked in. Here I use an HB pencil to establish a simple outline, with just a few scribbles of light tone to help me keep my place.

Back to the hatching and my first diagonal crosshatch. I keep the hatching spotty and "organic" so that I can preserve variety as I continue to build tone.

Another layer of diagonal hatch gradually strengthens the tone.

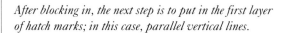

After blocking in, the next step is to put in the first layer of hatch marks; in this case, parallel vertical lines.

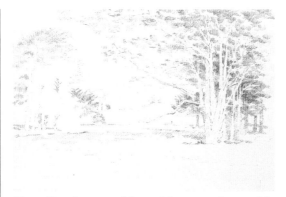

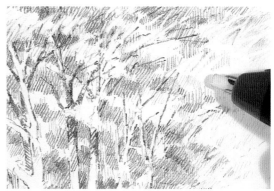

Up to this point, most of the work has centered around the dominant tree mass on the right. Before the drawing gets too complete, the subordinate parts of the composition must be considered.

Hatch lines can also be made with an eraser. The addition of "white" hatching creates a nice value reversal (white-on-black instead of black-on-white) while softening the mechanical look of the other cross-hatching.

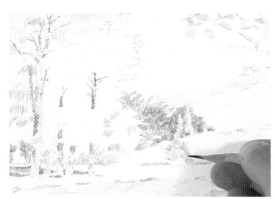

A radial, or fan-shaped, application of lines is a useful variation on parallel hatch lines.

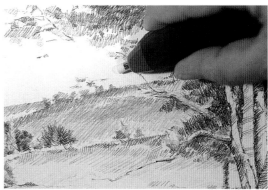

Now I am using the eraser to remove a branch from the drawing. Although the branch really exists on the tree, it doesn't work with the rest of my composition because it creates too much diagonal emphasis in the wrong place, and therefore detracts from the grouping of all the tree trunks.

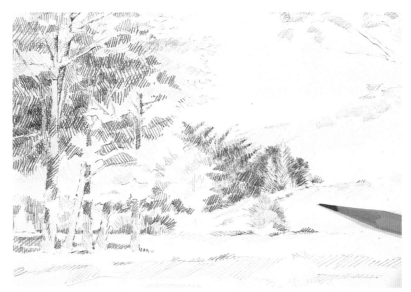

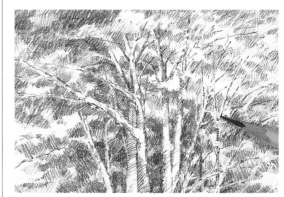

For delicate areas, a 4H pencil produces crisp, light lines. The hard lead stays sharp so that each line remains distinct though light in tone.

At this point I return with my No. 2 pencil to darken a few lines and add a final layer of hatch marks.

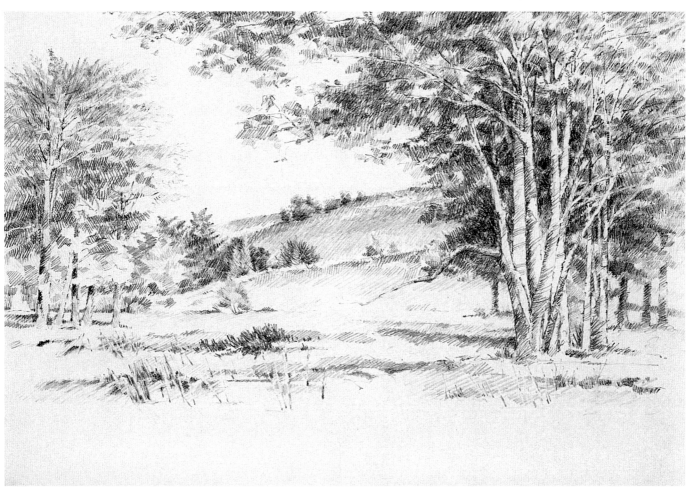

TOMALES AFTERNOON
Pencil on Strathmore
bristol paper,
7 × 12" (18 × 30 cm).

One day I took my landscape class to a small coastal town in northern California. I kept glancing at this scene as I talked to students, but only made the briefest of sketches (similar to Pres de Charmont *on page 78) during my lunch break. Fortunately, my sketch, memory, and imagination helped me complete this drawing.*

THE DRY WASH TECHNIQUE

For broad passages of soft tone, try the "dry wash" technique. It adds tonal distinction to a drawing and creates a mellow cast difficult to achieve any other way. Besides, the procedure is fun.

To begin, generously cover a piece of scrap paper with a coating of graphite. This is done by scribbling with a soft pencil (such as a 5B) or by dusting the scrap paper with powdered graphite. Then rub a cloth or tissue into this smudge to pick up the graphite. The darkened cloth can now be gently rubbed into the drawing, transferring the graphite and producing a delicate tone. Repeated applications will build up a rich, dark passage, and feathering with an eraser will yield a wide range of results.

A blending stump adds variety to dry wash. It will make a soft scribbled tone, a soft line, or soft points. A blending stump dipped in a graphite "pool" and then used as a drawing tool responds in much the same manner as a felt-tip pen that is running out of ink—the difference being that you can continue to reload the stump with graphite.

Also try using an index card or a stiff piece of paper as a template. Hold the card firmly in place as you wipe the graphite onto the drawing. Curves and unusual shapes may be cut into the card with scissors or a mat knife. With dry wash and templates it is possible to create many hard-edged or misty effects similar to those of airbrush.

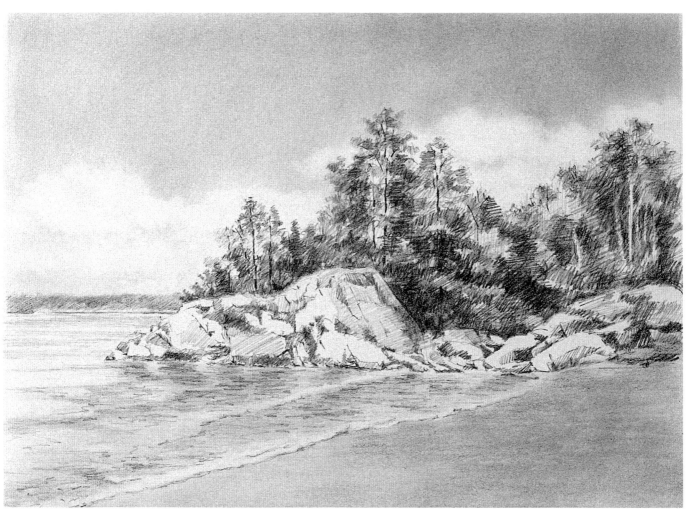

KINGSTON POINT
Pencil on museum board,
9 × 11" (23 × 28 cm). From *Hudson River Drawings* by Richard McDaniel (1994).

The soft sky tone is the result of the dry wash technique. I rubbed graphite onto the paper with a tissue and used an eraser to remove the tone in places such as the cloud shapes. Dry wash was also helpful for creating the sand and water in the foreground.

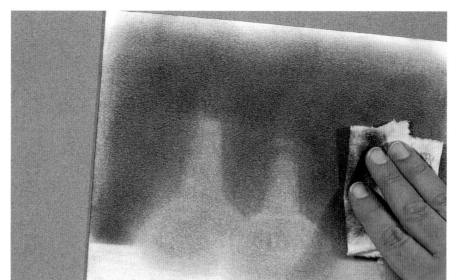

Here is a simple sequence: A dry wash tone is applied in basic shapes and rubbed into the paper; highlights are removed with an eraser; and details are refined with a tortillon. It is a method of drawing well worth investigating.

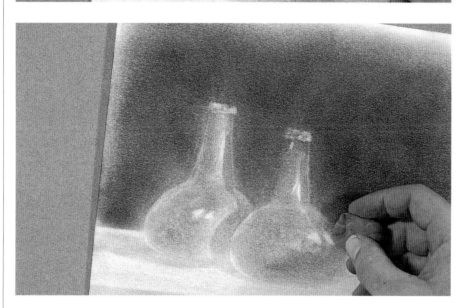

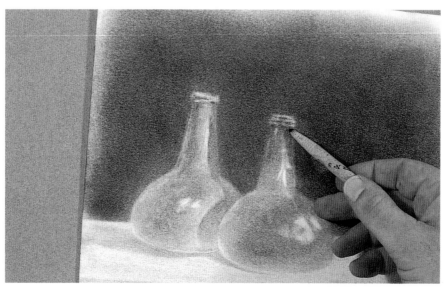

THE DRY WASH
TECHNIQUE

DEMONSTRATION

A completely different tonal effect from cross-hatching is achieved with the dry wash technique. Here, the lack of linear detail adds depth by keeping the sky and mountains in the distance.

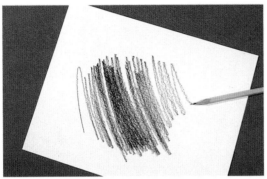

The first step in using the dry wash technique is to create a "pool" of graphite. The quick and simple method requires scribbling generously on a piece of paper with a soft pencil.

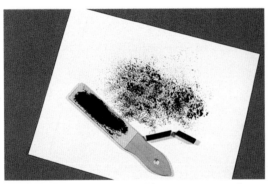

Another method, one that provides a greater quantity of graphite, employs a pencil or a graphite stick and a sandpaper block. A powder is made by rubbing the graphite against the sandpaper. (When a greater quantity is needed, graphite is also available in powdered form.)

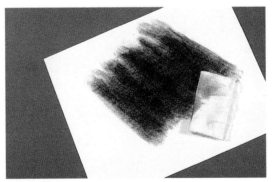

To pick up a tone, rub a soft piece of cloth or paper into the pool of graphite. Almost any absorbent material will work, although paper will shred sooner than cloth. I like to use Webril Wipes, a brand of lint-free cloth used by printmakers.

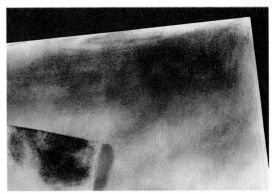

Next, I gently rub the darkened cloth over the drawing surface. It takes a little practice to avoid unwanted streaking, but skill in applying an even tone can be mastered fairly easily.

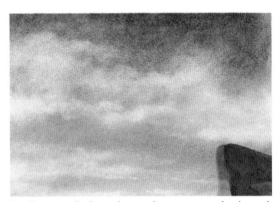

In this example, I use dry wash to represent the sky and a kneaded eraser to lift out the light areas of cloud. If too much tone is lifted out, however, it can quickly be replenished with another touch of the graphite cloth.

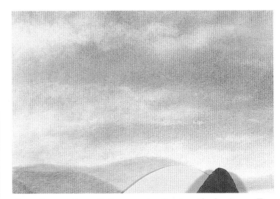

Here I use a kneaded eraser to sharpen the horizon. For a distinct edge, I cut a curve into a card and use it as a template.

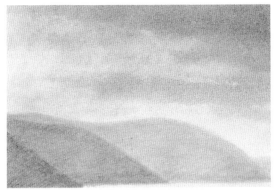

When applying a dry wash, a variety of tones can be laid down by controlling the pressure from the cloth, or by building up the tone in several light layers. In this case, the gradation of value helps me indicate the spatial relationships among the receding mountains.

Now I work pencil over the wash, adding definition and rhythm. This is also another way to even out the tone and adjust the values.

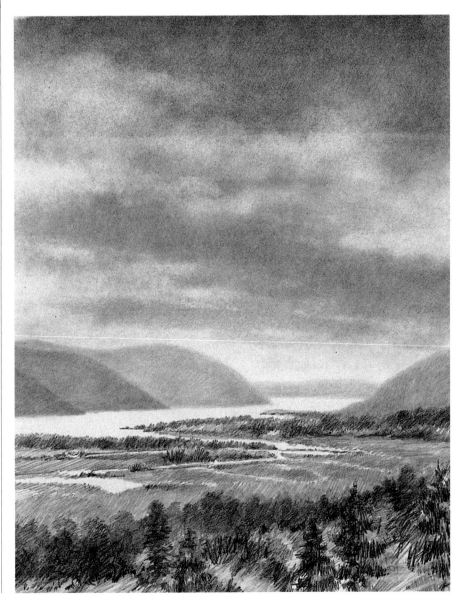

HUDSON HIGHLANDS: APPROACHING STORM
Pencil on museum board, 10¹/₂ × 9" (27 × 23 cm). From *Hudson River Drawings*, by Richard McDaniel (1994). Collection of Museum of the Hudson Highlands, Cornwall-on-Hudson, New York.

This view of the river looks north toward the aptly named Storm King Mountain. It is an area of the Hudson where the weather can be furious. The soft application of dry wash helps convey the thick atmosphere of the coming tempest.

Drawing with an Eraser

The eraser is a useful but frequently overlooked tool. True, it can remove unwanted lines, but it can also soften forms and smear shapes. In addition, it can create an abundance of light-value marks when worked into a dark mass of graphite or charcoal.

Softening Tone

Whenever a portion of a composition is too dark and attracts too much visual attention, I tone it down with my eraser. To retain detail while lightening a passage, I simply push a kneaded eraser into the dark area, then pull the eraser back. Bingo! It picks up some of the tone without disturbing the image.

Smearing

For a more active effect, try partial erasure, or smearing. By loosely erasing into a static drawing, the resultant smearing will frequently add zest to the composition. At times gentle erasing leaves a ghost image that blurs the edge of a form. It often suggests movement, as though the form has just moved from the space now occupied by the ghost image. Sometimes this even implies the act of breathing or the motion of the wind.

Lifting Out Highlights

Using an eraser calls to mind this oft-quoted axiom: You need dark to show light, and light to show dark. That is, the contrast of a dark area is necessary for any light areas to show up, and vice versa. In most cases it is the pencil that creates the dark passages while light areas are created by leaving portions of the paper exposed. The artist is drawing with dark marks and light spaces. With an eraser, the reverse is possible.

First, cover a portion of the paper with a tone of graphite or charcoal. Next, drag the eraser through the tone. This will produce a light mark on a dark field. A kneaded eraser is useful for this process since it can be molded into a variety of shapes. Try pinching the eraser into a narrow ridge to create fine lines, or into a point to make little flecks of light. I often use small areas of dry wash in a drawing for the express purpose of building up a soft, dark tone into which I can draw light lines with my eraser. The edges of these lines may be sharpened by going back into the drawing with a pencil.

It should be noted that some instructors discourage the use of an eraser. The reason is simple: A student preoccupied with "correctness" spends inordinate amounts of time reworking certain lines without proceeding to other parts of the drawing in a fluid, natural manner. The very act of erasing may focus a student's attention on mistakes rather than on learning to draw. This is a valid position: One should not become obsessed with correcting mistakes. That behavior accentuates the negative, removes the unexpected (often a great source of inspiration), and interferes with the natural rhythm of drawing. However, when used for making light marks on a dark ground, adding character, or making adjustments in value, the eraser is one of the most useful and versatile drawing tools available.

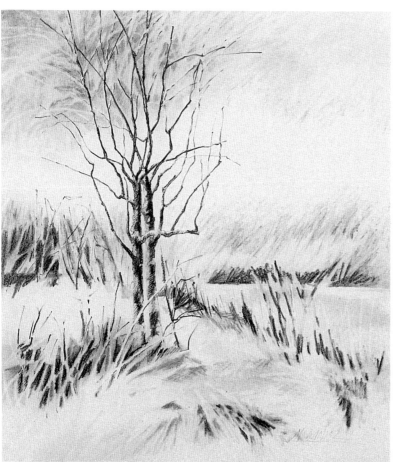

SPRING SAPLINGS
Pencil on bristol board, 11 × 9" (28 × 23 cm). From *Catskill Mountain Drawings* by Richard McDaniel (1990).

There is a time in the early spring when the snow is receding and a few shoots are peeping forth, seeming to stretch after a winter's nap. I made liberal use of an eraser, cutting through a dry wash tone to suggest these matted and tangled shapes.

MAYBE MARY
Pencil on Domestic
Etch paper,
9 × 12" (23 × 30cm).
Private collection.

This is a drawing of a friend's daughter, her mind far away, lost in personal thoughts.

In this detail you can see two erased streaks slanting across the eyelid. They were added spontaneously as the drawing evolved, and contribute to the relaxed, informal character of the portrait. I frequently use an eraser to soften edges that may be accurately drawn but don't seem to breathe. If an image is too precise it often looks stale.

DEMONSTRATION

This demonstration uses erasure as one of several techniques. An eraser is rarely my only image-making tool; I usually use it with others, as I do here with a blending stump and pencil.

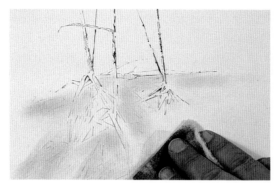

A simple contour drawing serves as a guide to getting started. The lines need not be precise, for some will be lost as the drawing develops. To rub in a tone I put the large shapes in first, with attention to the overall composition. I keep this part broad and simple.

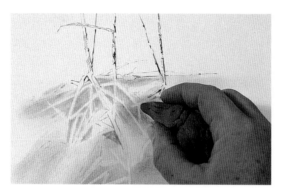

To lift out the light areas of weeds, I use a kneaded eraser pinched to a point. The eraser can be molded to any shape you find necessary.

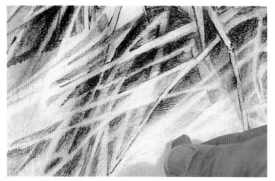

Sharp lines can also be lifted out with a piece of a regular eraser, such as a Pink Pearl, that has been sharpened with a knife. This is firmer than a kneaded eraser and is sometimes more convenient for making a series of fine lines.

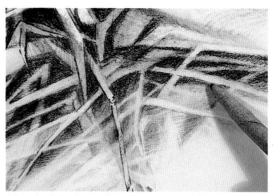

After the light shapes have been suggested by erasure, I deepen the dark tones with a blending stump. By working back and forth between the stump and the eraser, the image gradually becomes more defined.

For even greater definition, I sharpen some of the contours with a pencil line. A bit of hatching adds depth and variety to some of the dry wash passages.

WILD GRASSES
Pencil on museum board,
10 × 7" (25 × 18 cm).
From *Catskill Mountain Drawings* by Richard McDaniel (1990).

The finished drawing is a mixture of dry wash, contour line, and lots of erasure. Some portions of the image are quite clear, and therefore dominant; other areas are soft, and quietly recede into the background.

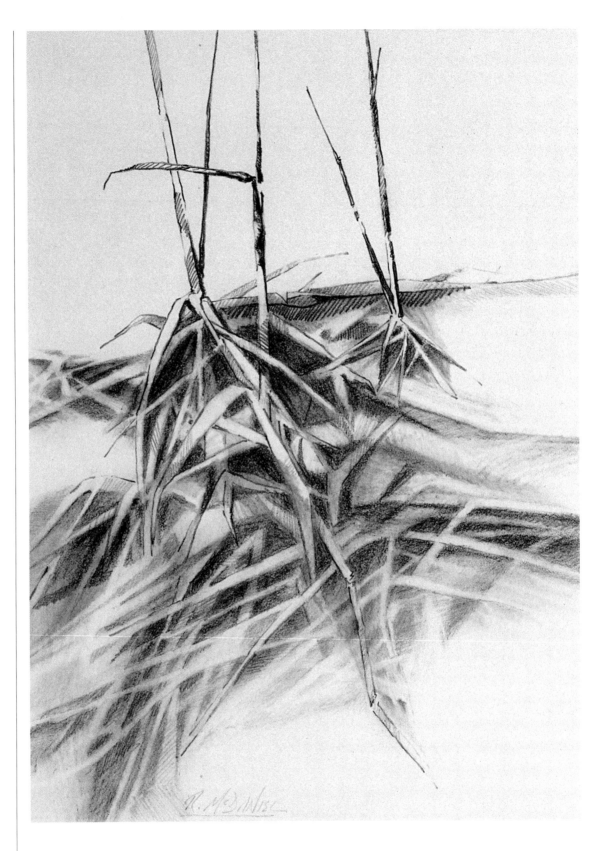

Dark Tones with Graphite

Drawings with large areas of dark tone are powerful. They seem to express passion and force, and perhaps mystery. Soft pencils (5B, 6B, and so forth) produce rich black marks and, with many small strokes, you can certainly build up large dark areas. For broader strokes, however, try using a graphite stick. Graphite sticks can be found at most art supply stores and are available in a variety of grades, such as 2B, 4B, and 6B. A graphite stick used on its side will make dark shapes 3 inches (7.62 cm) wide. By altering the angle of the stroke or by breaking the sticks in half, a number of stroke widths are possible.

The plastic-coated woodless pencil is a cylinder of graphite available in 10 degrees, from HB to 9B (the softer, darker range of the hardness scale). It may be sharpened like a pencil, but its uniqueness lies in the diameter of its lead. While a typical pencil contains a narrow rod of graphite surrounded by wood, the lead of this woodless pencil is nearly the entire diameter of the pencil, about 5/16 inch (0.79 cm). Therefore, its point can be worn down to a broad tip, resulting in wide lines. By scribbling with such a broad tip, or with a graphite stick, you can add large, dark masses to a drawing within seconds.

But to really get into graphite, I like to coat my paper completely with a dry wash or with powdered graphite and do all my drawing by lifting out shapes with an eraser.

LUNAR PLEXUS #3
Graphite on Fabriano Classico paper,
7¹/₂ × 18¹/₂" (19 × 47 cm).

For this image, I completely covered the paper with a deep graphite wash. All the light areas of the design were then lifted out with a kneaded eraser.

DEMONSTRATION

If you plan to rub graphite into your paper, be sure to use a sheet that can withstand the friction and won't wrinkle in the process. It isn't necessary to use such a rigid support as museum board, but it certainly doesn't hurt. The softer the paper, the deeper the graphite will penetrate. This makes for beautiful, dark tones, but they are difficult to erase completely. Try to use a paper that is durable with a receptive surface. A few suggestions are: A/N/W Drawing and Framing paper, Daniel Smith Archival Printmaking and Drawing paper, Fabriano Classico, or most bristol boards with a plate or vellum finish.

For this piece I have selected A/N/W Drawing and Framing paper. It is absorbent enough to accept plenty of graphite, yet has a slightly hard finish that will stand up well to erasing. Here I am applying drafting tape to mask the edges of my format. Because drafting tape is not as sticky as masking tape, it is less likely to harm the paper.

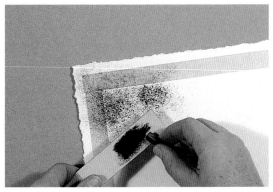

As in the dry wash demonstration (see pages 86–87), I scrape a 6B graphite stick against a sandpaper block, but in this instance I let the filings fall directly onto my drawing surface. Powdered graphite also works for those who wish to avoid the step of filing a graphite stick.

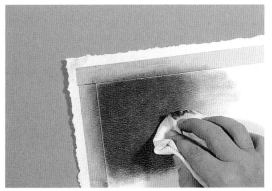

Using a Webril Wipe, I carefully begin rubbing the graphite into the paper. It takes a gentle hand and lots of patience to achieve a solid covering without any streaks. The trick is to apply the tone gradually, in several layers.

Once the surface is covered to my satisfaction, I begin to lift out a design with a kneaded eraser, using a piece of paper as a template. Beginning with the eraser on the template, I feather the stroke into the graphite.

Here a series of marks was made using a manila folder. For a clean curve, cut an arc into your template with scissors. Try a hole punch or an X-Acto knife if you want other shapes. Also, a metal erasing shield has several precut shapes you may find useful.

*As the kneaded eraser picks up graphite, I mold the
eraser around in my hands to fold in the soiled area
and expose a clean portion of the eraser.*

*If necessary, an erasure can be filled in with a dry wash
touch-up. The graphite-loaded cloth will quickly block
out large areas, while small spots can be touched up
with a tortillon. You will find this technique to be fairly
forgiving, and by working back and forth you can try
out different compositional ideas without the drawing
looking overworked.*

LUNAR PLEXUS #11
Graphite on
A/N/W Drawing and
Framing paper,
9 × 12" (23 × 30 cm).

*The completed drawing is very quiet. To me it suggests night vision, when the moonlight
reduces all forms to a colorless world of dim shadows. The dark mass is deep and mysterious,
while the light marks are soft, as though wrapped in a haze.*

WORKING WET WITH PENCIL

Pencils are most often used dry, as they were intended to be used, and the graphite mark is made on the paper by an act of abrasion. But the story doesn't have to end there. You can also use a solvent to alter the marks once they've been made on the paper.

The customary solvent for graphite is turpentine. It is less volatile than stronger solvents, and usually does the trick. Besides, most artists have a supply of turps readily at hand. There are three basic manipulations, and countless variations:

1. If a pencil line is drawn through an area of paper that has been moistened by turpentine, the graphite line becomes much darker in that area. The boldness of the stroke remains evident after the solvent has dried.

2. If you dip a brush into turpentine and apply it to a drawing—especially a tonal area with lots of graphite on the paper—it is possible to push the tone around and "paint" with the graphite. By scrubbing a bit, lines become less apparent and you are left with a soft-edged tone.

3. For an even softer effect, make a separate graphite pool, as in the dry wash technique (see page 86). Scribble generously on a scrap piece of paper, scrub a turpentine-soaked brush into this pool of graphite, and brush the tone onto your drawing. This creates a painterly character in the artwork while retaining a harmony with regular pencil lines.

These methods for using a graphite-turpentine solution also apply to the latest thing in the pencil world: the watersoluble pencil. The addition of a water-based binder in the production process enables an artist to easily manipulate the pencil tone in a wash state. Moreover, the only solvent required is safe, inexpensive, and (let us hope) odorless water. Furthermore, it is unlikely that any residual stain will be imparted to the paper by the water, as is sometimes the case with turpentine.

Watersoluble pencils are available in hard, medium, and soft configurations. If you use them dry they are just like any other pencil, but once the graphite has been liquified it is no longer easy to erase.

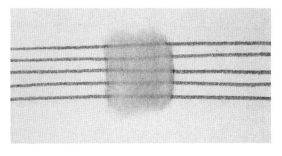

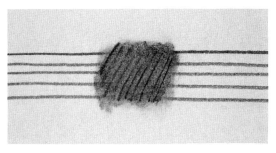

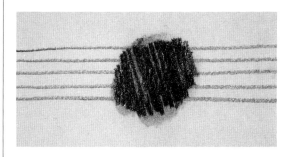

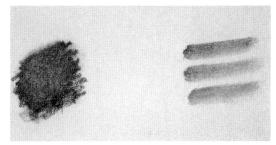

Working wet with pencil. (Top to bottom) Drawing lines through a turpentine patch; dissolving lines with a brush and turps; then adding a pencil tone when dry; adding lines with a solvent-moistened pencil tip; and making strokes (right) after scrubbing a turpentine-soaked brush into the pencil scribble (left).

Working Wet with Pencil

Demonstration

For this drawing I am working on Lanaquarelle 140-lb. watercolor paper. Its hot-pressed finish is relatively smooth and accepts pencil well. I've chosen an aquarelle paper because I will be using water to dissolve the pencil tones. Regular drawing paper will buckle when moistened in this way.

Here I lay out the drawing with scribbled pencil lines, then soften the tonal areas with a wet brush. I use a bristle brush for this procedure because it is stiff enough to scrub out the lines.

The visible pencil strokes dissolve into a homogeneous mass when water is applied. A moistened brush can slur and soften marks already on the paper, or the brush can pick up tone and deposit it again as a graphite brushstroke.

At this point the wash is distributed throughout the entire composition, much like an underpainting.

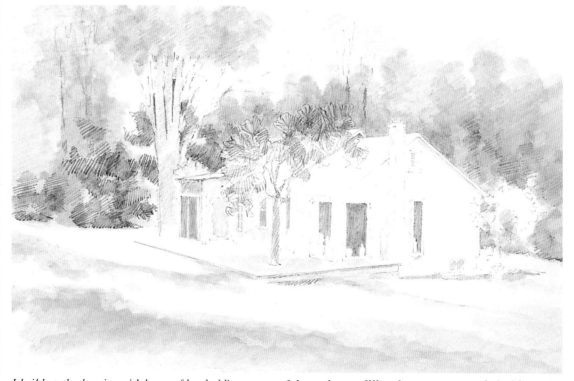

I build up the drawing with layers of hatched lines on top of the wash tones. When these areas are touched with a wet brush, they add dimension and contrast. I don't intend to completely blend in the line work. Instead, I plan to combine wash and line by dabbing a wet brush amidst the hatched tones.

To add clarity and dynamic motion, I dip the pencil in water and draw with a wet tip. This produces a very dark line that contrasts with the wash and other pencil tones.

For variety I go back into the drawing with an electric eraser. Once graphite has been dissolved into a wash it bonds with the fibers of the paper, so complete erasure cannot be expected. But the power of the electric can blast out areas that would otherwise be too difficult to remove. In a drawing with several layers it is possible to create many erasure tones.

THE WOODSTOCK OFFICE
Derwent Watersoluble Sketching Pencil on
Lanaquarelle 140-lb. hot-pressed watercolor paper,
9 × 13" (23 × 33 cm). Collection of
Wapner Koplovitz Futerfas & Stegmayer.

Compositions can be found anywhere. This little guy posed for me without moving a muscle as I worked. First I laid in a graphite and turpentine wash with a bristle brush, then I proceeded with the drawing, sometimes dipping the pencil tip in the solvent to produce the dark accents.

TONAL EFFECTS IN CHARCOAL

One of the reasons charcoal is so popular is its versatility as a drawing medium. An image can be sketched rapidly and then easily adjusted. Charcoal is responsive to pressure, and creates distinctive lines or solid tones with just a few strokes. The four basic forms of charcoal are: vine charcoal, compressed charcoal, charcoal pencils, and charcoal powder. Each has its own unique character, yet they all behave somewhat the same. Collectively they are among the most malleable and direct drawing materials available.

The mark made by charcoal can be removed or modified without effort, so alterations in a design are not difficult to make. To achieve subtle blending and soft edges, rub charcoal with a chamois skin or your fingers. Rubbing, erasing, feathering, and layering can all be employed in the same drawing to create a wide range of values from the very faintest suggestion of tone to the deepest black.

To hold the charcoal particles on the page, a paper with a slight texture is necessary. While most any paper will work, there are many that are manufactured expressly for charcoal drawing. Several colored papers, such as Ingres and Canson Mi-Teintes, are popular surfaces, especially when charcoal is combined with white chalk.

JADE
Compressed charcoal on Aquabee 808 sketchpad, 10 × 14" (25 × 36 cm).

This is a straightforward charcoal drawing of the tired old jade plant in my studio. Compressed charcoal is noted for the depth of its blackness, and I used it here to create a flat, empty background. I rubbed in the mid-tones with my fingers and lifted out the highlights with a kneaded eraser.

YOSEMITE VALLEY
Charcoal and white chalk on Canson Mi-Teintes paper, 8 × 12¹/₂" (20 × 32 cm). Courtesy of John Pence Gallery, San Francisco.

The black charcoal and white chalk stand out in contrast to the middle value of the gray paper. This drawing was essentially complete with various shades of charcoal, and only near the end did I apply the white chalk. It was as if I were flooding the scene with sunlight.

DEMONSTRATION

This series of steps illustrates a typical approach I take with charcoal. In actuality, a charcoal drawing doesn't always proceed in a predictable manner, but one of the nice things about charcoal is its workability. Its forgiving nature allows shapes to be put in and then taken out or adjusted with little effort.

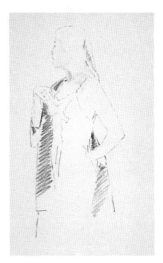

The first step is a simple drawing in vine charcoal. A light touch on the contour of the figure serves as a guideline for building up the composition. In places where I know the drawing will be dark, I hatch in a few lines right away.

After laying in the overall design, I return to the dark areas and build up the charcoal with another layer.

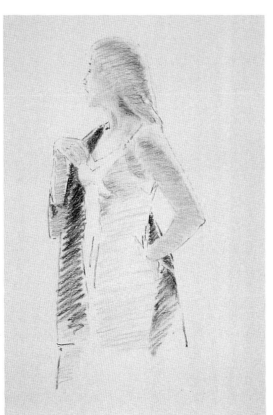

At this stage the tones are blocked in but still fairly light.

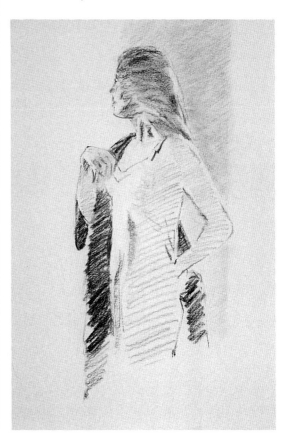

I decide that some darkness in the background would anchor the figure in space and restate the vertical shapes in the robe.

Now I add more layers of charcoal to create richer darks. In a few places I blend the tone with my fingers but never so much as to destroy all the hatch lines, for they provide a kinetic vitality.

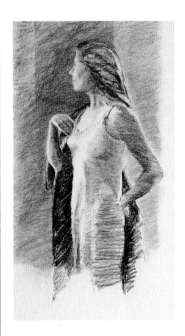

An eraser cleans up the edges, emphasizing the whiteness of the paper.

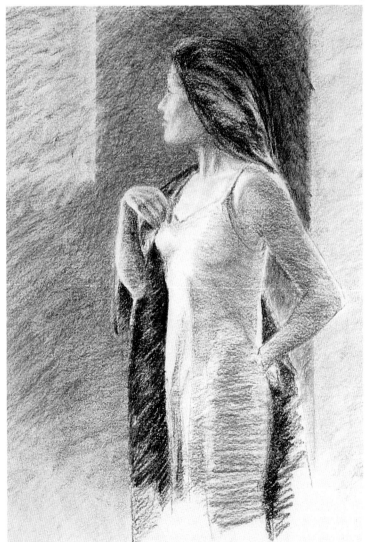

ROBE
Charcoal on Rives BFK paper,
17 × 11" (43 × 28 cm).
Collection of Nadja Yonik.

By now I've adjusted the background values and even opened up a "light source" in the upper left. The strength of this pose resides in the contrast between the model's erect posture and the angularity of her arms. This interaction is enhanced by the rectilinear shapes in the background.

TONAL EFFECTS IN INK

Ink is a liquid. It flows evenly from a pen point, but is also commonly applied with a brush. In fact, the widespread use of the brush for Oriental calligraphy and ink paintings attests to the superb compatibility of brush and ink.

You can mix the entire value range of grays by diluting ink with water. Add a single drop of ink to a puddle of clear water for a light tint, add more for the darker shades. One of the many palettes designed for watercolorists may be useful for your ink wash drawings. They have shallow indentations that will hold water. Drop varying amounts of ink into each little well and set up a series of different gray tones. You can lay in a wash on top of a dry ink drawing or lay one in first to signify areas of tone. After the wash dries, use pen and ink for any line work or details.

Perfecting a wash technique requires lots of practice. You must be familiar with your brush, ink, paper, the amount of wash in the brush, plus the speed and pressure of the brushstroke. All these variables may seem intimidating at first, but once you have them under control you will have a technique of great power and versatility at your command.

I am fascinated by the many ways in which ink can be used to create tones of gray. In addition to mixing white opaque ink with black ink (to create an opaque gray) or diluting black ink with water (to create a transparent gray), you can make wonderful tones of gray by grouping small ink marks in close proximity. In effect, the eye is blending the black of the ink with the white of the paper to produce an optical gray.

Stippled dots and hatching are two of the many groupings useful for creating mid-tones in ink. Any time small marks are clustered they will suggest a tone, but there is an incredible variety in the choice of marks available to you. A few examples are shown below.

Generally, you can make a shape appear lighter in one of two ways: by either lightening it, or by making the surrounding shapes darker. When making tonal marks in ink, only the second option is available. Hence you must save your darks in case you need them in a few minutes. In addition to gradually increasing the amount of ink in your wash solution (as described in the caption accompanying *Cinder Blocks*, opposite), try wetting an area with clear water first. Then, while the paper is still damp, lay in your wash loosely. The tone will bleed out into the wet areas, but stop where it meets dry paper. With this system you can very carefully and slowly paint in a complicated shape with nothing but water, but once the shape is precisely wetted you can dash in the tone with a much freer stroke. Let the drawing grow slowly. Don't develop one area completely before working on the rest of the design.

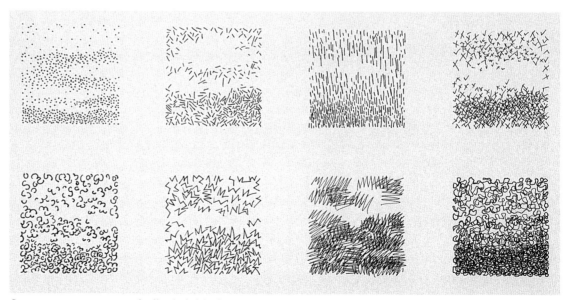

One way to suggest tone or shading in ink is through pattern. These eight squares show a fraction of the many strokes that can be combined to create a textural tone. All these marks were made by a single nib (fine) and a Pelikan Souverän M600 fountain pen. By using a variety of nib sizes, you can expand your repertoire of marks.

ABOVE SQUEAKER COVE
Fiber-tip pen on Sennelier
D1 sketchpad,
6 × 9" (15 × 23 cm).

*As this trail left the
sheltering woods
and approached the
ocean, I couldn't
resist setting down
what was before me.
After the briefest of
pencil sketches, some
lines of which are
still visible beneath
the ink, I completed
this drawing with a
fine-point disposable
technical pen. The
Itoya-Nikko 0.1 has
a nylon tip capable of
producing precision-
ruled lines, yet it is
flexible enough for
freehand drawing.*

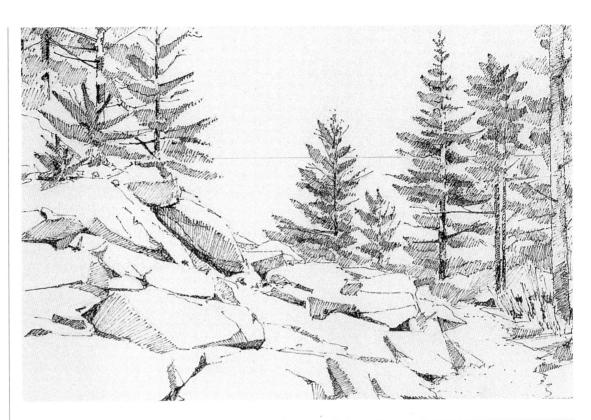

CINDER BLOCKS
India ink on Strathmore
Illustration board,
10 × 13" (25 × 33 cm).

*By diluting India
ink with water, I was
able to create several
values of wash tone.
I began by mixing
a drop of ink into a
little puddle of water
on a plate. I brushed
this light tone on
every part of my
design that was not to
remain white. After
the wash dried I
added another drop
of ink to the puddle
and brushed in the
next darkest gray
shape. I continued in
this manner for a few
more steps, putting in
the darkest wash last.*

STIPPLING WITH INK

Stippling, which is grouping little dots together to suggest tone, is a centuries-old technique employed extensively by printmakers as well as pen-and-ink artists. The quantity, size, and closeness of the dots determine the darkness and density of the tone.

While most artists consider stippling too laborious for frequent use, it is often used in conjunction with other techniques. Atmosphere and the volume of three-dimensional form can be convincingly suggested with stippling, although it requires lots of patience.

DEMONSTRATION

Stippling with ink can be accomplished with a variety of tools: dip pen, technical pen, or fiber-tip marker. For this drawing I used a Pigma Micron 0.03 pen, an inexpensive "tech pen" with a fiber tip. I like this pen because it delivers a constant supply of richly pigmented ink without the fuss of traditional technical pens.

Working on top of a pencil sketch drawn with a light, hard lead, I used a few dots to delineate the contour of the cup and saucer and establish the boundaries of the shadows. The faint lines of my original sketch have now been erased.

I apply little dots to all the shadow areas. Stippling takes patience and an unhurried attitude. Sometimes listening to music is an effective aid in preventing tedium.

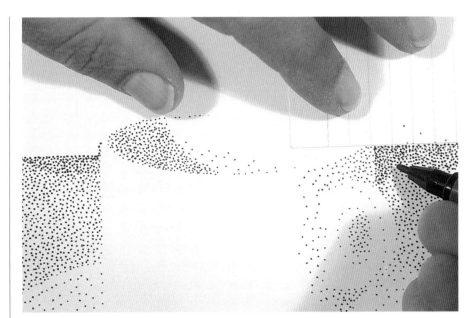

To keep a reasonably crisp edge between forms I use a note card as a masking straightedge. A curved template, if needed, can be cut out of an index card. In most cases a template is unnecessary, but it can help free you from concern about the accuracy of an edge.

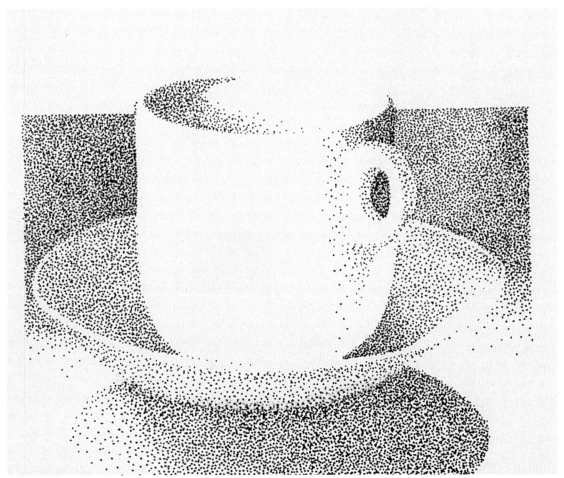

CUP AND SAUCER
Pigma Micron pen on Sax pen & ink paper, 6 × 7" (15 × 18 cm).

One of the intriguing aspects of a stippled drawing is the suggestion of atmosphere. It is as though each dot represents a molecular particle of the image as it floats and coalesces in space.

HATCHING WITH INK

Hatching is one of the principal ways of building up tone with ink. The density of the tone is increased by spacing the pen lines more closely, or by overlapping the lines with additional lines at a slight angle. The latter variation is known as cross-hatching, which is commonly used with pencil and crayon as well as with pen. Cross-hatching can be controlled and precise, with evenly spaced parallel lines, or can be quite informal, often combining near-parallel lines with scribbles, stippling, and assorted splotches.

DEMONSTRATION

A hatched drawing in ink frequently begins with a line drawing in pencil that is erased once the ink has been applied. In this case, though, I chose to work on top of an ink drawing I had done as a classroom demonstration a few years earlier.

I begin applying tone with freehand vertical lines. The lines are interrupted now and again as I change hand position. Since this occurs randomly and continually, it becomes part of the background pattern rather than a distraction. It also helps the image stay "organic," for it is not my intention here to produce a cold, mechanical-looking illustration.

Although a strong outline can interfere with the process of a tonal ink drawing, this contour is only weighted on the left and bottom edges, as though the light were coming from the upper right. Consequently, the barely rendered right side will not be overly conspicuous in the final drawing.

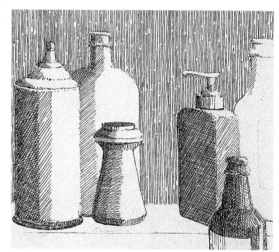

I systematically apply layers of parallel lines which I then overlap with additional layers, each at a different angle. I try not to get too dark too soon, yet I do put in a few areas of strong contrast to keep an eye on value relationships as the image progresses.

The method I use to keep my lines reasonably straight is to place a piece of scrap paper with its edge parallel to the lines I am drawing, and about 1 inch (2.54 cm) away from a straight line. I then fill in the lines freehand as I approach the edge of the paper. The lines waiver a bit but are basically parallel, without the impersonal look of precision ruling.

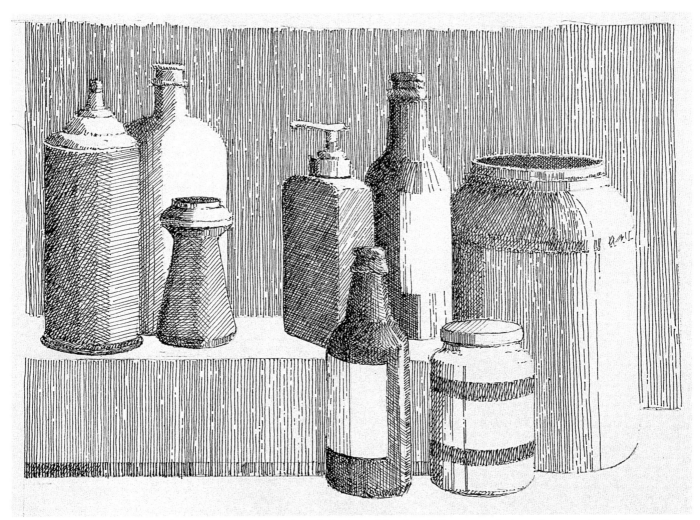

RAINY DAY IN VERMONT
Pigma Micron pen on
Utrecht 70-lb. Artists'
Sketchbook paper,
6 × 8" (15 × 20 cm).

Here is the finished drawing. Note how the horizontal band on the bottom gets darker as it approaches the left margin. This subtle modulation in value is a simple step, yet it is very important to the composition. Due to the contrast, this little bit of darkness has enough visual weight to balance the large forms at the right of the drawing.

THE SUBTLETY OF BALLPOINT

Ballpoint is a wonderful medium. It is so unassuming, like the yellow No. 2 pencil. Perhaps that is one reason I enjoy it. Another attractive quality is the physical operation of its rolling ball. With this type of point you can change direction at any time without snagging the nib or altering the character of the line. This freedom of movement makes the ballpoint pen respond much like a pencil.

The consistency of the ink paste is such that a ballpoint line appears to lie midway between a pencil mark and the stroke of liquid ink. The ballpoint line is reminiscent of graphite in its capacity for tonal variation. By holding the pen at a low angle you can cause the ballpoint to deposit a faint line on the paper. As you increase the angle towards the perpendicular the ball deposits an increasingly greater amount of ink with each stroke.

I offer two cautions. Ballpoint ink can glob up from time to time. Examine the pen tip periodically and wipe it clean. This will minimize the chance of besprinkling your drawing with unwanted blobs. Also, the ink paste does not dry immediately upon contact with the paper. For this reason the ink can smear if brushed too soon after application. It is very important to keep your hand from smudging the ink accidentally. Use an artist's bridge or a clean piece of paper beneath your drawing hand. Remember, the ink cannot be erased. Smearing must either be avoided or incorporated into the design.

Hint: If sometimes you just can't get the ink in a ballpoint started, dip the pen in warm water for a few minutes. This should soften the ink paste and allow it to flow smoothly.

PÂTÉ
Illustrator ballpoint pen on paper placemat,
11 × 8" (28 × 20 cm).

The good news is that I had an Illustrator India ink pen with me. The bad news is that I had no drawing surface other than a paper placemat. I did enjoy the process of making the drawing, however, and was surprised how resilient the paper was, and how much scribbling I could do without damaging its surface. Sometimes the act of drawing is far more important than the result.

DEMONSTRATION

If you erase a preliminary pencil sketch *after* adding a ballpoint pen drawing on top of it, there is a danger of smearing the ink. Therefore, if you map out your design in pencil, be simple, and let the lines serve as reference points or landmarks rather than precise matrices. Before inking, erase the pencil somewhat so that only a hint remains; that should still be sufficient to guide your drawing.

In this part of the sequence, you can see how the forms of branches are developed. First I lay in a light tone among the basic contour lines.

In this case I chose to draw directly in ink, holding the pen at a low angle to make a soft line. I concentrate on contours as I look at a sketch made earlier on location. The procedure I follow now is the same as for the initial drawing.

As I build up the hatching in the negative spaces, the positive forms of the trunks and branches seem to emerge.

I apply tone in a loose cross-hatching method, avoiding the temptation to let anything get too dark. Ink differs from pencil in that there is no eraser to remove unwanted lines or to lighten tones. It is therefore necessary to plan ahead.

Here branches come forward on the left side, although they were unplanned in the previous step. A branch that is an afterthought will be darker than one that was planned from the start because it begins on top of a layer or two of tone. In this case it works, for it appears to be a branch in shadow.

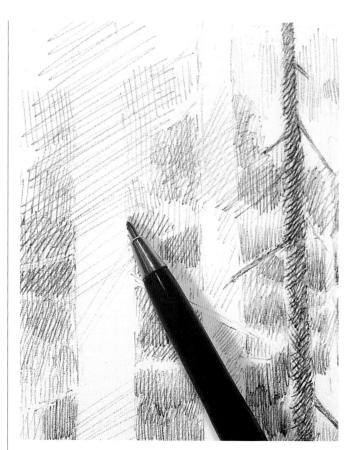

From time to time I drag some hatch lines across both the positive and negative spaces, unifying the forms while obscuring the boundaries. This helps to keep the drawing relaxed and loose—almost as if the forms were affected by the motion of the wind, with moving patches of sunlight and shadow. Landscape drawings can look lifeless if they are too precise.

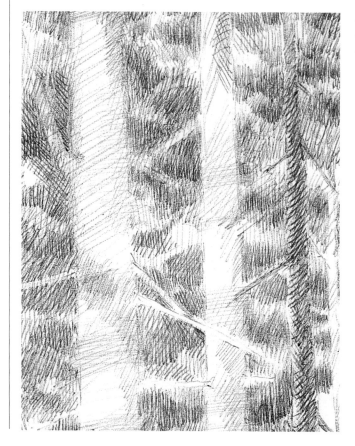

After more of the image is developed, the lightly scribbled tone added in the previous step recedes into the drawing like a shadow.

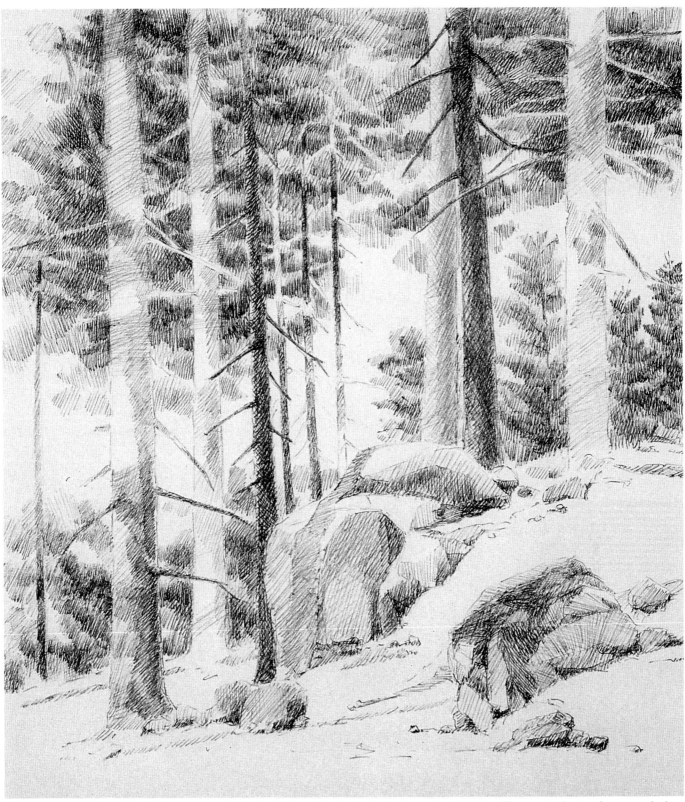

CATHEDRAL WOODS
Illustrator ballpoint pen on Strathmore Premium Recycled Drawing pad, 9 × 8" (23 × 20 cm).

Note the important role that the dark trunks play in developing a visual rhythm. These particular trunks are not dark by accident, nor are they an exact representation of the scene before me. Above all, my choice of light and dark forms, and their placement, is an aesthetic one.

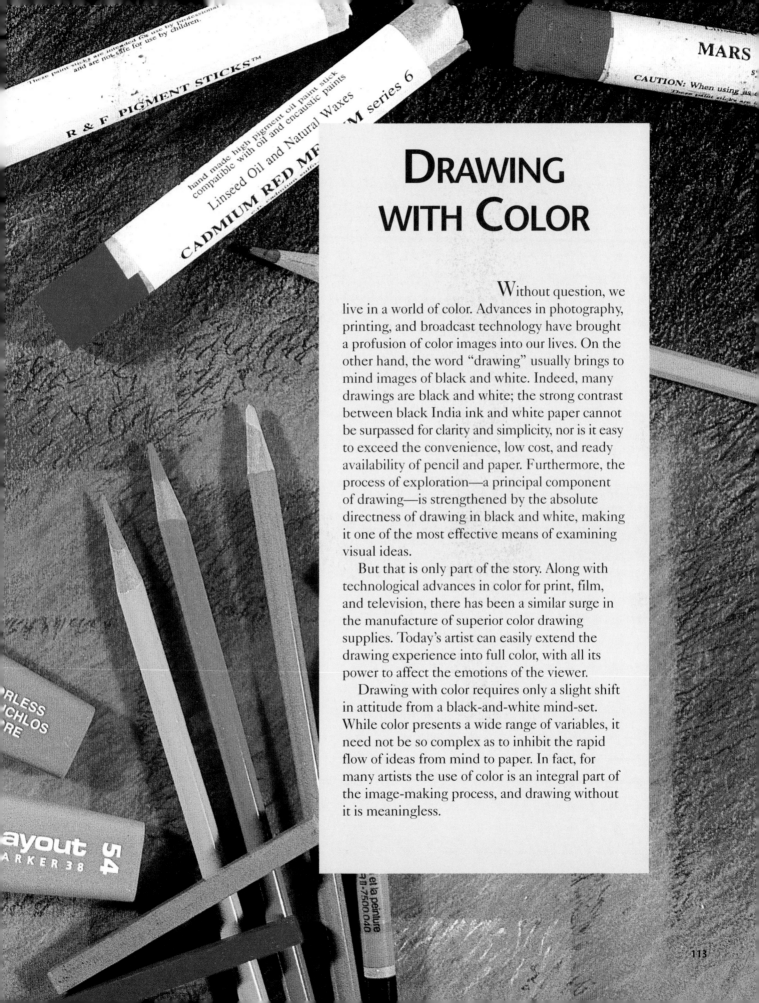

DRAWING WITH COLOR

Without question, we live in a world of color. Advances in photography, printing, and broadcast technology have brought a profusion of color images into our lives. On the other hand, the word "drawing" usually brings to mind images of black and white. Indeed, many drawings are black and white; the strong contrast between black India ink and white paper cannot be surpassed for clarity and simplicity, nor is it easy to exceed the convenience, low cost, and ready availability of pencil and paper. Furthermore, the process of exploration—a principal component of drawing—is strengthened by the absolute directness of drawing in black and white, making it one of the most effective means of examining visual ideas.

But that is only part of the story. Along with technological advances in color for print, film, and television, there has been a similar surge in the manufacture of superior color drawing supplies. Today's artist can easily extend the drawing experience into full color, with all its power to affect the emotions of the viewer.

Drawing with color requires only a slight shift in attitude from a black-and-white mind-set. While color presents a wide range of variables, it need not be so complex as to inhibit the rapid flow of ideas from mind to paper. In fact, for many artists the use of color is an integral part of the image-making process, and drawing without it is meaningless.

113

COLOR BASICS

Before investigating various color drawing media, let us consider some of the basic characteristics and terms associated with the subject of color. For a clear understanding of color, every artist should be thoroughly familiar with its standard terminology. While space here does not permit an in-depth examination of color theory, the following discussion, albeit brief, should help to reinforce your knowledge.

The word "color" is a general term. Every color can be described in terms of three physical properties: hue, value, and chroma. *Hue* is the characteristic of a color that designates its name: A leaf is green; green is the hue of that leaf. Any hue can be changed by mixing it with another hue. For example, when yellow paint is mixed with blue paint, the result is green paint—a change in hue.

Value refers to the apparent lightness or darkness of a hue; that is, the degree to which it corresponds to white or black. The concept of value is often illustrated with a range of grays (see "The Value of Value," page 75), but it is also by means of value that we can differentiate light blue from dark blue. There are two terms that are commonly used to describe value: tint and shade. A *tint* is formed by mixing a hue with white (red mixed with white produces the tint pink). A *shade* is formed by mixing a hue with black (red mixed with black produces the shade maroon). All tints are light; all shades are dark.

Chroma—also called *saturation* or *intensity*—refers to a color's purity. A vivid color, one with great saturation or intensity, is considered to be a high-chroma color. When a hue is less vivid, it is considered lower in chroma. Chroma may be the most difficult aspect of color to grasp, but an understanding of it is extremely helpful in creating artwork. Any hue can range from bright to dull (chroma), just as it can vary from light to dark (value).

THE COLOR WHEEL

When refracted through a prism, a ray of sunlight is divided into distinct bands of pure color. This arrangement of colors, known as the *spectrum*, conforms to a natural, scientific order, and can be observed in the sequence of colors in a rainbow. In the 17th century, Sir Isaac Newton (1642–1727) developed a system for arranging the spectrum in a circle, which today is commonly referred to as the *color wheel*. Several others, including Albert Munsell (1858–1918) and Friedrich Ostwald (1853–1932), have put forth valid theories of color and presented their own versions of the color wheel. For the purposes of this discussion, we shall use the simplest and most common configuration. Our wheel comprises a circular arrangement of 12 hues, though it is easy to imagine countless gradations among them.

The three *primaries*—red, blue, and yellow—cannot normally be obtained by mixing other hues, but all other hues can be produced by mixing the primaries. The three *secondaries*—orange, green, and violet—are the result of mixing any two primaries: Red mixed with yellow produces orange. *Tertiaries* are created by mixing a primary with an adjacent secondary: Red (a primary color) mixed with violet (a secondary color) produces red-violet.

Complementary colors are those hues that are directly opposite one another on the color wheel. Red is directly opposite green; thus they are known as complements. Mixing a color with its complement neutralizes the original hue, a technique often used by artists to control a color's

This value scale illustrates 9 gradations of green, from low (dark) to high (light). Every hue in the spectrum can be similarly divided into a range of values.

This color wheel is divided into 12 hues. They include the primaries (red, yellow, blue), the secondaries (orange, green, violet), and the six intermediate steps of color called tertiaries. This circular arrangement makes it easy to identify pairs of complementary colors, which lie directly opposite each other, 180 degrees apart on the wheel.

intensity (chroma). If you want to tone down some green, just mix in a bit of red. However, if you want to *intensify* the green, place some red *next* to it. The very quality that neutralizes complementary colors when they are mixed together—their extreme contrast in hue—produces the greatest color vibration when they are next to one another.

The color wheel displays other aspects of color organization as well. *Cool colors* are those hues with an inclination toward blue, such as green, blue, and violet. In artwork, these colors appear passive and tend to recede. In contrast, *warm colors,* such as red, orange, and yellow, appear active and tend to advance. The use of color temperature not only increases an artist's capacity for psychological expression, but also enhances the spacial interaction within a design.

Color harmonies or *color schemes* involve the organization of one or more colors in a single composition. *Monochromatic harmonies* are the simplest. They employ a single hue in conjunction with white, black, and/or gray. A modified monochromatic color scheme adds a little variety by including a subtle suggestion of other colors, but is dominated by a single hue. *Analogous harmonies* include colors that are near one another on the color wheel; for example, yellow, yellow-orange, and orange. A wider analogous harmony might also include red-orange or yellow-green, but seldom is more than a third of the color wheel used in this type of color scheme. Analogous colors are naturally harmonious because they all share a common hue.

Color theory is a fascinating and complex subject, one worth a lifetime of exploration. It is the key to understanding how color works. The application of this knowledge, however, must consider the inherent properties of each medium. When drawing with color, the outcome of your composition is influenced by the specific characteristics and limitations of the materials you use. Transparent markers and watercolor pencils will behave quite differently from pastels and oil sticks, but with a bit of practice and an awareness of basic color theory, you will be able to make all their colors work *with* you, not against you.

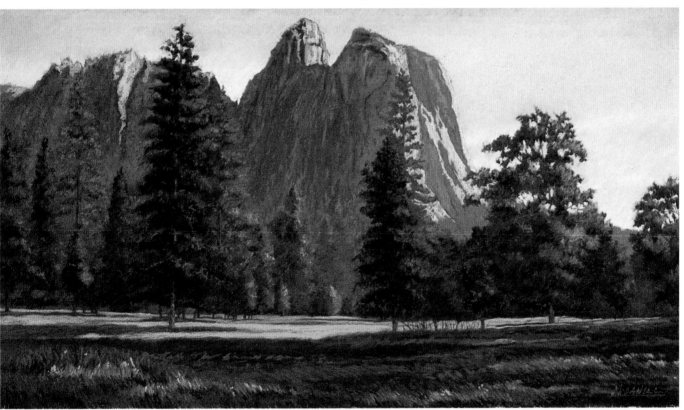

YOSEMITE VALLEY
Pastel and pastel pencil
on sanded paper,
20 × 36" (51 × 92 cm).

Compare this color version with the charcoal and chalk version on page 99. Having worked out the value scheme in the black-and-white drawing, I could concentrate on the sensation of late-day sunlight flooding the valley with a variety of warm and cool colors.

WORKING WITH CRAYONS

Many materials are surprisingly similar but for the differences in their binders. For example, oil paint, pastel, and watercolor (three media that are considered separate categories in art competitions) include essentially the same pigments. It is the *binder* (oil, gum tragacanth, and gum arabic, respectively) that imparts the characteristic properties to each medium.

Crayon, at least in the American sense of the word, uses wax as its binder. The pigment is combined with a heated wax or waxlike substance and molded into various crayon shapes. The resultant sticks of waxy pigment produce richly colored marks that adhere strongly to most surfaces. Of course, there is great diversity among products, based on the precise ingredients used. Crayons differ in hardness, opacity, shape, and watersolubility.

Crayons have one trait in common that sets them well apart from most of the materials we have discussed thus far: They do not erase. They can be scraped down to a degree, but the easy erasability of pencil and charcoal is missing from the crayon image-making process. Hence, a slight shift in attitude is required when applying crayon to paper. The image is either applied in a decisive, gestural fashion where no modification of design is employed, or the drawing is adjusted by means other than standard erasing.

The intrepid mark of the crayon is ideally suited to the bold hand. The simple and masterful line drawings of Matisse and Picasso are examples of forceful strokes, and crayon provides a direct channel for transmitting the artist's energy from hand to paper.

As to the "give and take" approach of manipulation and adjustment, one must plan ahead, scrape down, or cover over. In the first instance, planning ahead, I often think of this approach as *sculptural*. By this I mean it is a matter of "constructing" the drawing as if carving a shape out of a block of stone. Michelangelo said that he felt the image was already inside the stone; he was just releasing it by carving away what was superfluous. Tonal drawing with crayon suggests to me the same concept, although in reverse.

Since tones cannot be easily lightened, nor can highlights be lifted out from a dark background with an eraser, light portions of the design must be planned in advance, relying upon the value or color of the ground. A form can also be made to appear lighter by darkening the shapes surrounding it, thereby increasing contrast. To that end it is wise to avoid making any areas too dark too soon, for adding darkness is your primary means of adjusting value. In some cases it is possible to gently remove pigment by scraping it away with a knife, but unless your paper is extremely smooth, it is not feasible to scrape down to pure white. When working in color, though, you can certainly scrape away enough pigment so that a new color can be worked in. Some of the finer crayons, such as Caran d'Ache Neocolor, have such covering power that highlights can be made on top of the drawing with a light-colored crayon. This approach suggests the versatility of paint. In fact, the distinction between drawing and painting is blurred considerably with the use of crayons, especially oil pastels and oil sticks.

Yet another crayon application involves the use of solvents such as turpentine to break down the waxy binder and spread the pigment around in a fluid state. This can be a particularly satisfying technique, since it creates flat, paintlike tones into which the crayon can then be reintroduced. This linear/tonal combination of bold strokes and soft edges can be striking.

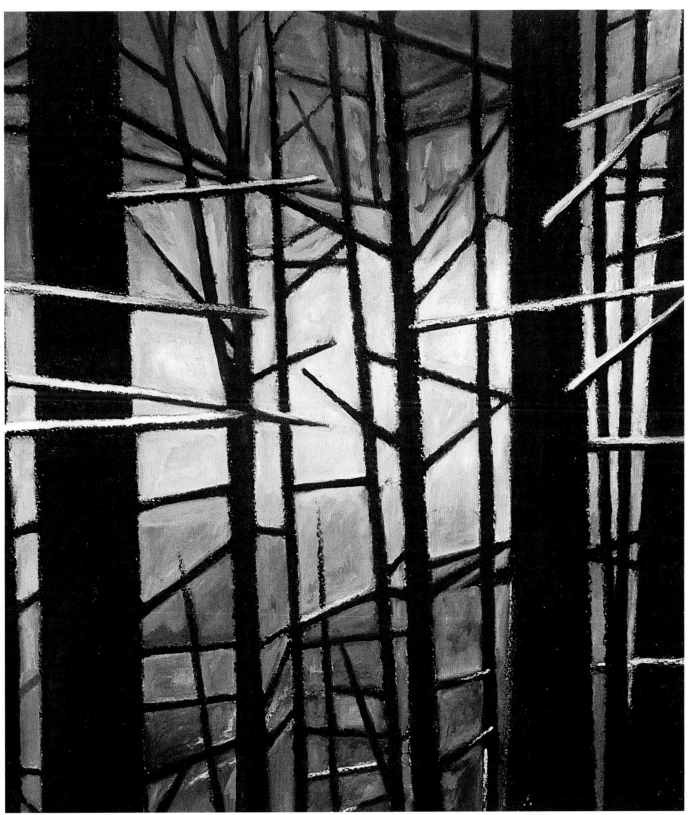

MOONLIT
Cattle marker on
Multimedia Artboard,
16 × 14" (40 × 36 cm).

Directness in handling and extreme opacity make cattle markers well suited to bold or expressive drawings. They are by no means a delicate medium, and therefore encourage simplification of design. For this piece, I used the marker like a crayon, then dissolved the pigment with turpentine and a bristle brush. After it dried, I reintroduced the marker as a top layer. The white is opaque enough to cover the black, and the black to cover the white.

NEUTRAL COLOR

Bright, fully chromatic color is not the only way to utilize color in art. It is usually value that commands the viewer's attention. Sometimes subtle coloration is all that is needed to convey the image, as long as the value relationships are sound.

Various grays and subtle earth tones are known as *neutral colors*. When used in conjunction with brighter colors, the neutrals play a subordinate role, allowing the dominant colors to stand out effectively. When used alone, neutral colors keep the image subdued but not suppressed. A composition of neutral colors, often called *achromatic*, can be a gentle introduction to the realm of color. If you've been working comfortably in black and white but hesitate to tackle color and all its complex relationships, try working with neutrals at first. Then add a single color, then two, then more.

DEMONSTRATION: YARKA SAUCE

Made from natural pigments and clay, these Russian crayons were unavailable until recently in the West. They are smooth, cover well, and stick to paper like fleas on a hound. They are like a cross between crayon and pastel, just not as waxy as the former or as dusty as the latter. Their subtle earth tones are of a pliant consistency, allowing the artist to push the color around on the paper quite freely.

The 10 Yarka Sauce colors range from black to white through a range of grays, often with a subtle greenish or brownish cast. These drawing crayons are ideal for executing a harmonious composition with a neutral color scheme. The still life in this demonstration was done on Arches 88, a printmaking paper with a smooth, delicate surface quite receptive to crayons.

Because Yarka Sauce is creamy and opaque and I plan to interpret the subject loosely, I can do all my sketching directly with one of the crayons.

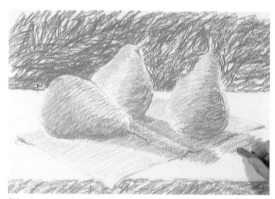

I begin defining form by generously scribbling with a moderately dark crayon.

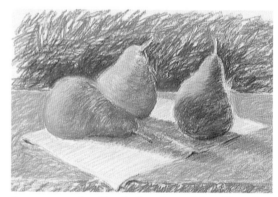

A warm gray describes the flat plane of the table and fills out the local tone on the pears.

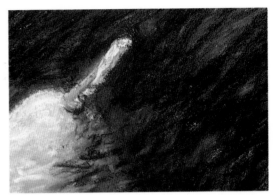

A lighter gray slurs the other tones together loosely. This creates a more active drawing than one made with soft blending. Note how the black marks in the background are drawn into the shadow area of the pear on the left, softening the edge and adding kinetic energy.

This detail shows how the light-colored crayon evokes the sensation of light falling upon a form. The contrast of the dark background intensifies the effect.

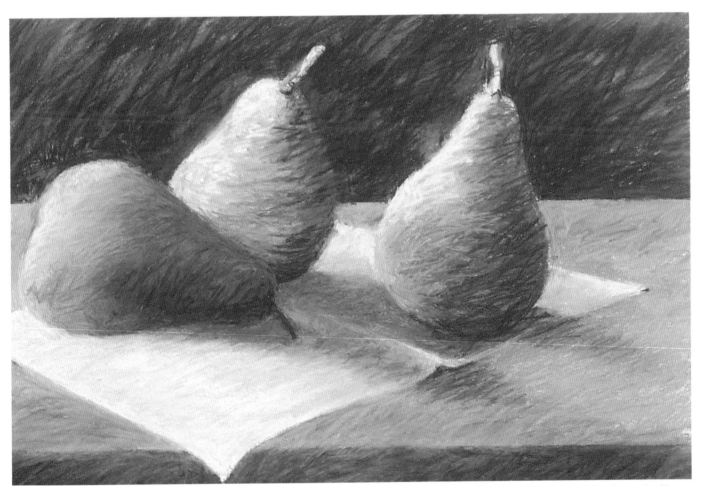

RED PEARS, ORGANICALLY GROWN
Yarka Sauce crayon on Arches 88 paper, 13 × 20" (33 × 50 cm).

One approach to drawing that often yields intriguing results is that of working larger than life-size. Each pear in this composition is about 8 inches (20.32 cm) tall, more than twice the actual size of the fruit. When beginning artists work at too small a scale, the result is often a rigid and constrained drawing. Working large automatically induces a freer application of tone and allows the artist to suggest details with a relaxed stroke. In Red Pears, the individual marks are casually scribbled, but the overall shapes are not destroyed by the loose application of crayon.

BLACK AND WHITE ON A COLORED GROUND

Color need not always be applied with ink, paint, or crayons. Sometimes the color can be in the paper itself. Using a colored ground is an effective way for adding interest to drawing with black and white media. All the dark (low-value) marks are applied with a black marker, such as black crayon or charcoal, while all the light (high-value) marks are applied with white crayon or chalk. This leaves the colored paper to portray all the mid-value tones of the composition.

The paper's color adds an overall mood to a drawing. This is one way to create a monochromatic composition using only black and white marks. For example, if the paper is a medium blue, the drawing will appear to be bathed in blue light, with roughly five value steps. Where the black crayon is densely applied, it will appear black; where it is lightly applied, the black will optically mix with the blue paper, resulting in a dark blue; the untouched blue paper suggests blue local color in the drawing; where white is lightly applied, the result will be light blue; and finally, densely applied white will create the highest value in the drawing, suggesting the effects of sunlight.

DISINTEGRID
Charcoal and white chalk on Canson paper, 11 × 18" (28 × 46 cm).

This drawing suggests the many tonal effects possible with charcoal and chalk on colored paper. The range includes full-strength white and black; mixtures of the two, producing several opaque grays; the pure, unmodified color of the paper; and a variety of tones resulting from the colored paper peeking through the pigment and optically blending with the white, black, and gray.

DEMONSTRATION: LITHO CRAYON AND CHINA MARKER

Although a lithographic crayon is intended for drawing on a smooth stone, it is equally effective on textured paper. The wax, soap, and lamp black that comprise the ingredients of the crayon enable it to cling to nearly all surfaces. You might want to compare litho crayons on very smooth cardboard and on rough watercolor paper. I particularly enjoy using litho crayon with white China marker on a toned ground. These two opaque crayons are frequently used together, for they both have the same waxy consistency.

Large areas of tone are laid in quickly with a litho tablet.

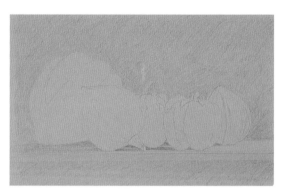

Since this procedure requires a paper of middle value, I have selected an greenish ochre Ingres paper. Erasure is next to impossible with lithographic crayon, so I work out a preliminary sketch in pencil on a separate piece of paper. To begin on the Ingres paper, I outline the design lightly and block in a background tone.

Now that the background is dark, it is easier to determine how dark to make shadows. I use a softer No. 2 crayon in a makeshift lengthener—the cap of a discarded pen.

A litho crayon in pencil form is convenient to use and easy to control. Here I am drawing the furrowed planes of the squash with a Korn's No. 4 (hard) litho pencil.

I decide to adjust the curve on the left and scrape off some of the crayon to eliminate any ghost image from the previous outline. A single-edge razor blade removes any crayon build-up that might be visible beneath the new shape. The contour of the squash that existed in reality was not convincing in the drawing, so I changed it. Sometimes you must fib for the sake of clarity. As Picasso once said, "Painting is a lie that tells the truth."

The fun part is pouring light onto the drawing with a white China marker. It has the same greasy feel as the litho crayon, and the two materials are often combined. Here I am keeping the white clean. A completely different look results from slurring the black and white together and creating shades of gray.

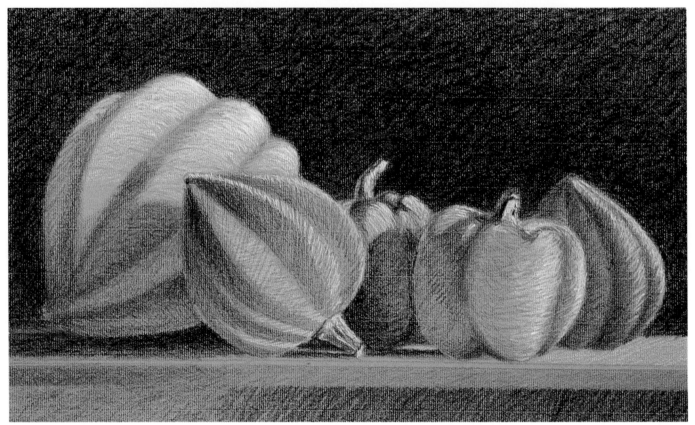

SQUASH AND PEPPERS
Lithographic crayon and China marker on Ingres paper, 9 × 15" (23 × 38 cm).

While only black and white marks were used to create this image, the hue of the paper makes this a "colored" drawing. Note how several different values of color are suggested by the various densities of black and white.

BUILDING COLOR GRADUALLY

There are several benefits to building color gradually. First, this technique allows you to think deliberately as you design an image. Little adjustments are easy to make if no single part of the composition is completely refined before the rest. Also, color that has been built up in stages has a different character than a solitary layer of color. Plying in several layers of pigment, weaving each color on top of the last, creates a richness of hue that is otherwise unobtainable.

Although this method can be used with virtually any medium, it is particularly handy for crayons, as their wax binder makes erasing extremely difficult. By establishing color and value through gradual layering, an artist feels less pressure to be precise. Moreover, such an approach offsets to some degree an overly cautious attitude toward applying each non-erasable mark.

THE DELTA AT GRIZZLY ISLAND
Neocolor crayon on Multimedia Artboard,
9 × 15" (23 × 38 cm).

Unless you leave them in your closed-up car on a scorching day, crayons are a very convenient medium for on-location drawings. For this piece, I backed my rented car up to the scene and sat on the rear bumper, the lid of the open trunk providing shade. The basic shapes are quite simple, and I blocked them in quickly. The rest of the time was spent working the crayons, putting in color and scraping it out.

DEMONSTRATION: CONTÉ CRAYONS

Nicolas Jacques Conté (1755–1805), a French painter, chemist, and inventor, is remembered by artists for two reasons. Conté created an early type of pencil by devising a system of mixing clay with graphite, and also developed the hard crayon that bears his name.

Conté crayons have been in use for two centuries and are still popular today. The traditional crayons have a limited color range of black, white, and a few earth tones, such as sanguine. Recently the company has expanded on the sedate palette of the classic crayons into a lively chromatic range of 48 highly pigmented colors. They perform just like the classic Conté crayons, but obviously offer a greater range of descriptive possibilities.

A hint of local color is suggested by a light layering of crayon. Conté crayon is not easily erased, but more color can be added on top as the image shapes up.

After sketching my image in pencil, I partially erase the lines so that only a faint guideline remains. I don't want any shiny graphite to be visible in the finished drawing. By using the side of a black Conté crayon, I lay in the background in broad sweeps, being careful not to get too dark at first—just enough to project a general tonality.

With some reddish hatching beneath, I apply a thicker layer of orange, forcing the color deeper into the paper and eliminating much of the white.

It is now time to bring the background along to a richer darkness. After making a few strokes with blue and purple, I slur them together with a black crayon. This provides a dark background that has more color interest than one of flat black. Immediately the form of the pumpkin seems to advance from the background because of the sharp contrast.

Another layer of orange at a slightly different angle unifies the surface. At this time I work deliberately and carefully as I render details. (For small or precise shapes the crayons can be sharpened with a razor blade.)

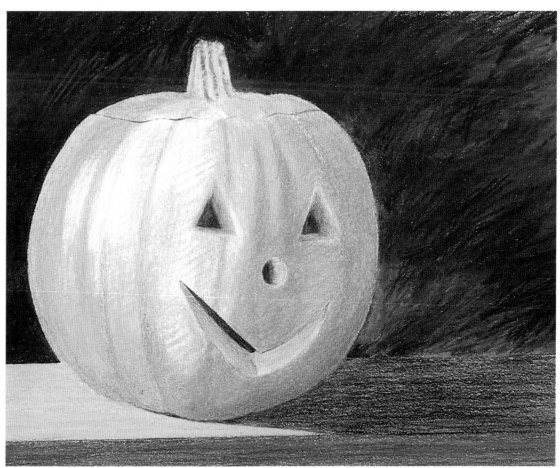

PUMPKIN ON A PLANK
Color Conté crayon on
Arches Satiné paper,
10 × 12" (25 × 30 cm).

The final image is whimsical, but then so is Halloween. For some interesting variations on this drawing, turn to page 62 for a discussion of xerography and color copiers.

DRY COLOR: PASTELS AND PASTEL PENCILS

Let us dwell for a moment on the fine line between drawing and painting. Extreme examples are easy to recognize: A linear treatment with pencil on paper is clearly a drawing, and a fully articulated, colorful oil is clearly a painting. Of course, a drawing may be "painterly," and a painting may have a "well-drawn" element, too.

Drawing and painting interact constantly, even in the most definitive cases. Additionally there are instances, midway between these two extremes, where the distinction is absolutely beclouded. And maybe it is also irrelevant. Pastel, for example, glides in and out of each category, its colorful pigment aligning it with painting, its immediacy and dry application linking it to drawing.

Pastel is a unique medium, one that yields the effects of line, tone, and color simultaneously. Pastels are especially prized for portrait and landscape work, as they lend themselves to quick execution in full color. They use no oils or solvents, require no drying time, and have no odor (although they can be a bit dusty).

Venetian painter Rosalba Carriera (1675–1757), who executed her work predominantly in pastels, brought the medium to international prominence in the 18th century. Edgar Degas (1834–1917) is also closely associated with pastel. His images of dancers and horses attest to the suitability of the medium for capturing the fleeting pose with spontaneous line and pure color.

While the basic shape of a pastel stick is suitable for making gestural lines and broad passages of tone, the pastel pencil is ideal for detail work. It handles like any other pencil, yet pours out a richness of color that typifies pastel painting. It is perhaps the action of using a pencil, more than anything else, that links it most directly to the act of drawing. The tactile sensation is the same as that of a charcoal pencil; that is, the feel is very dry and the pigment is fairly soft. Most of the better brands use the purest grade of artists' pigment for their pastel pencils. If you use good paper and frame a pastel drawing properly under glass, there's no reason it shouldn't last for centuries.

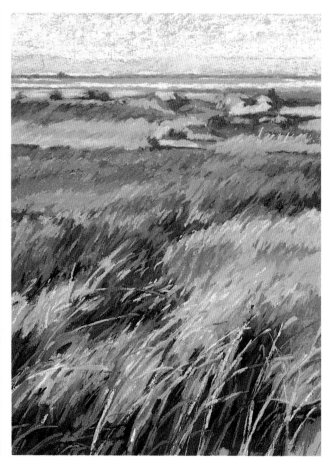

TULE RHYTHM: MONTEZUMA SLOUGH
Pastel on textured board,
18 × 12" (46 × 31 cm).

One of the chief attributes of the pastel medium is its strongly pigmented opaque color. Here you can see it resonate, especially where a brightly colored stroke crosses over a dark part of the background. Pastel requires a somewhat toothy surface to which its particles of pigment can adhere, and in this instance I prepared my own coating and applied it to a Masonite panel. The mixture—one of many suitable variations—consists of pumice powder stirred into liquid acrylic medium and a little gray paint. When brushed onto a support and spread out evenly with a short-napped roller, it provides a particularly receptive surface for pastel.

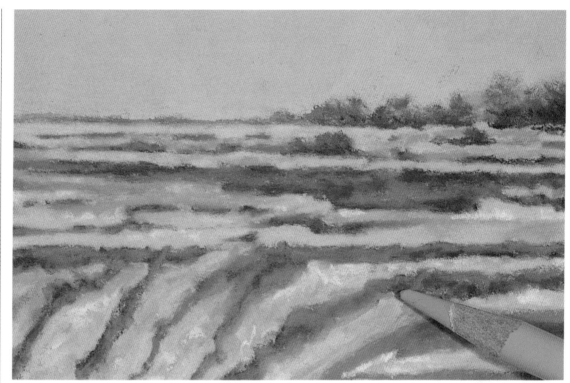

Pastel pencils are often used for details within a painting done with regular soft pastels. At times, however, there are so many little shapes in a particular composition that the bulk of the image is executed with pastel pencils. In Niagara, *the bands of water and foam were too narrow to be drawn with anything else.*

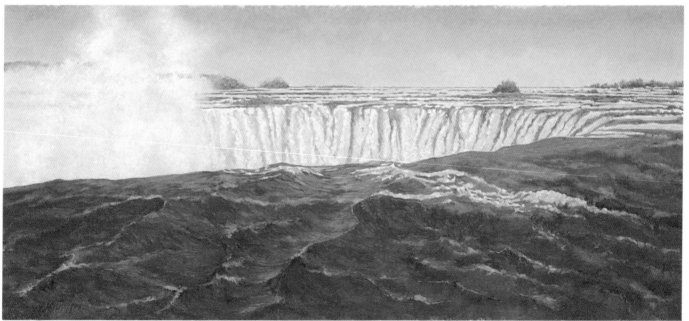

NIAGARA
Pastel and pastel pencil on sanded paper,
12 × 27" (30 × 68 cm). Courtesy of John
Pence Gallery, San Francisco.

Although regular pastels were used as an underpainting, only the sky and the mist were done exclusively with soft pastels. The other elements of the composition required the liberal use of pastel pencils.

DEMONSTRATION: PASTELS

Drawing isn't just a preliminary step in the painting process. Sometimes the drawn image develops as the artwork progresses, with compositional choices resolved on the spot, rather than planned in advance. This pastel drawing is an example of a searching, improvisational approach. Completely circumventing the preparatory sketch, it began merely with a vague idea from my imagination.

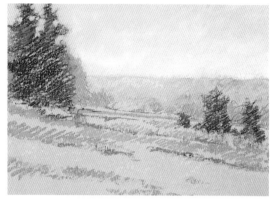

I soften the sky by adding more pastel and really pushing it into the paper, blending the color. The sky produces an overall golden mood, as a sense of landscape space becomes apparent.

The first step is a simple massing of large shapes, a blocking in of what I hope will become the major elements of the design. I use dark brown to represent the darkest value, sketching in blue nearby. Some earthy streaks of color establish a linear path between the dominant and subordinate shapes.

Next I add a layer of brighter color and continue to clarify the forms of the trees.

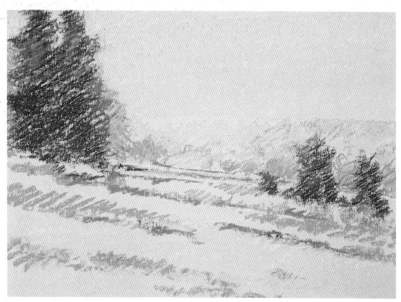

The first few layers of hatched color begin to suggest a rhythm while giving rise to some of the forms.

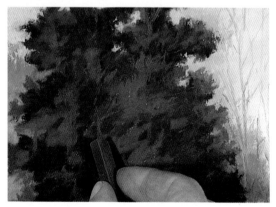

Using the edge of a hard pastel stick, I suggest some tree trunks on the left . . .

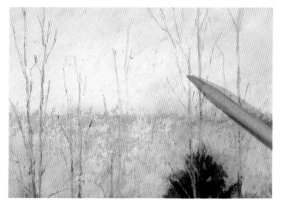

. . . *while using a pastel pencil for the thin branches on the right.*

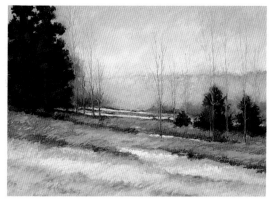

Although I like the brightness of the purple and orange, I decide to tone down the intensity of the color in an effort to portray the effects of a hazy atmosphere and golden light.

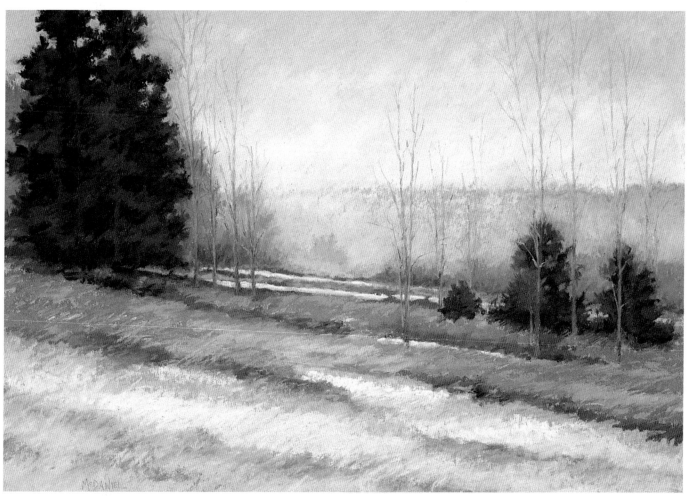

DECEMBER: RADIANT MIST
Pastel on sanded paper,
13 × 21" (33 × 53 cm).
Courtesy of James Cox Gallery,
Woodstock, New York.

To complete the painting, I added a little purple-gray bush just left of center to improve the transition from one side of the composition to the other. At its heart is a simple dialogue between large and small masses, with a unifying tonality of warm, hazy light.

DRY COLOR: PASTELS AND PASTEL PENCILS

DEMONSTRATION: PASTEL PENCILS

Drawing with pastel pencils provides an opportunity to use the pure, matte color of pastel while maintaining the line quality of pencil. Pastel pencils work well for a colorful line drawing or, as in the demonstration drawing, can be used to create a hatched tonal design. The application of color in this drawing is less dense than in a pastel painting, and the hatching strokes of the pencils are quite apparent. Still, the intensity of the color moves this image close to the realm of painting.

For the demonstration I chose La Carte Pastel as my drawing surface. Its muted purple was analogous to the color scheme I had planned, and its velvety surface receptive to pastel.

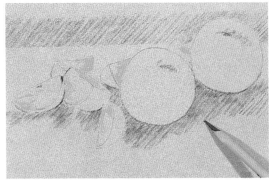

I begin with a basic contour drawing, starting with a bit of hatching with indigo blue. Not much color at first—I plan to build up the color in stages.

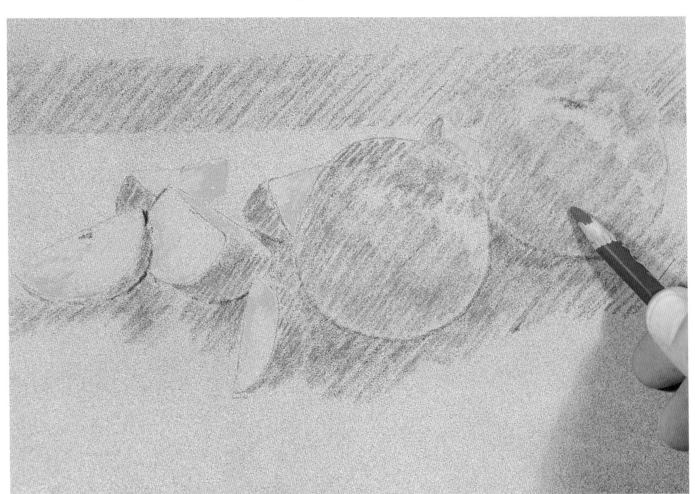

Now I apply a hint of local color for the apples' skins, but without highlights.

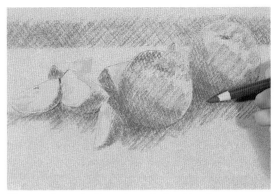

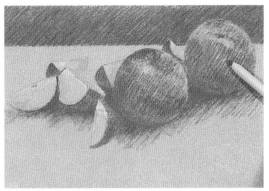

Here the "weaving" continues by hatching lines at a different angle. This provides an opportunity to soften edges by crossing over two forms with the pastel pencil. I also add a little darkness to the background.

After gradually building up the composition I ply in a bit more color, in this case a warmer red for the skin.

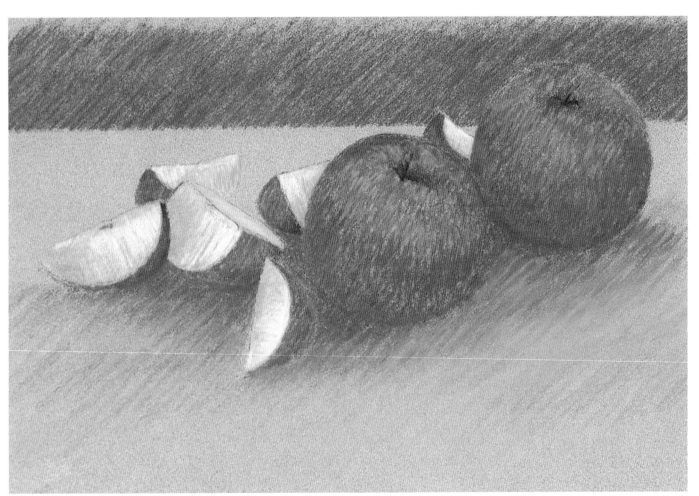

THREE APPLES
Pastel pencil on La Carte Pastel,
8 × 10" (20 × 25 cm).

I waited until the very end to add the highlights—touches of warm reds and oranges—to keep the color fresh. Notice also how a few streaks of red in the background blue connect it visually to the apples.

COLORED PENCILS: WET AND DRY

Unlike the weakly pigmented products we remember from childhood, the colored pencils on the market today are truly a fine art material. The new products come in a range of up to 120 lightfast colors. They are of high tinting strength and have a smooth handling consistency.

Although a colored pencil may look like a pastel pencil, they are miles apart. Gum tragacanth is the binder for pastel, while the pigments in colored pencils are held together with various forms of wax. The resultant product has a completely different feel than pastel.

The manner of application is a bit different as well. Dark values must be built up gradually, constructed rather than laid down in a single stroke. While layering and cross-hatching are useful options in pastel, they are the real bread and butter for creating intensity with colored pencils. One word of caution, however; don't use black as a darkening layer. It is a flat color, and if carelessly used it will make your picture dull. If you need a darker color than any you have available, put down some black *first* and then apply a color on top, not vice versa.

The wax binder in colored pencils is evident in their smooth handling, but can also be harnessed for its polishing effect. *Burnishing* is achieved by forcefully layering a light color over a previously applied layer. The action smooths out the texture of the paper and brings up a slight sheen. With practice you can control this technique for blending color, almost to the point of applying a translucent glaze over a portion of the image. (For an example, see *Riparian Winter,* page 5.)

Just one step beyond is the watercolor, or aquarelle, pencil. Used dry, it behaves the same as a regular colored pencil, but when wet the pigment dissolves and turns to watercolor. The watersoluble binder that enables this transformation to occur is quite a breakthrough, and as artists we are the beneficiaries of this recent technology.

Watercolor pencils are a versatile medium. While they are a proficient stand-in for regular colored pencils, you should always be thinking of their watersoluble capabilities. Hence, it is wise to begin with a paper that is able to withstand wetting. I prefer to use a watercolor paper, and think of these pencils as watercolor in stick form.

Probably the most common way to use this product is to start a drawing by scribbling in some color with a pencil, then dissolving and moving the pigment around with a wet brush. I have also found that by dipping the point of a watercolor pencil in water and drawing a line, I get a bold and intensely pigmented stroke. This is good for dark accents and sharp contrasts.

Another technique I find useful is to consider the pencil lead to be a little cake of watercolor. You can touch the pencil point with a wet brush and pick up color just as you can with a pocket watercolor set. This is a fine method for small on-location paintings. There are a great number of colors to choose from, offering a wide selection—even before mixing.

Working directly off the pencil tips is too awkward for a bold-wash watercolor technique, but is completely serviceable for small pointillist images. And don't forget the added advantage of layering colored line work on top of the wash if you so choose.

Colored pencils can be particularly handy for a quick sketch. As I was working on the demonstration for Autumn Cottage *(see pages 136–137), I looked over my shoulder and was reminded how much I like the view to the side of my studio. Within a minute or two I sketched in the green layer. Next I picked up two more pencils, magenta and violet, to add some touches of color. With just three pencils, and in about 10 minutes, I set down enough compositional information in this sketch to capture the most prominent features of the scene.*

Dipping an aquarelle pencil in water before drawing a line transforms the lead into its watercolor state. The color is more intense, and therefore works like an accent, adding liveliness and rhythm to the drawing.

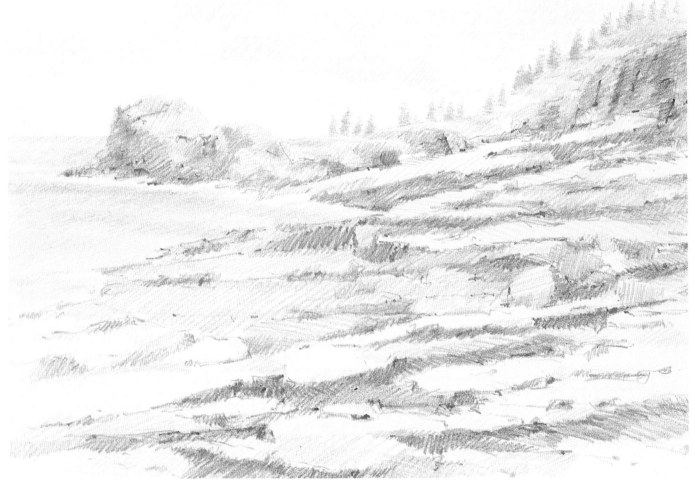

GULL ROCK
Bruynzeel Design Aquarel pencil on
Arches 140-lb. hot-pressed Aquarelle paper,
7 × 10" (18 × 25 cm).

Here I am holding an aquarelle pencil in my left hand and touching the pencil tip with a moist brush to pick up color. I transfer the pigment to the paper in small transparent patches, occasionally adding more water to the drawing to spread out the color.

DENALI FROM TALKEETNA
Derwent Watercolour pencil on
Arches 140-lb. hot-pressed
Aquarelle paper, 4 × 6" (10 × 15 cm).
Collection of Frayda Kafka.

The technique of using a wet brush and watercolor pencils is very convenient when traveling. This image of Alaska's Mount McKinley (Denali) is a view from the little town of Talkeetna, a good 50 miles (83 kilometers) to the south.

DEMONSTRATION: COLORED PENCILS

I don't usually like autumn paintings, especially those depicting peak foliage. Walking through the New England countryside on a fall day can be delightful, but paintings of the experience seldom capture the ambiance of the moment. The colors just don't look real. The subtle autumn paintings of George Inness (1825–1894) are successful because of their muted color, but the intense coloration of fall foliage at its peak can be a recipe for disaster.

Nonetheless, I couldn't help working on this image during a glorious October afternoon. I had just bought this little cottage in the spring, and it was the first fall I had seen on the property. The view is from the front porch of my studio, and to tell the truth, the real color was far brighter than I could show.

I start with cool colors only. Paying special attention to the architectural proportions, I use the edge of a piece of matboard to scribe the straight lines.

Next I hatch in several colors throughout the composition as well as light gray lines that follow the contour of the building. This gives direction to the form and will help maintain the integrity of the planes when I add crosshatching later on.

Since the image will contain so much yellow, I make sure to bring in some yellow at an early stage of the drawing to establish the overall mood of the composition.

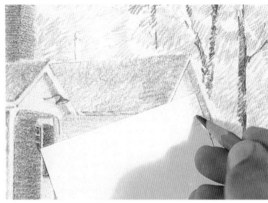

To maintain an even margin when using an open-stroke technique, I use a notecard as a straightedge. I begin each stroke on the card and pull the pencil point into the image. The resulting tone has both the accuracy of a straightedge and the looseness of freehand crosshatching.

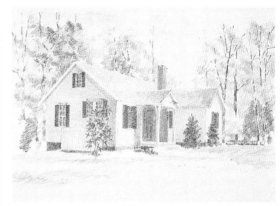

At this point the image is quite pale, but the colors and shapes are falling into place. Since no pigment has yet been applied thickly, it is still possible to erase and make some adjustments.

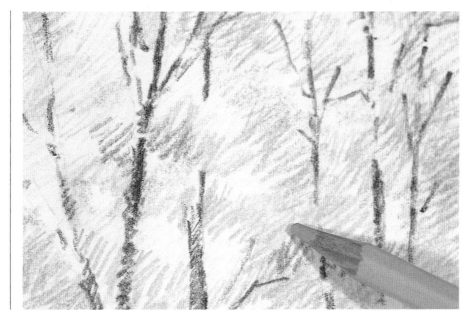

I drag yellow over the other colors to mimic the aureate glow of sunlight filtering through the leaves. By pressing hard, I can burnish the yellow on top of the previous layers of color. The effect is somewhat like a glaze of yellow light.

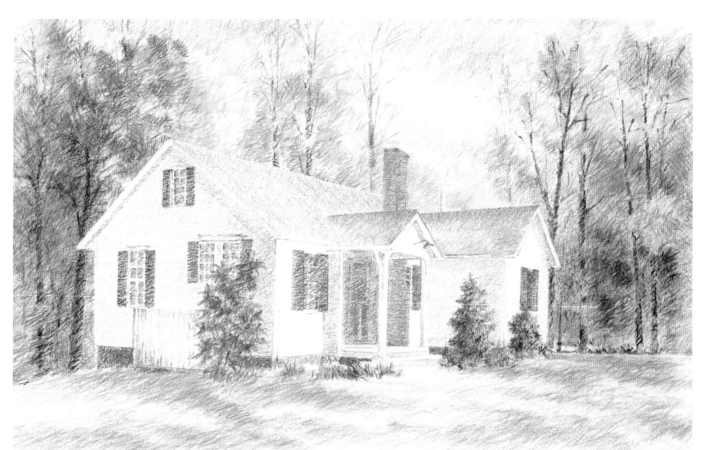

AUTUMN COTTAGE
Colored pencil on Lana Royal Classic paper,
9 × 15" (23 × 38 cm). Collection of Mr. and
Mrs. Edward Richardson.

The final drawing reveals denser color, the result of another layer of pigment. Note the yellow tint on what is visually accepted as a white house.

DEMONSTRATION: WATERCOLOR PENCILS

I composed this scene by combining a few sketches of my friends playing croquet. I am intrigued by the psychology of the sport and its effect on the posture of the players. I must admit, though, that I found the late raking afternoon light nearly as appealing as the game itself.

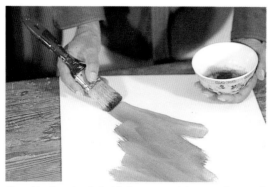

For this drawing I decided to start with a toned ground. After mixing a watercolor wash, I brush it onto a piece of Multimedia Artboard, which won't buckle when wet.

I begin with a simple line drawing, having made preliminary sketches in advance. As soon as the outline is drawn I wash in a little bit of blue in the space between the figures.

Using the watercolor pencils dry, I build up some of the flesh tones and the undertones for the clothing.

I add more color to the figures and increase the darkness of the background, thereby making the clothing appear brighter.

So far I've avoided the temptation to use any pure white for the clothing. The white is reserved for the final touches of light. However, the pale blues and light grays used here already suggest whiteness. The trick to showing brightness is to approximate the local color of an object without using pure color. When a small spot of pure color is laid upon this restrained background, it seems to glow, as if lit by clear sunlight.

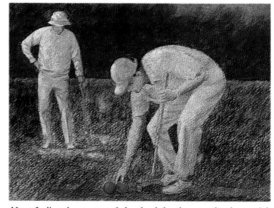

Next I dissolve some of the dark background colors with a wet sable brush. I strengthen the horizon and add bright color to the croquet balls.

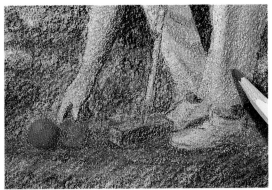

Even though the clothing is white, I can lace the shadows with plenty of color. I use the same red and blue of the croquet balls in the shadows to maintain color harmony within the composition.

Now I add brighter color to the grass and skin, flooding the picture with the light of late afternoon.

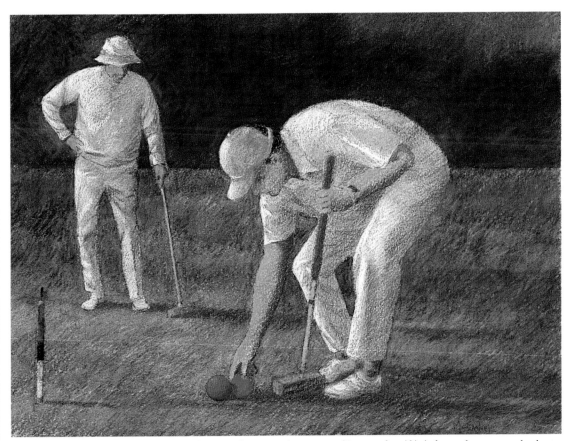

ROVER COMBAT
Derwent Watercolour
pencil on Multimedia
Artboard, 8 × 12"
(20 × 30 cm).
Collection of the
National Croquet Gallery,
Newport Museum of Art,
Newport, Rhode Island.

The completed drawing shows to what extent white can glow if it is layered over muted color and surrounded by contrasting darkness. The stake was added last, completing a triangular focal area. The two figures are looking at the croquet balls, which are aimed at the stake (the striker's mallet and the shadow of the stake strengthen this line), and the upward thrust of the stake leads the viewer's eye to the elbow of the rear figure. Furthermore, his feet are in alignment with the stake and the two balls, and the shaft of his mallet returns attention to the balls while the head of his mallet is in alignment with the stake.

For those of you who don't know all the nuances of the sport, the dejected figure in the rear is about to lose the game. His blue ball (which plays before red, and so has already had a chance to win—but failed) is now about to be "staked out" by his opponent.

STIPPLING WITH COLORED MARKERS

Markers have come a long way since ancient Japanese artists first placed felt nibs in bamboo pens. Early commercial markers were shunned by artists and relegated to laundry rooms. But in the past two decades there has been a great expansion in quality, variety, colors, and availability of art markers.

Markers dry quickly. To some this a blessing; to others it's a nuisance. Either way, drying time shapes how you work. You can build up layers of color without pausing for them to dry, a boon for rapid visualization. However, it's not easy to lay in broad areas of uniform color. The trick to creating even tone is to use as large a nib as possible, and to keep the leading edge wet. Some artists will open up a marker pen, extract the entire nib, and draw with the side of the nib—messy, but effective.

It is also difficult to create subtle gradations of tone. Try using a colorless blender or layering colors. Marker ink is transparent and behaves somewhat like watercolors. It helps to think in watercolor terms. I'm especially glad that watersoluble markers are now available. The ink color is intense and flows easily, yet there are no objectionable fumes. Watersoluble markers, such as Mars Graphic 3000 Duo Markers and Tombow Dual Brush Pens, can also be worked with a wet brush like watercolor. Be sure to use a watercolor paper if you plan to really soak your drawing.

This is a case where I recommend choosing one manufacturer and staying with their product line. You will want consistency throughout the color range as far as brilliance, liquid intensity, and paper saturation. Art markers are a medium that promotes speed, and speed comes from knowing exactly what to expect from your markers.

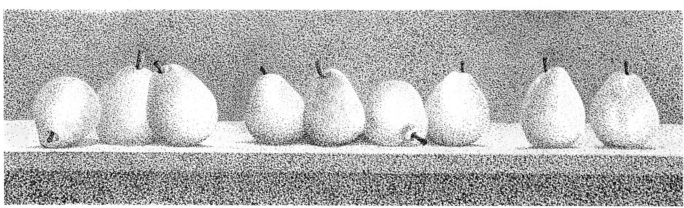

PEARADE
Mars Graphic 3000 Duo Marker on Lanaquarelle 140-lb. hot-pressed paper, 5¹/₂ × 19" (14 × 48 cm). Courtesy of James Cox Gallery, Woodstock, New York.

Airbrush, a computer, or the spatter technique will give you similar results, possibly in less time, but I find that markers are fun to use nonetheless. Since Duo Markers contain a watersoluble ink, you can easily lay in some color; hit it with a wet brush, and create a background wash. When the ink dries in a few minutes, you can add lines or stippling, as I have done here. Incidentally, I used only one pear as the model for this work.

DEMONSTRATION

Because they are easy to use and dry almost immediately, markers are often used by commercial artists and illustrators to render slick visualizations for advertisements. In contrast, building up a drawing with layers of colored dots may seem to be a painstaking process. True, it is slow at times, but the technique can create images of great charm. The pointillist paintings of Georges Seurat (1859–1891) and Paul Signac (1863–1935) are carefully arranged compositions incorporating a myriad of small colored dots. By means of the optical effect of *additive synthesis*, the eye merges the colors of the dots, producing an optical mixture. For example, if you apply tiny yellow and red dots immediately adjacent to one another, the result, when seen from a distance, would be orange—the same as if you had physically mixed red and yellow together. The characteristic shimmer of pointillist works can be echoed with the stippling technique using marker pens. Marker pens are also incredibly convenient. There's no need to mix colors, dip a pen in ink, or dip a brush in paint.

I use a number of different colors to build tone.

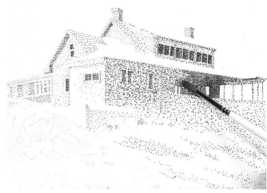

The ink in the Mars Graphic markers is watersoluble, so I use a wet brush to spread the tone around. Although it's not watercolor paper, the bristol board I'm using will accept some moisture without buckling.

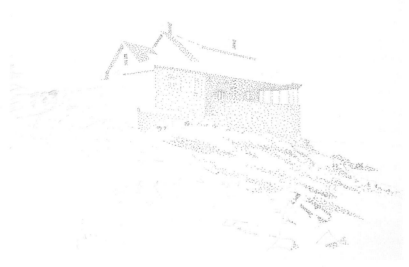

For the initial layer of dark stippling I use a pencil sketch as my guide. The ink dries quickly so excess pencil lines can be erased without smearing.

You can also scribble a marker on scrap paper and lift off the color with a wet brush. This allows you to create washes of varying intensity.

Stippling with Colored Markers

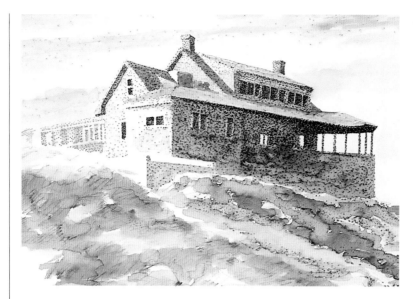

At this point I have spread out much of the ink in little patches of tone throughout the drawing. This underlying wash will help unify succeeding layers of stippled color.

I want sunlight to fall on the top of this post, so I scrape off the ink with an X-Acto knife. If you overuse this technique it will harm the paper, but it works fine in small doses.

I begin to cover the wash areas of the house with stippling.

(Above left) One end of a Duo Marker is fitted with a flexible nylon brush. I use it here to add calligraphic strokes in the foreground. (Left) Once again I use the knife, here to scratch through the darkness to create weed shapes. (Above) At this point the development of the image is drawing to a conclusion, so I make final adjustments by sprinkling dots throughout the sky, house, and foliage.

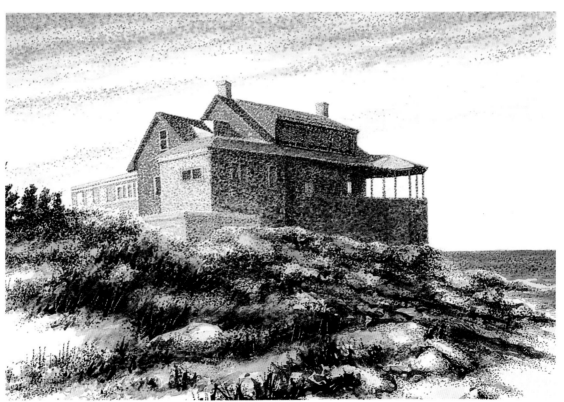

HOUSE AT SWIM BEACH
Mars Graphic 3000 Duo Marker
on Strathmore bristol, 8 × 12"
(20 × 30 cm). Courtesy of James Cox
Gallery, Woodstock, New York.

Even though stippling creates a diaphanous image, the tones are very dense. You can see here how important it was to leave some paper vacant in the foreground to relate to the openness of the sky.

DRAWING WITH PAINT

With oil pastels and oil sticks, perhaps the least distinguishable boundary between drawing and painting materials is at hand. These media are not identical, but share some crossover characteristics. Both are essentially crayons and applied with a drawing motion, yet both are also capable of a full range of luscious colors and painterly marks.

Of the two, oil pastels are a bit cleaner to use, in that they are easier to just pick up and set down without much preparation or clean up. They are usually small crayons, less than 3 inches (7.62 cm) long, but the pigments are clear and vibrant and will adhere to nearly any surface. Since oil pastels contain a wax binder mixed with a *non-drying* oil, they remain fresh, lipstick-soft, and ready for immediate application. This also means that completed drawings or paintings should be framed under glass.

A number of manipulations are at your disposal. While the tip of an oil pastel can be used to create linear marks, the whole crayon can be peeled out of its paper wrapper and used on its side for broad strokes. Once the pigment is applied it can be scraped or incised with razor blades, palette knives, or even the point of a pencil. In fact, a pencil works like a charm to delineate crisp edges and establish detail.

Turpentine and other oil paint mediums can be combined with oil pastels to achieve a host of painterly effects. Washes, glazing, and impasto textures are all easily accomplished, and the product is safely miscible with tube oil paints.

Oil sticks move one step closer to painting. In contrast to oil pastels, they contain a *drying* oil, such as linseed oil, which functions much the same as it does in oil paint. Depending on the specific color and the thickness of application, an oil stick layer will be surface dry in a few days,

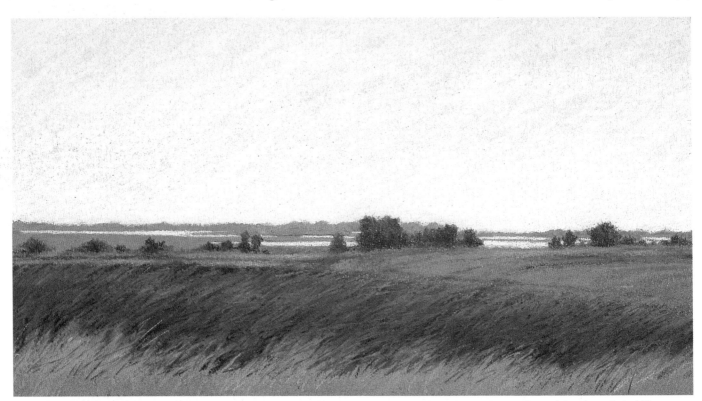

THE SACRAMENTO FROM THE MONTEZUMA HILLS
Neopastel on Daniel Smith Multimedia Artboard, 6 × 13½" (15 × 35 cm). Courtesy of John Pence Gallery, San Francisco.

This view of the distant river was my reward for early rising and a pre-dawn drive through the hills west of Rio Vista. After a few thumbnail sketches, I drew faint pencil outlines on the board, then started using oil pastels. Since the Neopastels' covering power is so strong, I could lay in a number of bright colors and then slur them together with a unifying layer of lighter color. The sky, for example, combines blue, purple, green, and pink beneath yellow and white.

or in some cases overnight. Once dry, they can be glazed, varnished, or worked on repeatedly with additional layers of oil stick or tube oils. For this reason, artworks created with oil sticks can be treated the same as any oil painting, and need not be framed under glass.

Oil sticks are larger than oil pastels, normally 4 or 5 inches (10.16 or 12.7 cm) in length, with "jumbo" sizes up to 6½ inches (16.51 cm) long and 1½ inches (3.81 cm) in diameter. To use them you must first peel back the film that forms at the end of the stick. If it weren't for this coating, the entire stick would dry out. Once it is stripped back, it exposes a continuous supply of pliant, colorful oil paint in a convenient crayon form.

The color goes on more like a paste than paint due to the balance of wax and oil that is mixed with the pigment. A line drawn with an oil stick does not drip or run, but it is certainly far from dry. It is a hybrid: not completely dry, not completely wet. It is neither exclusively for painting, nor is it exclusively for drawing.

As a drawing medium, oil sticks are not unique in their convenience or immediacy; other crayons have these qualities. But oil sticks possess these traits along with their absolute compatibility with tube oil paint, so an artist need not change materials (or mind-set) between drawing and painting. To put it succinctly, oil sticks offer an artist a direct, uncomplicated opportunity to draw with paint.

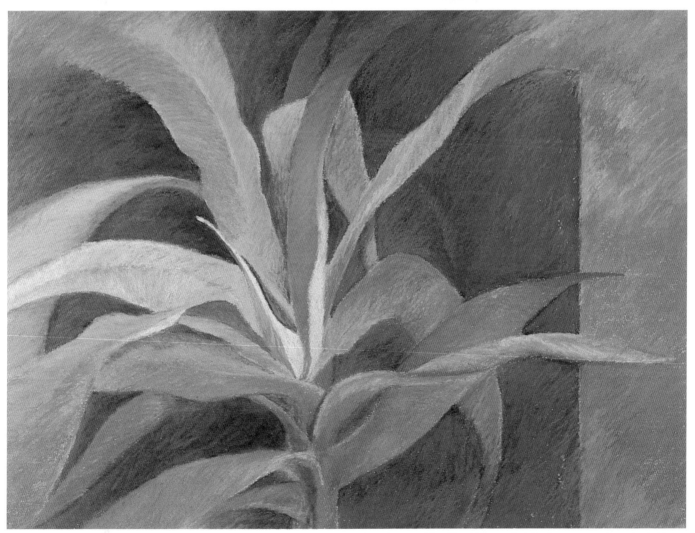

TROPICANARAMA
Oil stick on Multimedia Artboard,
17 × 23" (43 × 58.5 cm).

Warm hues are predominant in this color scheme, with a bit of blue and violet for contrast. I used a knife blade and my fingernails to create the mild, rhythmical hatching on the surface of the drawing. After incising into the pigment, I then softened the marks with a piece of paper toweling twisted to a point like a tortillon.

DEMONSTRATION: OIL PASTELS

Oil pastels are great for building up an image in layers. I like to scribble in a few strong colors and then slur them together with a layer of light yellow, gray, or white. This produces a soft, hazy tint with a suggestion of bright color that's great for skies or backgrounds. Of course, dark oil pastels can be slurred together to create a rich, low-value mixture.

My source material is a simple pen and ink line drawing of a little harbor in southern France. I sketched it quickly with a fiber-tip pen on a Derwent sketchpad.

After transferring the drawing to a 2-ply bristol board with the aid of Saral Transfer paper, I sketch in a few strokes with warm and cool colors.

Here I block in the basic image with near-complementary colors. It may look like a complicated mess of scribbles now, but I plan to pull it together as I progress. I hope to depict the color vibration of the Mediterranean light that caught my attention in the first place.

To create warmth in the hazy sky, I hatch in a few garish colors, knowing I will tone them down later. Oil pastel is reasonably opaque and malleable, so it's easy to build up layers in this fashion.

I use a white oil pastel to slur the colors together. Note how the white pastel picks up some of the underlying pigments. (Wipe the end of the pastel on a cloth or twist it on a scrap of paper to keep it clean.) This blending method creates an atmospheric effect, as though we are looking through a haze at bright objects. The distant boat at right continued to emerge as I worked.

With the sky tones under control, it is easier to work on the sails. At this stage, I avoid adding any details.

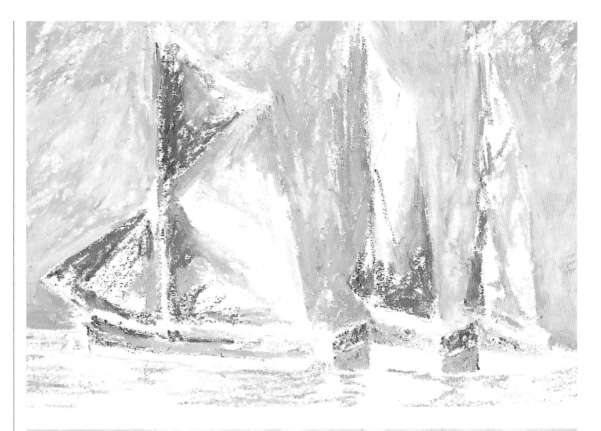

Gradually I define the forms, add color to the sails, and soften the sky.

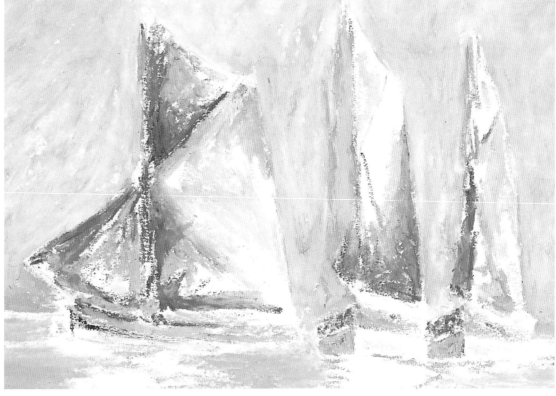

DRAWING WITH PAINT

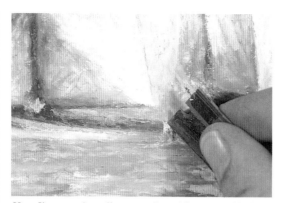

Here I'm scraping off excess color with a razor blade to create highlights. It's not quite as simple as using an eraser, but it works.

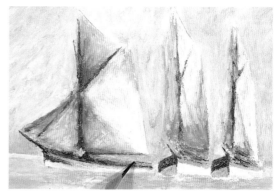

For a few select touches I use a regular pencil to further define small lines and to move the color around. If used sparingly, a pencil helps clarify an oil pastel image without altering its character.

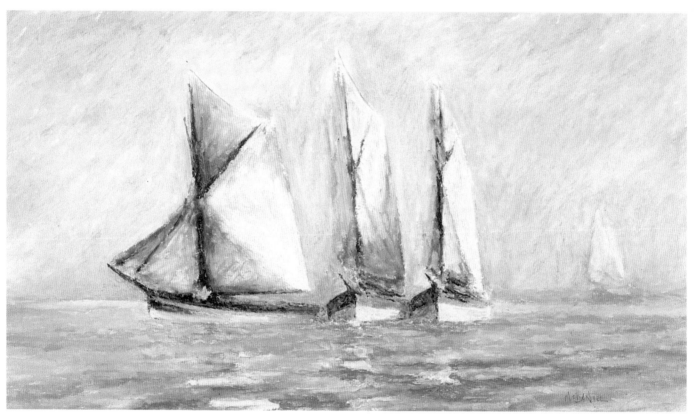

MEDITERRANEAN
Oil pastel on Strathmore 2-ply bristol
(plate finish), 6 × 10" (15 × 25 cm).

The completed picture has come a long way from those early scribbles. Now you can almost feel the warmth of the sun and sense the wetness of the water.

DEMONSTRATION: OIL STICKS

Oil stick is not a delicate medium. The size of the sticks and the manner in which they are applied are conducive to vigorous handling. Make sure you have a place to set the sticks down when not in use. I keep a small towel on the table by my easel. The sticks don't roll around on the towel, and the cloth absorbs any little specks of pigment that accumulate.

You will also need rags for your hands and to wipe the oil sticks from time to time. As the sticks wear down, little pieces of the protective film come loose and get into the paint. They won't harm anything, and sometimes add a nice organic blob in just the right place. But you may prefer to wipe the excess film from the tip of each stick.

This is one of my field sketches from Monhegan Island, off the coast of Maine. The fiber-tip marker is a great tool for suggesting the rugged angularity of the rocks. A bold drawing such as this makes a good starting point for oil stick.

I begin by sketching some quick lines in pencil, followed by a few outlines in Neocolor crayons. I used the large rock from the pen drawing, but add more shapes to the composition—partly from imagination, partly from another sketch.

Daniel Smith Multimedia Artboard is impervious to any rotting effects from the oil and provides a pleasing background color for the rocks. The sunny warmth of the paper will be a harmonizing factor; as new colors are applied they will all be affected by the ochre ground color. Using a small ultramarine blue Shiva Paintstik, I loosely hatch in the shaded areas.

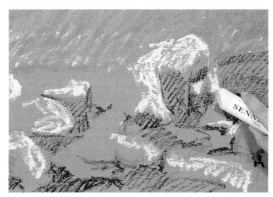

After a few strokes of sky blue, I pick up a Sennelier 96-ml stick and pour on lots of yellow sunlight. These jumbo sticks cover quickly and discourage fussiness.

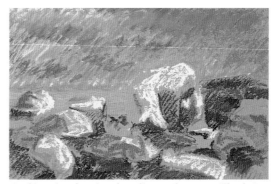

At this point there is color all over the paper. The design is ready to be evaluated and adjusted. The exaggerated color has a raw freshness I find appealing, but the composition has little definition. I decide to refine the image further.

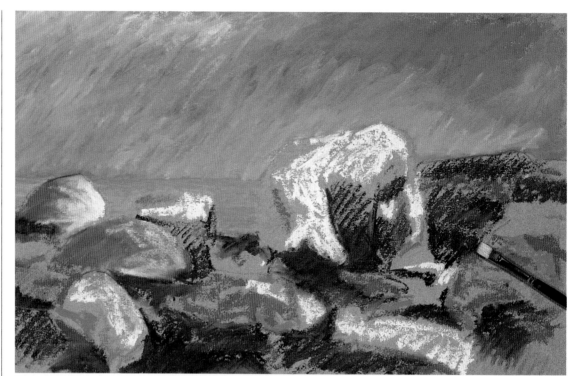

With turpentine and a No. 6 bristle brush, I blend the sky colors and begin slurring the shadow tones as well. This process unifies the design, but dulls the color somewhat. Fortunately I will regain color intensity as I add new layers of oil stick.

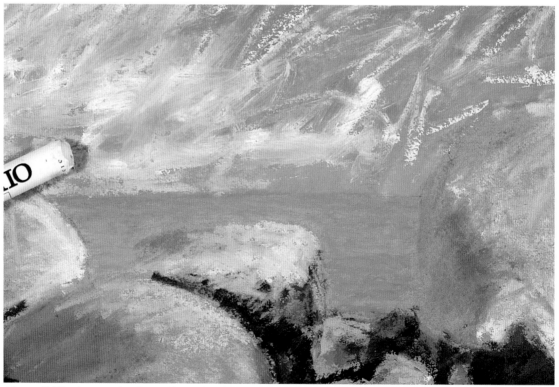

After scribbling in some titanium white and cobalt blue, I blend them together with a Winsor & Newton Colourless Oilbar, which softens and slurs the colors while making them more transparent.

R & F Pigment Sticks are highly pigmented and extremely soft and creamy. Here I use the king's blue (a cobalt blue and white mixture) to hatch strong color over some of the subdued passages. This also incorporates sky color into the rock mass, strengthening the color harmony of the scene.

As layers of oil stick build up, subsequent strokes reveal a marvelous texture, mimicking the rugged surface of the rocks themselves. A bit of indigo blue clarifies the deep space between rocks and redefines the shadows.

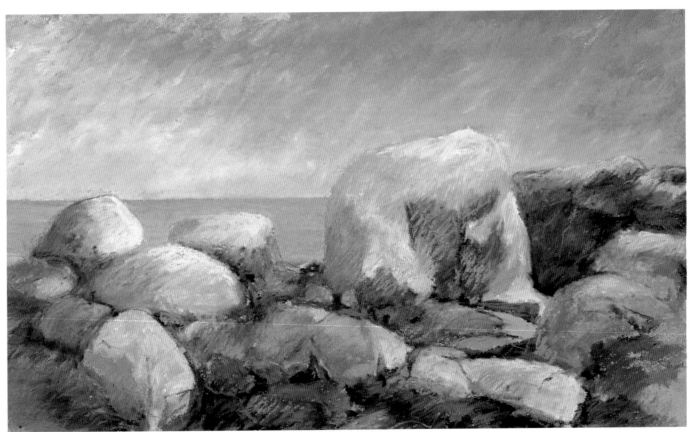

ROCKS
Oil stick on Daniel Smith Multimedia
Artboard, 13 × 23" (33 × 58 cm).

The completed image reminds me of the salty sea air, the wind, and the sun baking the coast. The immediacy and textural qualities of the oil sticks convey the solid mass of the rocks while retaining a remarkable clarity of color.

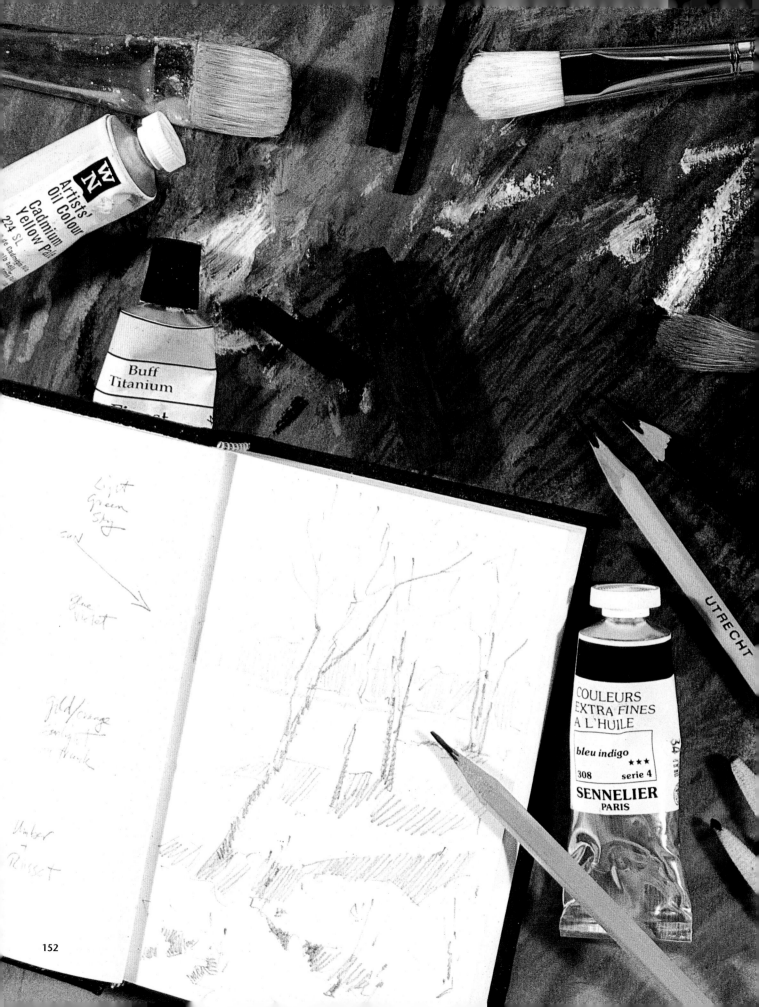

FROM DRAWING TO PAINTING

Drawing need not be cast aside once painting begins. The process of image-making, be it drawing or painting, should ultimately be one of discovery. It is the evolution of an idea, the pursuit of which can be like following clues in a treasure hunt. One discovery leads to another.

Sometimes an artist conceives several potential solutions to an aesthetic problem. Which solution to choose? Which to reject? The answer may not be clear. Sometimes an idea needs to be investigated before its worth is known. Here is where drawing can re-enter the province of painting.

As we discussed earlier, drawing is often considered "thinking on paper." It is in this capacity that drawing is invaluable to the painter. In most cases drawing is faster and more direct than painting. It serves as a shorthand procedure for exploring compositional alternatives quickly. Drawing helps us become visually familiar with each new idea as we sketch it out before us.

This is not to say that thoughts cannot be worked out directly in paint. Often it is the best way. But there are also times when a painting becomes fussy and overworked because the idea is tentative, and the resulting execution is indecisive. In such cases, a return to drawing can clarify the concept, free the mind of extraneous questions (and answers), and allow the painting process to be resumed with confidence.

DRAWING FOR COMPOSITION

Possibly the most common use of drawing as it relates to painting is in the preparatory stages of the artwork. Some artists begin with a few quick sketches, and perhaps a detailed study, before they open their tubes of paint. Many times an artist makes initial sketches on location and develops a painting much later in the studio. I, for example, like to travel with a sketchbook—somehow drawing on location completes the visual experience for me. It's true that many of these drawings will later turn into paintings, but that is not my primary concern when I begin to draw. I simply enjoy the process of making marks on paper.

Of course, there are other times when I am prepared to paint, with easel and palette ready, and I begin a drawing (on paper, or even on canvas with charcoal) as a preliminary investigation of my composition. Whether I am working out in the landscape, from a still life in the studio, or from my imagination, I like to begin my exploration by drawing.

This sequence illustrates how various kinds of drawings are typically used to develop a painting. Right: A few thumbnail sketches focus on the most basic shapes and values. At this point it's easy to try out a few designs. Below right: The quick compositional sketch is a bit more detailed, but without investing much time. Written notations in the margin can come in handy later.

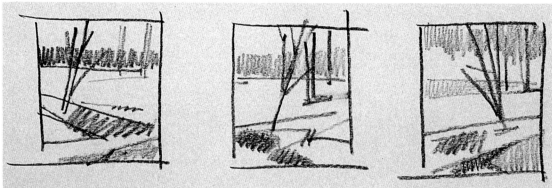

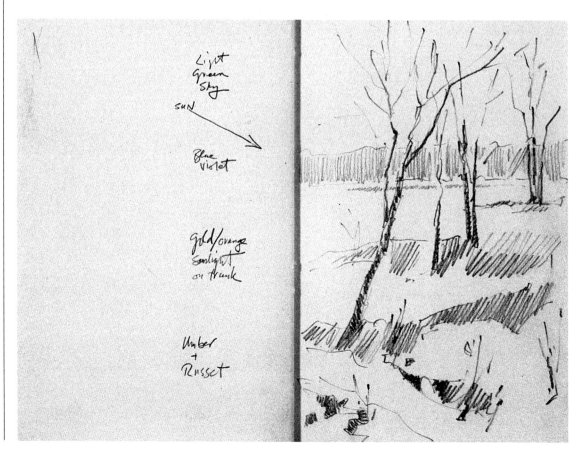

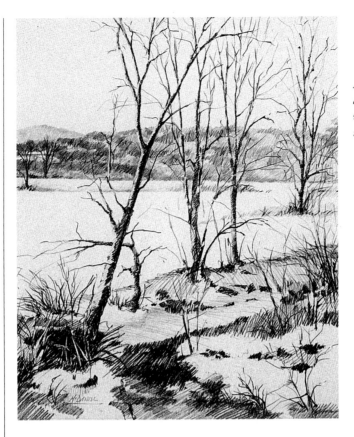

HURLEY FLATS IN WINTER
Pencil on museum board,
11 × 9" (28 × 23 cm).
From *Catskill Mountain Drawings*
by Richard McDaniel (1990).

*A finished drawing provides enough linear
and tonal information for an artist to follow
while painting, especially if some color
notations were recorded.*

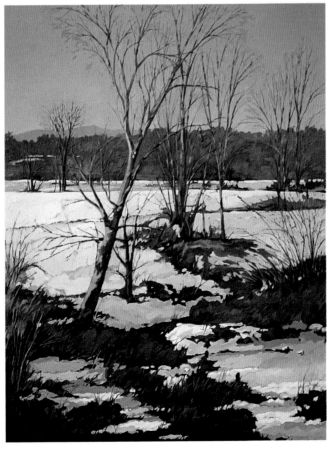

HURLEY FLATS IN WINTER
Oil on canvas,
48 × 36" (120 × 90 cm).

*The size of the canvas and the winter
temperatures dictated my painting this scene
in the studio. A few written observations
and the drawings were my only references.*

PAINTING FROM DRAWINGS

Although it is common for artists to use a compositional sketch at the beginning of the painting process, what about later on, when additional design choices must be made? Don't overlook the effectiveness of drawing as a method for working out your ideas.

DEMONSTRATION

Drawing comes into play several times in this demonstration. Not only does the image begin as a drawing, it also incorporates some details from other drawings, and uses drawing techniques to test a few evolving ideas.

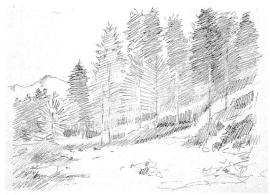

The first step is a compositional sketch. It is hardly more than a scribble but lays out the basic shapes and their position. It is easy to rearrange elements within the design at this stage, since I have little time invested in the sketch.

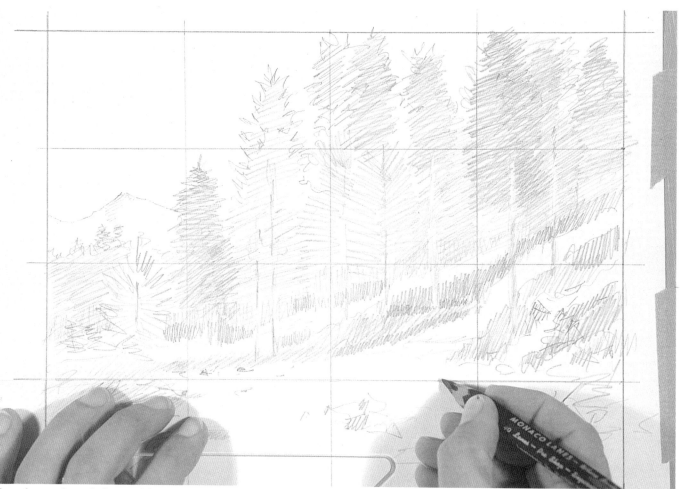

In order to enlarge the image and transfer it to a canvas, I draw a grid over my original drawing. If you need to preserve your sketch, you can draw a grid on clear acetate and superimpose it over your drawing.

On a gray-primed canvas I draw grid lines in pastel pencil that correspond proportionally with those on the sketch. I can now transfer the image freehand by drawing the lines that fall within each box. With a few strokes of turpentine-diluted paint I block in some of the dominant shapes.

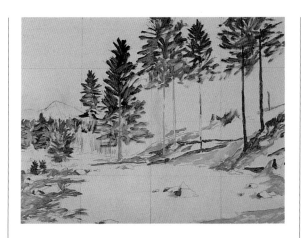

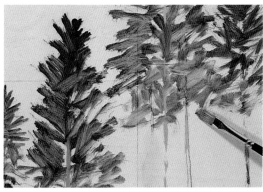

Rather than filling in drawn lines with paint, I draw the foliage directly with thinned burnt sienna and a bristle brush.

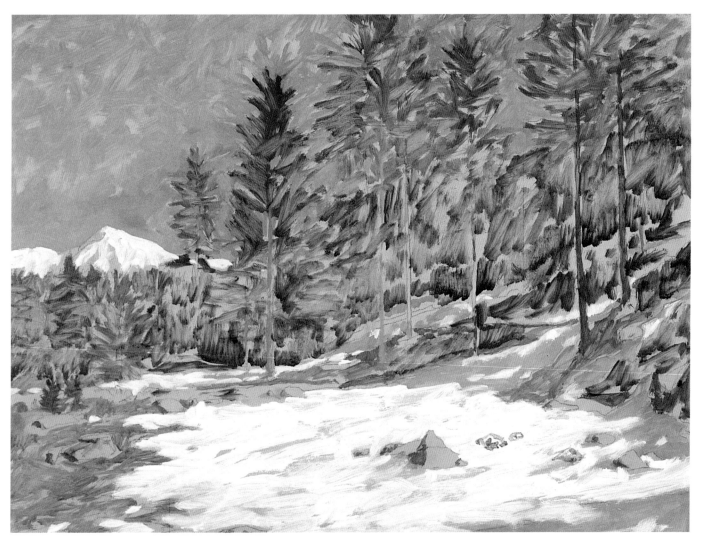

Some quick scrubbing with white, violet, and umber gives me a basic idea of what my painting will look like later, but so far I've only been sketching with a brush. It's still easy to change things around now before any details are rendered.

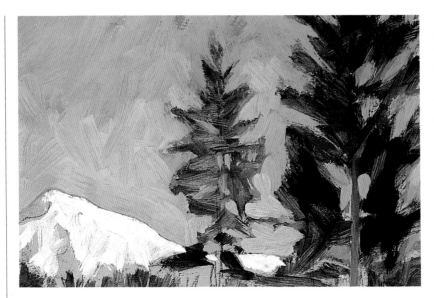

The mountain is a well known landmark in northern California, so I'd like to be topographically accurate. Unfortunately, there wasn't much information in my preliminary sketch.

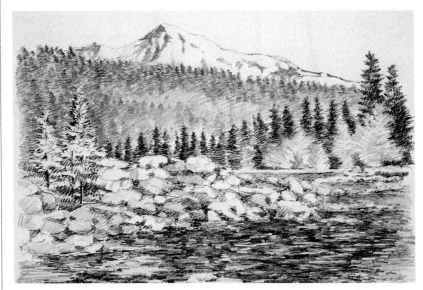

Luckily I have another drawing from a previous sketching trip. It shows the mountain from nearly the same angle at the same time of day.

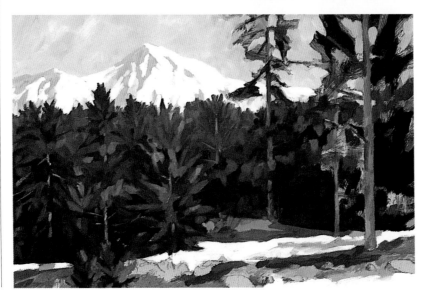

From the drawing I can gather all the facts I need about the distinctive profile of Mt. Shasta.

The foliage is built up gradually, much like working in pastel or crayon. I start with the darker background colors and save the highlights for last.

The sketch reminds me of how the light fell on the trunks, and clarifies the rhythms of light and dark.

Once again I consult a location sketch for more information on the trees. My attention was first attracted by the grace of these pines, their shadows, and the slope of the hill. The drawing sparks my memory.

Here I adapt that sensation of filtered sunlight to the trees in the painting.

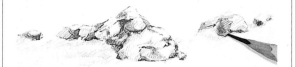

The next area I want to develop is in the foreground, where I want the small grouping of rocks to subtly echo the shape of the mountain. First I work out the idea in my sketchbook.

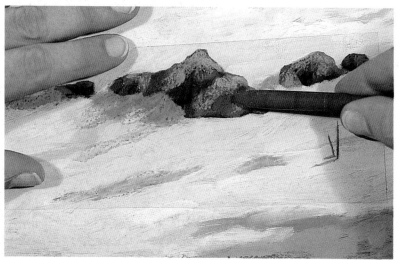

I stick a piece of clear acetate to the surface of the painting with four dabs of rubber cement and draw my rocks with oil pastels. I then move the acetate around until I find the best location for the rocks. Note that most times it's faster and easier to paint a new shape directly on the canvas—if it's wrong, you can wipe it out and start over. I include the acetate procedure as an alternative for those times when the decisions are not coming quickly. It is a good way to safely put down a shape and see how it works in different locations before investing the time painting.

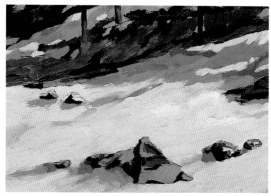

I begin the rocks with the dark shaded areas . . .

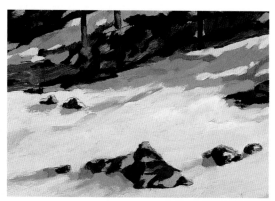

. . . and while the paint is still wet I brush in the low and middle values, adding a few warm browns.

Finally, I add the light grays and ochres on top, as well as the two little weeds in the lower right corner.

SHASTA: MEADOW: THAW
Oil on canvas, 18 × 24" (46 × 60 cm).
Courtesy of John Pence Gallery,
San Francisco.

It's good to see the history behind such a painting, and how the act of drawing plays a vital role in its creation. We can separate drawing and painting media (at times), but let us not forget that drawing is more than its materials. It is also a process of thinking and exploring.

VALUE ANALYSIS

For developing a clear sense of design, I place great importance upon the technique of value reduction. It forces you to make some difficult choices in order to simplify your image into two or three values. A basic two-value formula requires all shapes of a middle value and darker to be rendered in black, and everything else in white. This means that some shapes will merge together, losing their identity as separate objects. At times this can be disconcerting, but it can also make an image bold and mysterious.

This is where your ingenuity is challenged and your creativity aroused. You may need a more flexible formula, or you may need to arbitrarily change some of the values for the sake of clarity in the composition. It is a fascinating procedure, one that helps you focus on the most significant elements of the design. The purpose of a value-reduction exercise is not necessarily to improve a specific painting, but to increase one's understanding of how value works in an image.

For greatest contrast, many artists use black ink on white paper. There are two ways to approach inking: (1) To fill in all the large areas first with a big brush, which carries with it the danger of accidentally obliterating details, or (2) to fill in detailed areas first with a small brush or pen, which can be time-consuming and lead you to overemphasize detail. Either way works fine if you avoid these two pitfalls.

CROWS IN SNOW
Conté crayon on Arches Satiné paper,
5 × 8¹/₂" (13 × 22 cm).

Here, value reduction occurs naturally. There is very little choice required in deciding whether shapes should be black or white. For this drawing, I put my preliminary pencil sketch on a light table and covered it with another piece of drawing paper, then applied a liquid frisket mask to the negative space around the birds. When the masking fluid dried, I hatched across the drawing with parallel strokes before removing the mask.

OCEAN LIGHT
Pro Black and Pro White on
Lanaquarelle 140-lb. hot-pressed paper,
8 × 13" (20 × 33 cm).

This is a value reduction in three values. The gray helps a lot in the description of form, though some strict choices must still be made. This is a good exercise in simplification, and is useful preparation for designing graphic images, especially those for woodcuts and serigraphs.

DEMONSTRATION

You don't need to work from a completed painting to design a value reduction. I used the example here only to show the source, so that you can see the original image from which the value reduction was made. You can probably tell that the color of the poster I used to make the tracing is not the same as that in the oil painting. This happens occasionally when artwork is printed, but if the composition is strong, especially the shapes and value relationships, any color discrepancies shouldn't lessen the impact of the image.

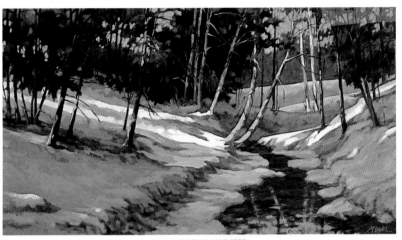

LOCK CREEK IN WINTER
Oil on panel, 16 × 29" (40 × 73 cm). Collection of Merrill-Lynch, Albany, New York.

This is the original painting from which I designed the value-reduction drawing. The strong contrast of late day sunlight and shadow gave me a lot to work with. The sloping creek bank allowed me to delineate the topography with diagonal shadows.

I use an exhibition poster of the original image to begin my value-reduction drawing. This is not required, but it was certainly convenient. With a "dead" ballpoint pen I follow the outline of its forms. There is a piece of Saral Transfer Paper beneath the poster, and as I press down on the pen a line is made (like carbon paper) on my drawing surface.

The transferred image looks like any graphite line drawing. (In fact, it is graphite.) With a pencil I mark a few Xs to differentiate some areas that will be black. Sometimes it's easy to lose your way in a value-reduction exercise, and I don't want to put India ink all over a shape that's supposed to remain white.

The entire traced image. I partially erase the Xs so that they won't be visible in the final drawing.

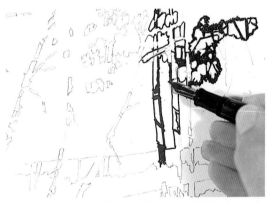

I begin inking with a Pelikan Souverän M600 fountain pen filled with India ink. The pen is ideal for areas with small shapes that would be difficult to manage with a brush.

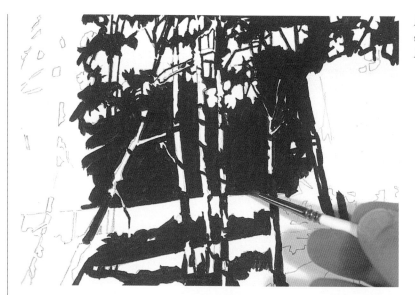

I continue to ink in the tracing with a brush, using the same India ink as in the pen.

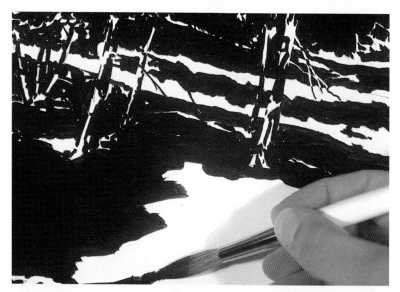

A large sable brush saves time on the big shapes.

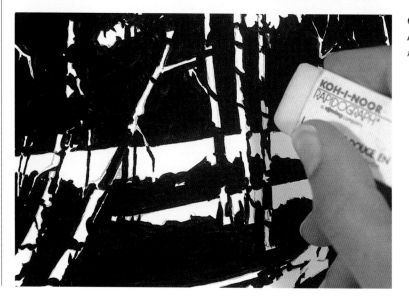

Once the ink is dry, stray pencil lines are easy to erase with a nylon eraser.

Now I bring out the pen again for little touches. In a value-reduction drawing, many edges become lost. One way to retain detail is to exaggerate or reverse the mid-value shapes. Here the branches are treated as white when they traverse a black shape, and black when they cross over white.

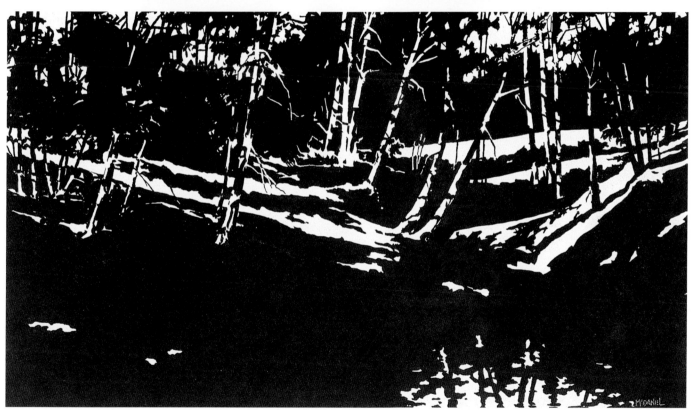

LOCK CREEK IN WINTER
India ink on Letramax 4000 illustration board, 9 × 16" (23 × 40 cm).

The completed piece has the rhythm and composition of the painting but quite a different character than the original. Value reduction requires imaginative decision-making at times, but provides a naturally occurring abstraction and the eye-attracting power of maximum contrast.

DRAWING TO RESOLVE A PAINTING

There are times when the painting process becomes bogged down, and the way ahead is unclear. When this occurs, you can take a break, think about the problem as you sit in your armchair, battle things out on the canvas—or you can think things through on paper. Drawing is usually faster than painting, which allows you to explore several ideas quickly. It is economical with respect to materials and time, providing the artist with a sort of visual shorthand for rapidly translating ideas into a graphic state.

DEMONSTRATION

Here is another example of the symbiotic relationship between drawing and painting. In the midst of working on the painting, I put aside my brushes and redrew the image completely in another medium, ink. The stronger contrast of ink and white paper alerted me to new possibilities I had not gleaned from my pencil sketch. Also, by avoiding color for a while I could return my focus to other elements of the composition, such as value contrast, rhythm, and movement.

Using a No. 4 bristle brush, I block in my darkest colors . . .

. . . then my mid-tones. Note how the strokes are left as is, without scrubbing or blending.

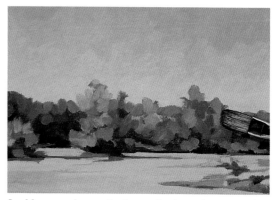

I add a second coat of color to the sky and water and continue to refine the foliage.

I draw a grid over my pencil sketch so I can copy, square by square, the scene onto a painting panel.

After drawing a grid of white chalk on a panel painted neutral gray, I transfer the image from my sketch. I paint in the sky first (which affects the entire landscape) and then the water (which reflects the color of the sky).

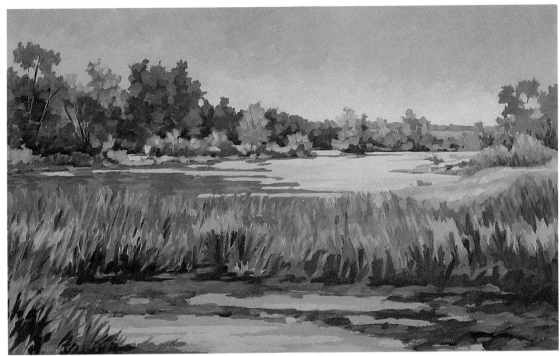

Although the image is pretty much complete, it has no sparkle. The foreground seems lifeless to me, but I am uncertain about how to proceed.

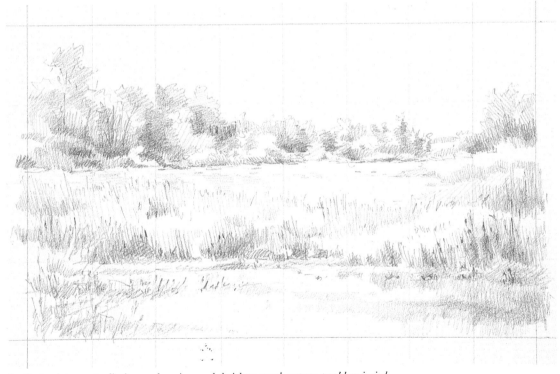

I refer back to my preliminary drawing and decide to work out my problem in ink.

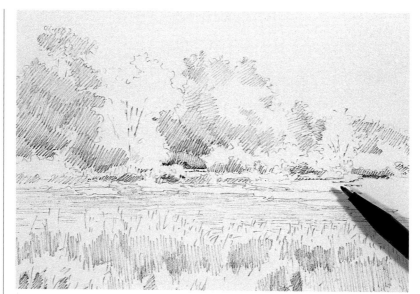

After "gridding up" a separate
piece of paper and drawing
a few guidelines in pencil to
suggest the edges of each form,
I soften the pencil lines by
pouncing with a kneaded
eraser. I begin inking with
light hatch marks over the
pencil with Penstix, a nylon-
tip pen containing India ink.

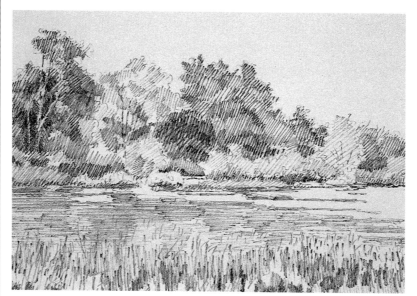

You can control the Penstix by
varying its angle. When held
at a severe angle it makes a
faint line, and by holding it
almost perpendicular to the
paper the ink flow increases
and the line darkens.

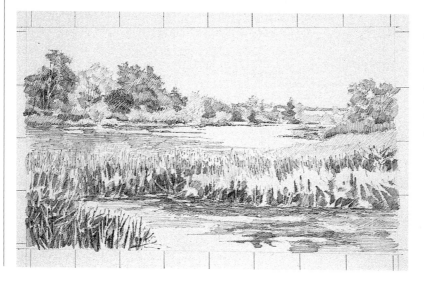

The drawing is now laid in,
although it is sparse in areas.
I am pleased with the freshness
and vigor displayed by this
pen-and-ink version, but
since my objective is that of
exploration, I decide to push
a little further.

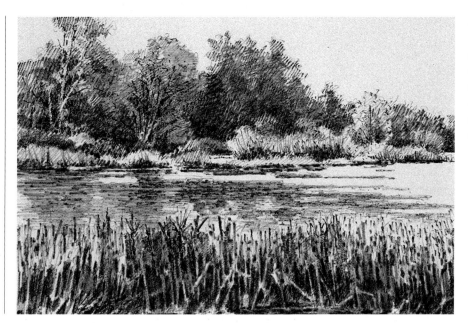

I add darker layers of ink through cross-hatching, stippling, and short lines in an effort to increase the contrast and strengthen the impact of the image.

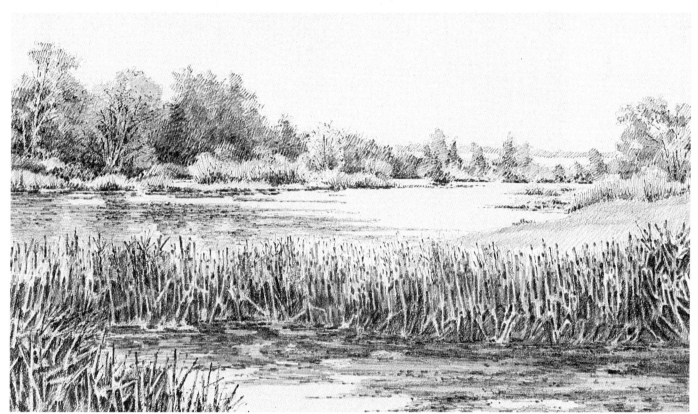

THE SACRAMENTO AT TURTLE BAY
India ink (Penstix) on Daniel Smith Archival paper,
6 × 10¹/₂" (15 × 27 cm). Collection of the
Redding Museum of Art and History, Redding, California.

From the completed drawing I conclude that greater contrast provides the sparkle that the painting needs, and that a more active foreground will add energy to the composition.

DRAWING TO RESOLVE A PAINTING

Returning to the painting, I draw some guide lines with soft chalk . . .

. . . and attach little pieces of drafting tape to indicate where I might want highlights.

With dashes of color I imitate the high contrast and crisp strokes of the pen drawing.

THE SACRAMENTO AT TURTLE BAY
Oil on panel, 12 × 20" (30 × 50 cm).
Collection of the Redding Museum of Art
and History, Redding, California.

The completed painting has much more life than the step shown at the top of page 167, thanks to my return to drawing and the understanding gained from my pen-and-ink research.

LIST OF SUPPLIERS

Where on earth can you find all the stuff in this book? Your local art supply store should carry much of what you need, and they can probably order what they don't have on hand. If after some energetic sleuthing you fail to locate your supplies, I suggest you try the companies listed below.

Co-op Artists' Materials and Atlanta Airbrush, P.O. Box 53097, Atlanta, GA 30355. Toll-free: (800) 877-3242. The Co-op catalog offers a large selection of drawing materials, especially inks, and a generous assortment of airbrush supplies. Ordering by phone, mail, or fax is simple, and all in-stock items are shipped within 48 hours. They also offer express shipping for those art supply emergencies.

Daniel Smith Inc., 4130 First Avenue South, Seattle, WA 98134-2302. Toll-free: (800) 426-6740. This Seattle-based firm produces one of the finest art supply catalogs in the United States. It is extensive, well written, and well illustrated. Each new edition also includes advice on materials and techniques that is fun to read and informative. Moreover, the sales staff is amiable and helpful, and will do their best to answer any questions you may have. Ordering by phone is easy and the prices are competitive. Supplies are very well packaged for shipping, and overnight rush service is available if you're in a real hurry.

Dick Blick Art Materials, P.O. Box 1267, Galesburg, IL 61401. Toll-free: (800) 447-8192. Dick Blick is a good source for the majority of drawing supplies you will ever need. They have art and craft supplies of every kind, and with 33 locations nationwide there may be a store near you. If not, they will ship anywhere promptly. Their 500-page catalog has a fine selection of pens, markers, pencils, and crayons, as well as furniture and storage systems for your studio.

New York Central Art Supply Company, 62 Third Avenue, New York, NY 10003. (212) 477-0400. Toll-free (800) 950-6111. An exceptional store to visit! A knowledgeable and courteous staff will help you select from a substantial inventory of the finest materials available. This supplier carries a full line of drawing materials, including pencils, pens, crayons, inks, charcoals, pastels—just about anything you can imagine, and a lot that has never crossed your mind—which are listed in the pages of their catalog of art supplies. New York Central is also internationally known for its extensive assortment of fine papers. In fact, its 100-plus-page paper catalog is regarded by many as the definitive resource for papers today. Supplies can be ordered by phone from both catalogs, and I suggest that you ask them to send both.

Pearl Paint, 308 Canal Street, New York, NY 10013. Toll-free: (800) 221-6845. Pearl is recognized as the world's largest supplier of art materials. A trip to their Manhattan store will astound you. Pearl features thousands of items from around the world to satisfy your creative needs. They have almost everything—and if they don't have it, they'll try their best to get it. Their fine catalog offers a large assortment of first-rate supplies, though it can't even begin to suggest the incredible selection available at their store. Pearl carries virtually everything mentioned in this book, and is also a reliable source for some of the European manufacturers, such as Bruynzeel and Sennelier.

Sax Arts & Crafts, P.O. Box 51710, New Berlin, WI 53151. Toll-free: (800) 558-6696. Above all, Sax prides itself on customer service. Their friendly and informative sales staff ensures a speedy response to all orders and guarantees satisfaction. Originally geared toward the art education market, Sax not only has an enormous array of materials for the art educator, but has expanded its line to include a full range of supplies for the individual artist. The 500-page Sax catalog offers a broad selection of art materials with a great variety in brands. The $4.00 fee is refundable with the first order, and the catalog is free to art educators. Sax also produces several smaller catalogs covering specific categories of materials. Of particular interest is the "Art Papers" and "Visual Art Resources" catalogs. The latter provides an outstanding selection of books, videos, films, slides, and computer products.

Utrecht Art & Drafting Supplies, 33 Thirty-fifth Street, Brooklyn, NY 11232. Toll-free: (800) 223-9132. Known as a manufacturer of artists' canvas and painting supplies, Utrecht offers a number of its own drawing supplies as well as the leading brands. Orders can be shipped anywhere around the world from its Brooklyn warehouse. Utrecht also has 7 additional branches in major cities across the country. Each store has a large variety of drawing and drafting materials, or you can order directly from their catalog.

INDEX

Italics indicate illustrations

Acetate, 160
Achromatic composition, 118
Acid-free paper, 42
Additive synthesis, 141
Airbrush, 38, 61, 140
Alvin pens, 32, 34
American EcoWriter pencil, 14–15, *15*
Analogous harmonies, 115
A/N/W Drawing and Framing paper, 45, *45*, 93
Arches papers, 45–46, *46*, 74, 118
Archival papers, 42
Arjomari papers, 45
Art gum erasers, 57, *58*
Art Stix, 20, *20,*
Automatic pencils, 16

Ballpoint pens, 33–34, *34,* 108, *109–11*
Banana paper, 51, *51*
Berol
 markers, 36, *36*
 pencils, 13, 14, *14,* 15, 20, *20*
Binder, 116, 132, 144
Binney & Smith, 27
Black, 120, *121–22,* 132
Blaisdell Lay-Out Pencil, 15, *15*
Blending, 58–59, 77, 84
Boards, 52–53, *53,* 93
Bodleian Handmade Paper, 49–50, *50*
B pencils, 12–13, 72
Branding Paint Sticks, 26
Bread, as eraser, 57, *58*
Bridges, artist's, 59, 60, 108
Bristol board, 93
Broad stroke, 77
Brushes, 37, *37*
Brush pens, 37, *37,* 102
Bruynzeel
 graphite products, 17
 pencils, 13, *14,* 20, 21, *22, 23,* 23
Buffering, 42
Burnishing, 132

Calligraphy
 brushes, 37, 102
 nibs, 30, 31
 papers, 46
Calli inks, 40, *40*

Canson Mi-Tientes, 47, *47*
Caran d'Ache
 crayons, 25, *26*
 oil pastels, 28, *28*
 pencils, 21, 22, *22*
Carbon pencil, *15,* 15–16
Carb-Othello pencils, 23, *23*
Carriera, Rosalba, 126
Cattle markers, 26–27, *27,* 117
Ceramicron pens, 32, *32*
Chalk
 fired/unfired, 19
 vs. pastel, 22
 railroad, 19, *19*
 red, 19, *19*
 white, 19, *19,* 99
Chamois, blending, 58–59, *59*
Charcoal drawing, tonal effects in, 99, *100–101*
Charcoal white, 19
China marker, 27, *27,* 121
Chroma, 114
Clayboard, 55, *55*
Coffee sticks, 61, *61*
Cogon grass paper, 51, *51*
Col-erase, 21
Cold-pressed paper, 42, 43
Color, 113. *See also* Colored pencils; Crayons; Markers; Pastels; Value
 inks, 40–41, *41*
 layering, 123, *124–25,* 140
 neutral, 118, *119*
 papers, *47,* 47–49, *48,* 99, 120, *121–12*
 terminology, 114–15
Colored pencils
 applications of, 132
 manufacturers of, 20–23
 pastel, 22–23, *23*
 watercolor, 21–22, *22,* 132, *138–39*
 wet/dry technique, 132, *133–39*
Colorless blenders, 35
Color wheel, 114–15
Complementary colors, 114–15
Compositional drawing, 68, *69–70, 154,* 154–55
Computer imaging, 63, *64–65,* 140
Conté, Nicolas Jacques, 12, 124
Conté
 crayons, 24, *24,* 25, 26, 124–25

pencils, 16, 21, 22, *22,* 23, *23*
Cool colors, 115
Cotton wipes, as blending tool, 59
Crayola, 27, 120, *121–22*
Crayons
 applications of, 116, 118, *119,* 120, *121–22,* 123, *124–25*
 drawing, 24, *24,* 124
 fine art, 25–26, *26*
 graphite, 17, *17*
 lithographic, 24–25, *25,* 121
 oil pastel, 28
 properties of, 116
 schoolyard, 27
 specialty, 26–27, *27*
Cray-Pas, 28, *28*
Creevy, Bill, 22
Cross-hatching, 77, 80, *81–82,* 86, 106, 132
Crow quill pens, 30–31
Cyklop pencils, 22, *22*

Daler-Rowney inks, 40, *40,* 41, *41*
Daniel Smith papers, 45, *45,* 52, *53,* 93
Deckle edge, 43
Degas, Edgar, 126
Derwent
 crayons, 24, *24*
 pencils, 13, *13,* 15, *15,* 20–21, *21,* 22, 23, *23*
 sketchbook, 44, *44*
Design
 markers, 36, *36*
 pencils, 14, *14,* 21, 22, *22,*
Dixon
 China markers, 27, *27*
 lumber crayons, 27, *27*
Drafting supplies, 59–60
Drawing. *See also* Charcoal drawing; Ink drawing; Pencil drawing
 with color. *See* Color
 compositional, 68, *69–70, 154,* 154–55
 creative, 60–61
 defined, 8–9
 dry wash, 17, 77, 84, *85–87*
 with eraser, 17, 77, 82, 85, 86, 88, *89–91,* 93, 94
 fear of, 8

linear, 67, 71–74
materials/supplies/tools, 12–61, 172
vs. painting, 126, 153
painting from, 156, *157–61*
in painting process, 166, *167–71*
technology and, *62*, 62–63, *64–65*
tonal. *See* Tonal effects
Dr. Ph. Martin's inks, 39–41, *40, 41*
Dry wash, 17, 77, 84, *85–87*
Duster, draftsman's, 59, *60*

Eberhard Faber
 erasers, 58
 pencils, 13, 14, 21
 pens, 34, 35
Edding 950 marking crayon, 27, *27*
Edges, softening, 89
Electric erasers, 57, *58*
Erasers
 drawing with, 17, 77, 82, 85, 86, 88, *89–91*, 93, 94
 types of, 57–58, *58*
Exploratory drawing, 68, *69–70*
Eyedroppers, 61, *61*

Faber-Castell
 markers, 36, *36*
 pencils, 14, 21
Fabriano papers, 48, *48*, 93
Fiber-tip pens, 34–35, *35*
Film, for ink, 53, *53*
Fine art crayons, 25–26, *26*
Fixative, *59*, 59–60
Fountain pens, 31, *31*, 102
Frisket, liquid, 60
FW Artists Ink, 41

General
 graphite products, 17
 pencils, 14, *14*
Gold nibs, 31
Grams per square meter (g/m²), 43
Graph 1000, 16
Graphite
 coating, 84, 86, 92, 93
 crayons, 17, *17*
 pencils, 12–13, *13*, 71
 powdered, 17, *17*
 sticks, 17, *17*, 77, 92, 93
Grays, 102, 118, 119
Griffin pens, 33–34, *34*
Grumbacher pencils, 15

Handmade paper, 42, 43
 Indian, 51, *51*
 Japanese, 50, *50*
 types of, 51–52, *52*
 vintage, 49–50, *50*
Hardtmuth, Franz von, 12
Hardtmuth, Joseph, 12
Harmony, color, 115
Hatching
 ink, 102, 106, *107*, 110
 pencil, 77, 80, *81–82*
Highlights, lifting out, 17, 77, 85, 88, 90
Hot-pressed paper, 42, 43
H pencils, 12, 13
Hue, 114
Hydro markers, 27, *27*

Illustrator pen, 33–34, *34*
India ink, 33, 38, *38*, 61, 103
Indian papers, 51, *51*
Ingres, Jean Auguste Dominique, 48
Ingres papers, 48, *48*
Ink drawing. *See also* Drawing
 ballpoint, 108, *109–11*
 cross-hatching, 80, 106
 hatching, 102, 106, *107*, 110
 linear, 74, *74*
 stippling, 102, 104, *105*
 tonal effects in, 102, *103*
 value reduction in, 162, *163–65*
Inks
 ballpoint, 33–34, 108
 colored, 40–41, *41*
 India, 33, 38, *38*, 61, 103
 paper/film for, 53, *53*
 qualities of, 38
 sumi, 38–39, *39*
 for technical pens, 38, 39, *39*
 waterproof, 31, 32, 37, 38
 white, 39–40, *40*
 xylene-based, 35, 36
Inness, George, 136
Intensity, color, 114
Itoya pens, 34

Japanese papers, 50, *50*

Kaimei brush pen, 37, *37*
Karat pencils, 21, 22, *22*
Karisma Watercolor Pencils, 15, *15*
Kneaded erasers, 57–58, *58*
Knife
 sharpening with, 56, *56*
 X-Acto, 93

Koh-I-Noor
 erasers, 58
 graphite products, 17, *17*
 inks, 32, 39, *39*
 lead fillers, 16, *16*
 pencils, 12, 13, 14, 15, *15*, 16, 22, *22*
 pen cleaners, 33, *33*
 pens, 31, 32, *32*
Kolinsky brushes, 37, *37*
Korn lithographic products, 25, *25*

La Carte Pastel, 48–49, *49*
Laid paper, 43
Lana papers, 46, *46*, 48
Lanaquarelle, 46–47, 96
Layering, 123, *124–25*, 132
Lead fillers, 16, 22
Lead holders, 16, *16*, 22
Letramax board, 52, *53*
Lifting out highlights, 17, 77, 85, 88, 90, 93
Linear drawing, 67, 71–74
Lithographic crayons, 24–25, *25*, 121
Lithography, 24–25
Lumber crayons, 17, 27, *27*

Machine-made paper, 42, 43
Markal
 chalks, 19
 crayons, 27
 marking products, 26–27
Markers
 art, 35–36, *36*
 cattle, 26–27, *27*, 117
 China, 27, *27*, 121
 Edding 950, 27, *27*
 Hydro, 27, *27*
 stippling with, 140, *141–43*
 watersoluble, 140
Marvy marking pen, 40
Masking fluid, 60
Materials/supplies/tools, 12–61, 172
Mechanical pencil, 16, *16*
Mexican bark paper, 51, *51*
Michelangelo, 116
Monochromatic harmonies, 115
Monotech, 16, *16*
Mouchet é paper, 49, *49*
Mouldmade paper, 42, 43
Multimedia Artboard, 52
Munsell, Albert, 114
Museum board, 52–53, 93

Negro Pencil, 16
Neocolor crayons, 25, *26*

Neopastels, 28
Neutral colors, 118, *119*
Newton, Isaac, 114
Nibs
 calligraphy, 30, 31
 fountain pen, 31
 marker, 35–36
 technical pen, 32
Nonobjective art, 8
No. 2 pencil, 13, *13*
Nouvel Carré crayons, 26, *26*

Oilbars, 29, *29*
Oil pastels, 28, *28*, 144, *146–48*
Oil sticks, 28–29, *29*, 144–45, *149–51*
Osmiroid fountain pens, 31
Ostwald, Friedrich, 21, 114

Paintstiks, 26, 27
Paper
 for charcoal, 99
 colored, 47, *47–49*, *48*, 99
 drawing, 45, *45*
 for graphite, 93
 handmade. *See* Handmade paper
 for ink, 53, *53*
 invention of, 42
 printmaking, 45–47, *46*, *47*
 for silverpoint, 54
 sketchbooks, *44*, 44–45
 specialty, 52–53, *53*
 terminology, 42–43
 transfer, 60
 types of, 42
 watercolor, 45–47, *46*, *47*, 96
Papyrus, 51–52, *52*
Pastel Book, The (Creevy), 22
Pastels
 applications of, 126, *127–31*
 defined, 22
 oil, 28, *28*, 144, *146–48*
 pencils, 19, 22–23, *23*, 127, 130, *131*
 properties of, 126
Pelikan
 fountain pens, 31, 102
 inks, 39, 41, *41*
Pencil drawing. *See also* Drawing
 dark tones in, 92, *93–94*
 hatching/cross-hatching, 77, 80, *81–82*
 linear, 71–72, *73*
 tonal effects in, 76, 77–79, 92, *93–94*
 wet, 95, *96–98*, 132, *134–35*
Pencil marks, 76, *76*

Pencils, 12–16. *See also* Colored pencils
carbon, *15*, 15–16
casual, 14, *14*
colored, 20–22, *21, 22*
graphite, 12–13, *13*, 71
grips, 60, *60*
hardness, 12, 76
history of, 12
lead holders, 16, *16*
lengtheners, 60, *60*
lithographic, 25
mechanical, 16, *16*
No. 2, 13, *13*
numbering system, 13
pastel, 19, 22–23, *23*, 127, 130, *131*
selection criteria, 12
sharpness, *56*, 56–57, *57*, 72
soft-lead, 14, *14*, 92
watersoluble, 15, *15*, 77, 95
woodless, 14–15, *15*, 92
Pen holders, 30, 31
Pen and Ink Book, The (Smith), 30
Pens. *See also* Ink drawing; Inks; Nibs
ballpoint, 33–34, *34*, 108, *109–11*
brush, 37, *37*
dip, 30
fiber-tip, 34–35, *35*
fountain, 31, *31*, 102
quill, 30–31
reed, 30
rolling ball, 34, *34*
technical. *See* Technical pens
Penstix pens, 34, *35*, 168
Pentalic Woodless Pencil, 15, *15*
Pentel
lead fillers, 16, *16*
pencils, 16, *16*
pens, 32, *32*, 34
Permaroller pen, 34
pH, 43
Photocopy technology, *62*, 62–63
Picasso, Pablo, 28
Pigma pens, 35, *35*, 37, 37
Pigment Sticks, 29, *29*
Pilot markers, 36
Pink Pearl erasers, 58
Pixels, 63
Plate finish, 43
Platignum fountain pens, 31
Ply, 43
Pointillism, 141

Pounds per ream, 43
Prang
chalk, 19
crayons, 27
Primary colors, 114
Printmaking papers, 45–47, *46, 47*
Prismacolor
Art Stix, 20, *20*
pencils, 20, *20*

Quicker Clicker, 16, *16*
Quill pens, 30

R & F Pigment Sticks, 29, *29*, 151
Rag paper, 43
Railroad chalk, 19, *19*
Rapidograph pens, 32, *32*, 33
Rapidoliner pens, 32, *32*
Reed pens, 30
Reform Refograph pen, 32, *32*
Rice paper, 43
Rising papers, 45, *45*, 47
Rives papers, 44, *44*, 47
Rolling ball pens, 34, *34*
Roma paper, 48, *48*
Rotring
erasers, 58
inks, 40, *40*, 41, *41*,
pens, 31, 32, *32*
Rough paper, 42, 43

Sakura
erasers, 58
oil pastels, 28
pens, 35, 37
Sandpaper blocks, 57
Sanguine, 19
Sargent crayons, 27
Saturation, color, 114
Saunders (T. H.) papers, *44*, 45, 50
Schoolyard crayons, 27
Schwan
markers, 36, *36*
pens, 33, *34*
Schwan-Stabilo crayons, 26, *26*
Scraperboard, 55, *55*
Scratchboard, 54, 54–55, *55*
Scribble, 68, *68*
Secondary colors, 114
Select-O-Matic, 16, *16*
Senefelder, Alois, 24–25
Sennelier, Gustav, 28
Sennelier
oil pastels, 28
oil sticks, 29, *29*
sketchbook, 44, *44*

Seurat, Georges, 141
Shade, 114
Sharpeners, *56*, 56–57, *57*
Shiva Paintstiks, 26, *27*
Signac, Paul, 141
Silverpoint, 54, *54*
Sizing, 43
Sketchbooks, 42, *44*, 44–45
Sketching, 68, *69–70*
Smearing, 88
Smith, Jos. A., 30
Soft-lead pencils, 14, *14*
Solvents, 61, 77, 144
with crayon, 116
for graphite, 95
transfer technique, 61
Spatter technique, 61, 140
Speedball ink, 41, *41*
StabiLayout Marker, 36, *36*
Stabiliner pen, 33, *34*
Stabilotones, 26, *26*,
Staedtler
markers, 36, *36*
pens, 32, 33
Stippling, 102, 104, *105*, 140, *141–43*
Stonehenge paper, 47
Stones Crayons, 25, *25*
Strathmore
board, 53, *53*
papers, 45, *45*, 49, *49*
sketchbooks, 44, *44*
Study, 68, *69*
Stump, blending, 59, *59*, 84, 90
Sulphite, 43
Sumi brushes, 37
Sumi inks, 38–39, *39*
Supports. *See also* Paper
boards, 52–53, *53*, 93
for scratchboard, 55, *55*
for silverpoint, 54, *55*
Supracolor pencils, 22

Tape, 60, 93
Technical pens, 31–33, *32*, 103, 104
cleaners for, 33, *33*
inks for, 38, 39, *39*
Technology, new, *62*, 62–63, *64–65*
Templates, 84, 93, 105
Tertiary colors, 114
Tint, 114
Tombow
markers, 36, *36*
pencils, 16
pens, 34
Tonal effects, 67
with charcoal, 99, *100–101*

with crayon, 116
with graphite, 92, *93–94*
with ink, 102, *103*
with pencil, 76, *77–79*
Toothbrush spattering, 61
Tortillons, as blending tool, 59, *59*, 85
Transfer paper, 60
Transfer technique, solvent, 61
Turpentine, 61, 77, 95, 144
Twinrocker papers, 52, *52*

Utrecht sketchbook, *44*, 45

Value
reduction, 162, *163–65*
scale, 75, *75*
terminology, 114
Vellum finish, 43
Videography, 63
Vinyl erasers, 58, *58*

Wacom Digitizing Tablet, 63
Warm colors, 115
Wash technique, 102, *103*
Watercolor papers, 45–47, *46, 47*, 96
Watercolor pencils, 21–22, *22*, 132, *138–39*
Watermark, 43
Waterproof ink, 31, 32, 37, 38
Watersoluble markers, 140
Watersoluble pencils, 15, *15*, 77, 95
Webril Wipes, 59, 86, 93
Wet pencil technique, 95, *96–98*, 132, *134–35*
Whatman papers, 50, *50*
White
chalk, 19, *19*, 99
on colored ground, 120, *121–22*, 139
hatching, 82
inks, 39–40, *40*
pastel pencils, 19
Winsor & Newton
inks, 40, *40*, 41, *41*
oil sticks, 29, *29*
Wolff pencils, 16
Woodless pencil, 14–15, *15*, 92
Wookey Hole papers, 50, *50*
Wove paper, 43

X-Acto knife, 93
Xerography, *62*, 62–63
Xylene, 35, 36

Yarka Sauce crayons, 24, *24*, 118, *119*

ABANDONED FERRY SLIP
Pencil on museum board, 8 × 10" (20 × 25 cm).
From *Hudson River Drawings* by Richard McDaniel (1994).
Collection of Mr. and Mrs. Robert Gravinese.

Senior Editor: Candace Raney
Associate Editor: Joy Aquilino
Designer: Areta Buk
Graphic Production: Ellen Greene
Text set in Caslon 540